HELEN LEVITT

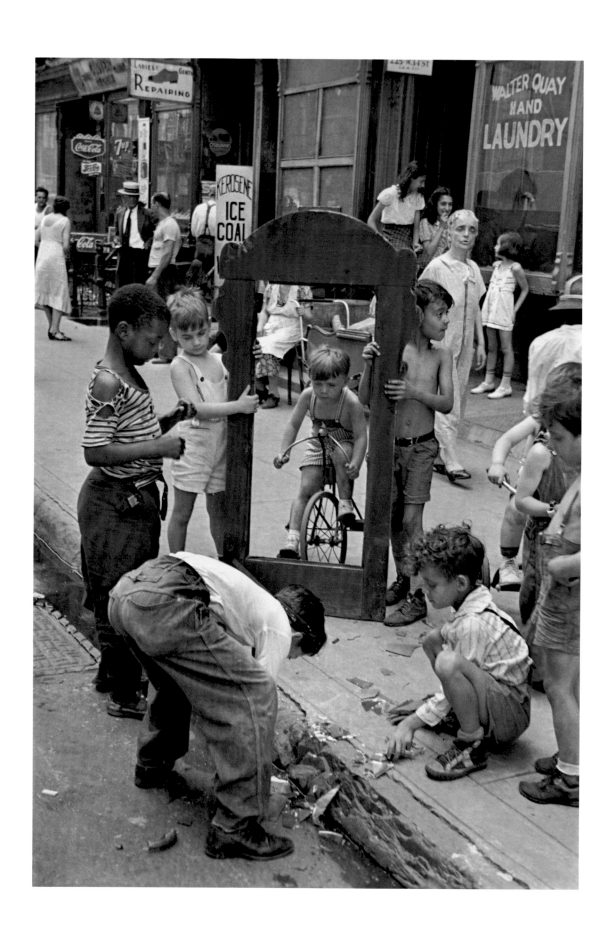

HELEN LEVITT

SANDRA S. PHILLIPS

Curator of Photography

San Francisco Museum of Modern Art

MARIA MORRIS HAMBOURG

Associate Curator, Department of Prints and Photographs

The Metropolitan Museum of Art, New York

This publication is issued on the occasion of the exhibition *Helen Levitt*, organized by the San Francisco Museum of Modern Art and co-curated by Sandra S. Phillips, curator of photography, San Francisco Museum of Modern Art, and Maria Morris Hambourg, associate curator, Department of Prints and Photographs, The Metropolitan Museum of Art, New York, and held at the San Francisco Museum of Modern Art (December 19, 1991–March 15, 1992); The Metropolitan Museum of Art, New York (April 1–June 28, 1992); National Museum of American Art, Smithsonian Institution, Washington, D.C. (July 24–October 18, 1992); The Detroit Institute of Arts (November 11, 1992–January 10, 1993); The Art Institute of Chicago (February 4–May 2, 1993); Presentation House Gallery, Vancouver, B.C. (May 31–July 29, 1993); Seattle Art Museum (August 20–October 13, 1993); Utah Museum of Fine Arts, Salt Lake City (October 31–December 12, 1993); and Los Angeles County Museum of Art (January 6–March 27, 1994).

Helen Levitt is made possible by The Chase Manhattan Bank. Additional support has been provided by the National Endowment for the Arts and the National Endowment for the Humanities.

A number of the black-and-white plates in *Helen Levitt* were previously published in editions of Helen Levitt's *A Way of Seeing*, published by Duke University Press, Durham, North Carolina.

Designer: Catherine Mills
Project Coordinator: Kara Kirk
Editors: Gail Larrick, Susan Weiley
Duotone and Tritone Negatives: Robert J. Hennessey
Text Composition: Wilsted & Taylor, Oakland, California
Printing: Meridian Printing, East Greenwich, Rhode Island

Library of Congress Cataloging-in-Publication Data:

Phillips, Sandra S., 1945–
 Helen Levitt / Sandra S. Phillips, Maria Morris Hambourg.
 p. cm.
 ISBN 0-918471-20-6 (softcover)
 ISBN 0-918471-22-2 (hardcover)
 1. Photography, Artistic—Exhibitions. 2. Levitt, Helen—Exhibitions. I. Hambourg, Maria Morris. II. Levitt, Helen. III. San Francisco Museum of Modern Art. IV. Title.
TR647.L47P45 1991
779′ .092—dc20 91-3782
 CIP

Cover: Helen Levitt, New York, c. 1940. Private collection.
Frontispiece: Helen Levitt, New York, c. 1940. Private collection.

CONTENTS

HELEN LEVITT has for half a century occupied a position of quiet but special distinction within the worlds of American photography and filmmaking. It would hardly be creditable to suggest that an artist has been underappreciated whose first solo exhibition was at The Museum of Modern Art, New York—as Levitt's was in 1943—and whose ensuing career has been followed with interest by that great center of photography studies and by other informed and discerning individuals and institutions. Helen Levitt may count as close friends and colleagues many luminous figures in modern cultural life, yet her achievements heretofore have not reached the broader awareness of a popular audience. With special pleasure, then, the San Francisco Museum of Modern Art presents this exhibition, the first full-scale critical survey and catalogue of Levitt's work. The exhibition will travel to eight other North American venues, offering the opportunity for her art, and the qualities of lyricism and humanitarianism that inform her exceptional contribution to that essential modernist tradition of street photography, to be regarded widely.

Helen Levitt was conceived as a project by Sandra S. Phillips, curator of photography at the San Francisco Museum of Modern Art, and organized by her and Maria Morris Hambourg, associate curator in the Department of Prints and Photographs at The Metropolitan Museum of Art, New York. We are most grateful to these collaborators for their keen commitment to realizing this undertaking. Many other individuals have contributed information and expertise, and we offer thanks to Berenice Abbott; Richard Benson; Sandra Berler, Sandra Berler Gallery, Chevy Chase, Maryland; Joseph Church; Wanda Corn; Susan Delson; Arnold Eagle; Morris Engel; Jeffrey Fraenkel, Fraenkel Gallery, San Francisco; John Szarkowski, Peter Galassi, Susan Kismaric, Charles Silver, and Ron Magliozzi, The Museum of Modern Art, New York; Philip Gefter; Howard Greenberg, Howard Greenberg Gallery, New York; John Hill; Leo Hurwitz; Judith Keller, J. Paul Getty Museum; Robert Klein, Robert Klein Gallery, Boston; Arthur Leipzig; John R. Levitt; Mimi Levitt; Robert Levitt; William H. Levitt; Jane Livingston; Janice Loeb; Ben Maddow; the late Paul Magriel; Edna Ocko Meyers; Laurence Miller, Laurence Miller Gallery, New York; Beaumont Newhall; Christopher Phillips; Naomi and Walter Rosenblum; Bernarda Bryson Shahn; Clara Shapiro; the late Aaron Siskind; Alan Trachtenberg; David Travis and Colin Westerbeck, The Art Institute of Chicago; Julia Van Haaften, The New York Public Library, and Deborah Willis, Schomberg Center for Research in Black Culture, The New York Public Library; Stephen Vincent; and Bonnie Yochelson, Museum of the City of New York.

At the San Francisco Museum of Modern Art the project was advanced by the special efforts of staff members Janet Bishop, John Caldwell, Inge-Lise Eckmann, Barbara Levine, JoAn Merle, Kent Roberts, Richard Siegesmund, and Jane Weisbin, aided by interns Jahna Antoniades, Sarah Berg, David Brown, Lesley Davison, Jennifer Hermesmeyer, Christiane Hertzig, Elizabeth Hutchinson, Alison Kohrs, Elliot Linwood, Laura Murray, and Greg Williams, and at The Metropolitan Museum of Art Jeff Rosenheim, Nina Maruca, and Malcolm Daniel offered distinct assistance to the venture. This publication, which accompanies and catalogues the exhibition, was coordinated by Kara Kirk and designed

by Catherine Mills of the San Francisco Museum of Modern Art using tritone separations prepared by Robert Hennessey; the texts were edited by Gail Larrick and Susan Weiley.

On behalf of the artist and the San Francisco Museum of Modern Art, it is a pleasure to extend particular thanks to two individuals who have been helpful personally to Helen Levitt as well as to the museum in this endeavor: Marvin Hoshino for his extensive contributions as special consultant for the exhibition and catalogue and Knox Burger as advisor in matters associated with the publication.

We are especially obliged to the following lenders to *Helen Levitt* for sharing their works with the audiences of the museums on this exhibition's extensive itinerary: David Bransten; Joyce and Robert Menschel; The Metropolitan Museum of Art, New York; The Museum of Modern Art, New York; The New York Public Library; and anonymous lenders. It is a source of enduring satisfaction to note that a not insignificant number of prints come from the San Francisco Museum of Modern Art's own collection.

For desiring to present this exhibition at their institutions we thank: Philippe de Montebello and Maria Morris Hambourg, The Metropolitan Museum of Art, New York; Elizabeth Broun and Merry Foresta, National Museum of American Art, Smithsonian Institution, Washington, D.C.; Samuel Sachs II and Ellen Sharp, The Detroit Institute of Arts; James N. Wood and David Travis, The Art Institute of Chicago; Karen Love, Presentation House Gallery, Vancouver, B.C.; Jay Gates and Rod Slemmons, Seattle Art Museum; E. F. Sanguinetti and Thomas Southam, Utah Museum of Fine Arts, Salt Lake City; and Earl A. Powell III and Robert Sobieszek, Los Angeles County Museum of Art.

Great appreciation is due to The Chase Manhattan Bank and the National Endowment for the Arts for the generous grants that have made possible the organization and tour of *Helen Levitt*. Enrichment and educational programs at the San Francisco Museum of Modern Art associated with the exhibition enjoy the support of the California Arts Council.

In addition to expressing our enthusiastic respects to Helen Levitt for her five decades of high artistic accomplishment, we wish also to offer her our most sincere thanks for the aid she provided in the development of this exhibition and publication project.

John R. Lane
Director
San Francisco Museum of Modern Art

THE CHASE MANHATTAN BANK is pleased to join the San Francisco Museum of Modern Art in presenting the exhibition and national tour of the photographic works of Helen Levitt, one of the artists represented in our corporate art collection.

Helen Levitt has always made her home in New York, and the city has been a constant source of inspiration to her. When Levitt began her work in the 1930s, most of the country's population was spread through rural areas where the vibrant street life of New York seemed distant and unfamiliar. Today, most Americans share the urban experience that Levitt so vividly portrays.

Helen Levitt has long been considered a "photographer's photographer"—esteemed by her colleagues but not well known to the general public. We at Chase are delighted to be able to bring her work to a wider audience as part of our continuing commitment to the communities across America where our clients and staff members live and work.

Thomas G. Labrecque
Chairman
The Chase Manhattan Bank

LIST OF ILLUS-
TRATIONS

22. Arnold Eagle and David Robbins, Untitled (New York City), 1938, from the WPA Federal Art Project series *One Third of a Nation*. Reproduced courtesy of Arnold Eagle. Photograph courtesy of the National Archives, Washington, D.C.

23. Alexander Alland, *Home of the Gypsies on Hester Street*, 1940. Collection of the Estate of Alexander Alland, Sr. Photograph courtesy of the Museum of the City of New York.

24. Aaron Siskind, Untitled, c. 1940, from *The Most Crowded Block* series. Reproduced courtesy of The Estate of Aaron Siskind.

25. Arthur Leipzig, *Chalk Games*, 1948. Photo © Arthur Leipzig.

26. Ben Shahn, *Houston Street Playground, New York*, c. 1932. Collection of the Fogg Art Museum, Harvard University, Cambridge, Massachusetts; Gift of Mrs. Bernarda Shahn. Reproduced courtesy of Bernarda B. Shahn.

27. Ben Shahn, *A Group of Young Negroes*, 1935. Photograph courtesy of the Library of Congress.

28. Ben Shahn, *Scenes from the Living Theatre—Sidewalks of New York*, from the November 1934 issue of *New Theatre* (pp. 18–19). Special Collections, The Museum of Modern Art Library, New York. Reproduced courtesy of Bernarda B. Shahn.

29. Walker Evans, *Family*, 1938. The Metropolitan Museum of Art, Gift of Arnold Crane, 1971 (1971.646.9). © 1991 Estate of Walker Evans.

30. Walker Evans, *42nd Street*, 1929. Collection, The Museum of Modern Art, New York. Purchase. © 1991 Estate of Walker Evans.

31. Walker Evans, *Child in Backyard*, 1932. © 1991 Estate of Walker Evans.

32. May Levitt with daughter Helen, 1914. Reproduced courtesy of William H. Levitt.

33. Henri Cartier-Bresson, *Mexico City*, 1934. © Henri Cartier-Bresson and Magnum Photos, Inc.

34. Jean Cocteau, film still from *Blood of a Poet*, 1932. The Museum of Modern Art, New York, Film Stills Archive.

35. Helen Levitt, Central Park, New York, 1936. Private collection. © Helen Levitt.

36. Helen Levitt, Untitled, 1936–38. Private collection. © Helen Levitt.

37. Helen Levitt, Untitled, 1936–38. Private collection. © Helen Levitt.

38. Helen Levitt, New York, 1936. Private collection. © Helen Levitt.

39. Helen Levitt, New York, 1936. Private collection. © Helen Levitt.

40. Helen Levitt, New York, 1936. Private collection. © Helen Levitt.

41. Helen Levitt, Florida, c. 1938. Private collection. © Helen Levitt.

42. Arnold Eagle and David Robbins, Untitled (New York City), 1938, from the WPA Federal Art Project series *One Third of a Nation*. Reproduced courtesy of Arnold Eagle. Photograph courtesy of the National Archives, Washington, D.C.

43. Ben Shahn, Untitled, c. 1934. The Metropolitan Museum of Art, Ford Motor Company Collection, Gift of Ford Motor Company and John C. Waddell, 1987.

44. Helen Levitt, New York, 1946. Private collection. © Helen Levitt.

45. Helen Levitt with movie camera, 1944–45. Reproduced courtesy of Dr. Robert Levitt.

46. Helen Levitt and Janice Loeb, Untitled detail from film footage of three gypsy boys, 1944–45. San Francisco Museum of Modern Art. © Helen Levitt and Janice Loeb.

47. Helen Levitt and Janice Loeb, Untitled detail from film footage of Yorkville parade, 1944–45. San Francisco Museum of Modern Art. © Helen Levitt and Janice Loeb.

48. Helen Levitt, New York, c. 1940. San Francisco Museum of Modern Art, Purchased through a gift of Paul and Prentice Sack, 89.177. © Helen Levitt. (On view at SFMOMA only.)

PLATES

All works in the exhibition are illustrated herein. Black-and-white photographs are gelatin silver prints; color photographs are dye transfer prints. Unless otherwise noted, all works will travel to all venues.

1. New York, c. 1938. The Metropolitan Museum of Art, Purchase, The Horace W. Goldsmith Foundation Gift, 1991.

2. New York, 1938. Private collection.

3. New York, 1940. San Francisco Museum of Modern Art, Purchase 88.373.

4. New York, c. 1938. Private collection.

5. New York, 1938. Romana Javitz Collection, The Miriam and Ira D. Wallach Division of Art, Prints and Photographs, The New York Public Library, Astor, Lenox and Tilden Foundations.

6. New York, 1938. Private collection.

7. New York, 1939. Private collection.

8. New York, 1939. The Museum of Modern Art, New York, Anonymous gift. (SFMOMA and MMA only.)

 Private collection. (All venues except SFMOMA and MMA.)

9. New York, 1938. Private collection.

10. New York, 1938. The Museum of Modern Art, New York, Purchase.

11. New York, 1938. Private collection.

12. New York, 1942. Private collection.

13. New York, c. 1939. The Metropolitan Museum of Art, Purchase, The Horace W. Goldsmith Foundation Gift, 1987.

14. New York, c. 1940. Private collection.

15. New York, 1938. Private collection.

76. New York, 1972. San Francisco Museum of Modern Art, Print commissioned for *Helen Levitt* exhibition.

77. New York, 1978. Private collection.

78. New York, 1972. The Metropolitan Museum of Art, Gift of Laurence Miller and Lorraine Koziatek, 1991. (First five venues only.)

 Private collection.
 (Last four venues only.)

79. New York, 1971. Private collection.

80. New York, 1971. Private collection.

81. New York, 1972. San Francisco Museum of Modern Art, Print commissioned for *Helen Levitt* exhibition, 91.112.

82. New York, 1971. Private collection.

83. New York, 1971. Private collection.

84. New York, 1972. The Metropolitan Museum of Art, Gift of Marvin Hoshino, 1986. (First five venues only.)

 Private collection.
 (Last four venues only.)

To understand poetry we must be capable of donning the child's soul like a magic cloak and of forsaking man's wisdom for the child's.

—Johann Huizinga[1]

HELEN LEVITT'S NEW YORK

Sandra S. Phillips

AT FIRST GLANCE Helen Levitt's work is so undemonstrative, so seemingly artless that it is not easily perceived as the complex, knowing, and highly lyrical art that it is. In one of her photographs, children playing with a broken mirror on a New York sidewalk (pl. 30), we are deceived at first into thinking that this scene is simply and unobtrusively ordinary reality, that on a sunny day in 1938 Levitt merely found some children on a sidewalk on the Upper East Side and took their picture. The photograph reveals little detail about the lives of these children—their social and economic needs or hardships, their psychology—although we notice that the little black boy's shirt is torn. Levitt's avoidance of social content is especially remarkable, for the picture was made at a time when the social consciousness that arose to rectify the problems of the Depression was reflected in American photography. More intriguing, Levitt was, at the time this photograph was made, assisting her friend Walker Evans in printing his work for "American Photographs," a show at The Museum of Modern Art. Many of Evans's photographs were made for the Roosevelt administration's Farm Security Administration (FSA), documenting the conditions of rural southern poverty.

Levitt made most of these early pictures at the end of the 1930s and the beginning of the next decade, a time when she was nurtured by her early and important friendships and the activity in art, writing, film, and photography in that changing, difficult, and fascinating period. Almost exclusively, Levitt has looked to the New York streets as the source of her art. She has been making photographs for more than fifty years, yet her eye was formed in the 1930s. And, although Levitt was originally unaware of it, her work was made at a time of major change for the city.

The 1930s were vital in the diversity of cultural life, and the social and political issues that emerged from the Crash posed questions not only for that time but also for the future. The year 1929 effectively divided the Roaring Twenties with its individualism, optimism, and expatriate culture from the new concerns of artists affected by the economic consequences of the Crash. In 1929 and shortly thereafter most American cultural refugees, including the photographers Walker Evans and Berenice Abbott, returned home from abroad, to be followed in the next years by increasing numbers of intellectual and political refugees fleeing the events in Europe. As a result, New York became the major intellectual and creative center of Western culture, as it was to become the world's financial center, displacing the European capitals of Paris and Berlin. In 1936 French architect Le Corbusier exultantly called it "a city in the process of becoming. Without anyone expecting it, it has become the jewel in the crown of universal cities in which there are dead cities whose memories and foundations alone remain."[2] Ten years later, after World War II, New York would achieve the symbol of capital of the world when it became the designated site for the United Nations.

Paradoxically, although Levitt has chosen the active city streets as her prime subject and has had a special attraction to the uninhibited play of children, her photographs reveal an appreciation of privacy, as though the subject were so delicate that she had to be quiet and unobtrusive so as not to scare it away. Levitt's children

with the mirror (pl. 30) are entirely and imaginatively absorbed in their play: Some pick shards out of the gutter; others examine the broken bits of glass; and two others, with the grace and solemnity of Renaissance angels, hold the empty frame as though parting a curtain for the child on the tricycle. The children are surrounded by more activity on the street than is usual for most of Levitt's work. Other children giggle, a woman tends a baby carriage, men lounge in front of a shoe repair store; but the children near the curb, spread out into a graceful circle and seen with the formal elegance of a group of dancers in a Poussin painting, are as unaware of them as they are of the photographer herself. It is almost as though she were invisible.

This anonymous stance of the photographer, and the formal purity of her photographs, has been noticed and described most recently by Levitt's two close friends Marvin Hoshino and Roberta Hellman; they speak of it as the "white style," meaning a style uncolored by style.[3] Levitt herself has also said, "The aesthetic is in reality itself."[4] She has a deep sense of respect for the private lives of the people she photographs, aided by her use of a right-angle viewfinder, which, in those times when it was uncommon, enabled her to make pictures without being noticed. However, this style of anonymity is also an accurate reflection of her own personality, which has always, and rightly, put the attention on the pictures rather than on the person who made them. She has always been elusive, and has never considered written criticism as central to the understanding of her work.[5]

It has become common to describe the spaces Levitt finds on the streets as "stagelike," and to see the inhabitants as members of a silent, universal, and unending cast of characters. This description is entirely apposite and accounts for the sense that these pictures, made in the midst of an ever-flowing activity, are yet distanced and stilled. Thus, we sense her appreciation of and warm response to the two men seated near the El, one gesturing like a Shakespearean actor (pl. 37). She seems greatly fond of the woman in galoshes, wearing a funny hat, hosing down her stoop (pl. 38). She admires the young dandy, somewhat scary yet distinctive in a new fedora and wide-lapelled suit, as a part of a frieze of personalities that unfolds, turning back and forth along the railing (pl. 23). She acknowledges

the tragic, too—the woman with a frayed coat under the El, her back to us, whose gesture assumes an ageless pose of comforting a despairing friend (pl. 46). But she most frequently finds children for her subjects, since they assume imaginative characters with more ease than adults. These characters sit on curbs to be comforted (pl. 42), or transform butcher's paper and baseball caps into uniforms of the Foreign Legion, mugging for the audience (pl. 14). In Mexico, they collapse like spent *toreros* in a schoolyard (pl. 51). For the most part her casts are not limitless but modest; her stages are small but timeless. She admires and records their earthy, diverse presence from the stance of impersonal, self-possessed lyricism. Her work is as closely observed as Alfred Kazin's descriptions of Brooklyn, where he grew up, although she does not share his sense of despair:

> It is always the old women in their shapeless flowered housedresses I see first; they give Brownsville back to me. In their soft dumpy bodies and the unbudging way they occupy the tenement stoops, their hands blankly folded in each other as if they had been sitting on these stoops from the beginning of time, I sense again the old foreboding that all my life would be like this. . . .[6]

In describing the particularities of life in New York City streets of a certain time, Kazin and Levitt both perceive a continuum of existence. As if to underscore the perpetual nature of what she sees, Levitt avoids observation of a specific time or place. We find no suggestion, for instance, of season; except for the children who are ecstatically running into the spraying water hydrant or the four little girls with soap bubbles who are sparingly clad, we would scarcely know it was summer (pls. 35 and 48). There are no rainstorms, no snow heaps; there is no sense of time of day, much less time of year. Most of the pictures have a pearly light, an unspecified, general illumination. Nature, when it rarely enters, is usually an abstraction: the backyard tree haunted by the masked child (pl. 6), the Easter lily clutched by the fierce little girl in the doorway (pl. 7). More characteristic is the lot where a boy picks up a needleless tree and bears it in some passionate, imaginative play, utterly transformed (pl. 34). Levitt finds the texture of a sidewalk, slightly littered with debris, beautiful, and

she is sensitive to the delicacies of worn facades, soiled stoops, brick walls marked by chalk or paint and decorated with odd wires. But we are given no clue as to their real location, because that does not interest her.

As discreet and private as she was in the 1930s and 1940s, Levitt had a few very good friends who served as her indirect access to the cultural concerns of the period. These friends were in many cases major figures in photography, film, and literature: Henri Cartier-Bresson (whom she knew briefly when he came to the United States in the mid-1930s); Walker Evans; the writer James Agee (a friend of Evans and, later, a film critic); Janice Loeb (a Vassar graduate in art history who worked as researcher at The Museum of Modern Art); and filmmaker Sidney Meyers. Reticent she may have been, but she was not unaware. Her work was unquestionably enriched by the activities that took place in New York in these decades. But once she found her own way of seeing in those early years, it hardly changed. Levitt's photographs reveal children of various ethnic and racial backgrounds in harmonious play. In plate 48, for example, four little girls walk up Park Avenue where the train comes out of the tunnel, leaving a trail of soap bubbles. We find in the photograph no sense of class, no stereotyping, but an acute perception of its various characters. Her hand on her hip and her little shoulder blade defiant and vulnerable cogently describe the child on the left—a small but vivid personality.

Levitt lived near the site of the photograph, in Yorkville on the Upper East Side, the home also of Walker Evans, Ben Shahn, Janice Loeb, and other artists, writers, and intellectuals—she moved downtown to Greenwich Village only in the 1960s. The German community had settled in Yorkville; nearby were Hungarians and, not far away, in Harlem was the center of black life. Levitt also visited Spanish Harlem. A small group of Italian families lived twenty blocks south of her, and sometimes she ventured farther, to visit the Lower East Side, Brooklyn, or the Bronx. She photographed gypsies, Poles, Italians, blacks, and many others. When her first photograph was published in *Fortune* magazine, in an issue devoted to New York, the anonymous author of one of the essays saw this diversity as one of the city's most distinctive characteristics.

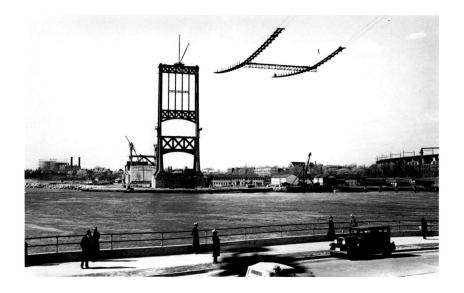

To most Americans the fact is that "New York is not America." It is un-American in lots of ways. The concentration of power that exists among these spires is itself un-American, and so are the tumultuous vowel-twisting inhabitants who throng the sidewalks and push their way into the subways.[7]

Figure 1.
O. WINSTON LINK
Untitled from the *Triboro Bridge Series*, 1931–35

The writer was correct. Not only did Americans perceive New York as "not America," but the cosmopolitan city seemed antithetical to a contemporary sense of American culture. The modesty of Levitt's work—not only in the rather poor people she photographed but through her undemonstrative presence in the pictures—is in direct contradistinction to the momentum that was transforming the city at the very moment she photographed.

The ideal American city of the time, represented in European and American utopian schemes, was clean and orderly, elegant in polished chrome and steel.[8] Small streets were superceded by the new, efficient highway system, and people made way for the automobile. By the mid-1930s New York was engaged in a massive building boom, in which skyscrapers, bridges, and new highways built for economy and speed were energized by the magic symbolism of the machine and brought to existence by the young Robert Moses (fig. 1).[9] The notion of an efficient, machinelike modern city was in great opposition to Levitt's understanding of a very different kind of city, and the wonderful ethnic and cultural richness she photographed was strained at this

Figure 2.
Illustration from *Magic
Motorways* by Norman
Bel Geddes with the
caption "Street
intersection—city of
tomorrow—World's Fair 1939"

Figure 3.
Illustration from *Magic
Motorways* by Norman
Bel Geddes with the
caption "Air, light,
space—and safety for
pedestrians and
motorists in tomorrow's city"

very moment.[10] The influx of immigrants, especially those from eastern and southern Europe, had been effectively stopped by the 1924 laws that closed America's open door. The middle classes began their move outside the city in their automobiles, over the new bridges, to populate the suburbs.

Nothing epitomized the ideal city of the late 1930s better than the 1939 New York World's Fair, an expensive symbol of escapism into "The World of Tomorrow." The Fair presented three highly idealized visions of the modern city, all based generally on New York: "The City of Light," Con Edison's pavilion; "Democracity," housed in the perisphere at the center of the Fair; and "Futurama," in the General Motors building (fig. 2). All three displayed the city at some distance (for "Democracity," the public was transported on "magic carpets" to what represented two miles above).

Seen from far above the complications of real life, city streets were transformed into a fairy pattern of highways and bridges, and buildings were translated into skyscrapers—all to promote material comfort and leisure in a future, massive parkway system and the consequent eradication of undesirable "slum" areas to create that system. In plans, photographs, and ideal renderings, streets were seen from afar, and people not

at all. In fact, people contaminated the vision of pure efficiency bestowed by the highway systems and new city planning (fig. 3).

The surburban movement to trees and sunshine, so clearly absent from Levitt's pictures, was, at this time, part of a larger idealization of the town or countryside as the true center of American democratic life. The vision is probably as old as American culture itself—the ideal was shared by Thomas Jefferson—but was more clearly articulated at the 1939 New York World's Fair. The theorists of the moment, especially Lewis Mumford (because he was so tireless in his advocacy), sought to encourage small centers, away from the chaos and dirt of the large city, where inhabitants could enjoy the healthful benefits of the country in close proximity to the city. Apparently, only cities "bred" crime—not the country. Mumford said tellingly, "The hope of the city lies outside itself."[11] These escapists were called the Decentrists, and they advocated the Garden City. Their most concrete effect, outside of the great suburbs, is the projects—anonymous high-rise buildings set within parklike (and usually empty) spaces. These living complexes are the antithesis of what Levitt's photographs celebrate.

Levitt's understanding of the city is more humanist and personal. Rather than envisioning it

as an abstract and efficient machine, an enlarged and extended version of contemporary architecture, she sees the city essentially as populated streets of great implicit, rhythmic beauty. Rather than the dynamic "magic motorways," she prefers worn stoops and littered sidewalks. But her view of the city is also an ideal one: It is a place where children play, where mothers tend their children, where old people gossip and observe. No one seems to work there, and, although there is deprivation, no one suffers from it. Anger, sorrow, and tension exist but only as moments in a grand and harmonious continuum. (No one is privileged, or even middle class.) Levitt is something of a feminist, and her poeticizing of ordinary street life is similar to Jane Jacobs's perception of an order, complex and subtle, found on the street, of which she said: "This order is all composed of movement and change, and although it is life, not art, we may fancifully call it the art form of the city, and liken it to the dance."[12]

These two very different attitudes toward the city, the purified abstraction and the intimate human city of the streets, are revealed in the way the city was photographed. Alfred Stieglitz can be said to have invented the city as a subject for serious photography in America. While a young man in the early twentieth century, he found it picturesque, transformed in rain or snow or mist. When he returned as a man in his sixties to make a series of photographs of the city seen from his apartment in the Shelton Hotel, the view beneath his window was emotionally as well as physically distant and abstract (fig. 4). Younger photographers such as Paul Strand and Charles Sheeler were encouraged by Stieglitz's conviction that photography was an expressive art form and that photographers could learn from the example of painters, particularly some of the Cubists that Stieglitz and others exhibited. Strand's view of New York in the 1910s and early 1920s is very pure and clearly Cubist; abstraction is achieved by looking down from above (fig. 5). Sometimes people are included; they are usually a kind of decorative, shorthand indication of human activity. Only in his few early photographs (taken with a right-angle finder) of a blind woman, a woman yawning, or a troubled elderly man does Strand confront the city's working people from close range (fig. 6). These pictures, admired later

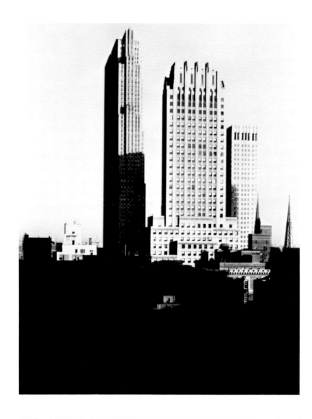

Figure 4.
ALFRED STIEGLITZ
From the Shelton Looking West, 1935–36

Figure 5.
PAUL STRAND
The Court, 1924

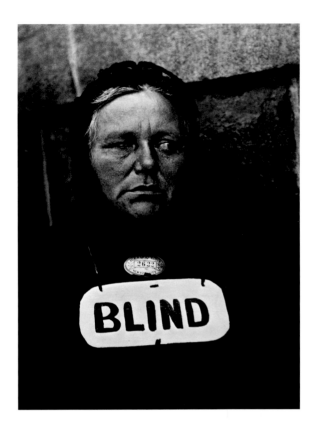

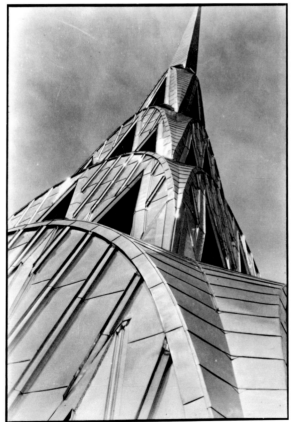

by Levitt and early on by Walker Evans, allude to the work of Strand's mentor, Lewis Hine. For the most part Stieglitz, Strand, Sheeler, and others saw the city as a beautiful abstraction, endowed with machinelike towers and remote shadows, with people (when they appear) unintegrated and unrelated to the enclosing structures.[13]

The energetic, streamlined view of the city as a machine of beautiful working parts so similar to the ideal city displayed at the World's Fair was a vision also promoted by photographers in the 1930s, a continuation of the aesthetic discoveries of Strand and Sheeler. Just as ideas of architecture and urban planning were affected by the machine idealism of Europeans such as Le Corbusier and members of the Bauhaus, so these visions were transformed in photography in the work of Edward Steichen and Margaret Bourke-White, both widely published in magazines (fig. 7).

But in the 1930s a change took place, a shift away from the idealization of immaculate abstractions to a depiction of the inhabited city. City buildings were seen directly at street level, in context with other buildings and with people. In some respect this change must have been a response to the very present and disturbing suffering that inspired humanitarian response, but it was certainly also affected by newspapers and magazines. *Life* (its first issue, in 1936, had a Bourke-White cover) and *PM* (which began in 1940) centered editorial attention on people.

Berenice Abbott, who documented particular buildings and neighborhoods and published her book *Changing New York* in 1939, was not much affected by the romanticism of the machine. Abbott documented city buildings and streets before they changed, before they were transformed by the radical modernist construction of Rockefeller Center, for instance. Like Levitt's streets, Abbott's most memorable buildings are worn and modest. Paul Strand had learned from Cubism how to make formal innovations in seeing, how to convert the experience of finding a photograph into constructing a work of art equal to painting; Abbott was not interested in this approach at all. For her, photographing a storefront was an act of describing how that particular place, in that specific neighborhood, differed from any other. She had, after all, before returning to New York in 1929, made her living as a por-

trait photographer in Paris. There she became aware of the documentary photographs of Eugène Atget, and not only learned from his vision but preserved his work. Abbott's photography has less to do with the construction of art than the literary and historical process of placing. Characteristically, *Changing New York* provides historical background and other nonformal information in the text accompanying each photograph, supplied by the able art critic Elizabeth McCausland. Pictures and text cohere as they have not before. And it was important for Abbott to state that she was not an "artistic" photographer but something else (fig. 8).[14]

American painting of this period also shifted direction. The work of Charles Demuth, John Marin, and Abraham Walkowitz was the counterpart of Strand's vision, while in the 1930s the group known as the Fourteenth Street Painters—Kenneth Hayes Miller, Reginald Marsh (fig. 9), and the three Soyer brothers—found their subjects in the press of crowds seen from street level, with a focus on ordinary people. Realism became meaningful again, and art reflected everyday experience. Abstraction was generally less absorbing to younger artists—or, as in Stuart Davis's case, it could be used for a social purpose. One of the strongest American painters to emerge was Edward Hopper, who was far more interested in Realism than the idealism associated with Cubism. Some of the efforts of Davis and others were devoted to examining the social questions the times provoked, and Davis for one responded by contributing drawings to the leftist magazine, *The New Masses*.[15]

These changing concerns created a perceptible shift away from the idealism of the city as a shiny and beautiful abstraction to photographs of people in the streets. In many cases this work, gritty and real, is illustration or description, but not, by its declared intention, art. The photographs of Lewis Hine and Jacob Riis were gradually rediscovered, printed, and finally exhibited at the end of the 1930s and during the 1940s. Hine's retrospective was held at the Riverside Museum in 1939. Riis's work was shown at the Museum of the City of New York in 1947 by Alexander Alland, himself a photographer of the city's many ethnic populations. Hine's work in the 1930s, especially the photographs documenting the construction of the Empire State Build-

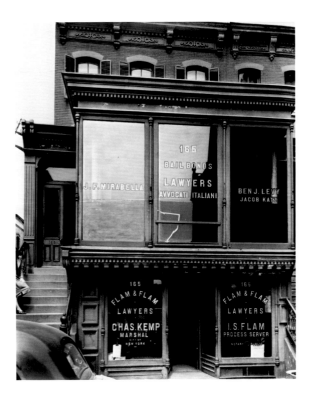

Figure 8.
BERENICE ABBOTT
Flam and Flam, New York, 1938

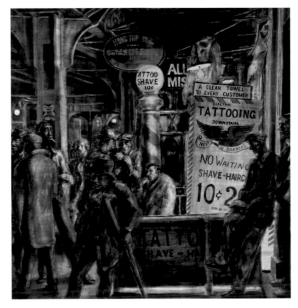

Figure 9.
REGINALD MARSH
Tattoo and Haircut, 1932

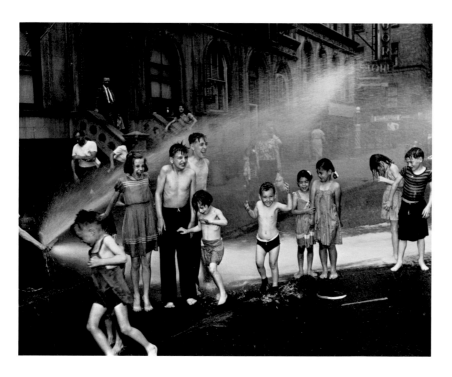

Figure 10.

**WEEGEE
[ARTHUR
FELLIG]**

*Summer, Lower East
Side,* 1937

used as a counterpart to Hart Crane's poem "The Bridge." In placing photographs against words, something different was expected of the photograph than when it was put on a wall, as Stieglitz had done, and called art. The photographically illustrated book could serve a didactic, engaged purpose, as in *An American Exodus* (1939), a sociological study of the agricultural problems of the period by Dorothea Lange and her social scientist husband, Paul Schuster Taylor. Photography books could be as populist as Bourke-White and Erskine Caldwell's *You Have Seen Their Faces* (1937), or as informational as Edwin and Louise Rosskam's books illustrated with FSA photographs. Archibald MacLeish's poem *Land of the Free*, also accompanied by FSA photographs, is a meditative response to some of these very images.

Levitt's work, small in scale and seen to its best advantage in the pages of a book or magazine, is also not illustrative or informational. It is as much lyrical as realist. Like the work in Walker Evans's classic book *American Photographs* (1938), Levitt's work is meditative. But the differences between the photographs of the two are instructive. As with most of the work of that period, *American Photographs* is more focused on rural America than on the urban scene, finding in the country the essential American experience. Levitt's book *A Way of Seeing*, originally conceived and planned for publication in the 1940s, was unusual because it was a lyric, rather than a social, examination of city streets. As Kazin's work is a response to the specific environment of Brooklyn, Levitt's book is related to the direct and specific observational literature of the period. *Let Us Now Praise Famous Men*, James Agee's and Walker Evans's book on southern tenant families, was also a part of that literature. This literature of observation was related to journalism but found a very authentic expression in the 1930s in that great collective documentation of the mythology and specific character of the diverse American landscape in the Work Projects Administration (WPA) guidebooks. New York produced two of these; they were prepared by writers employed by the WPA and illustrated with photographs.[17] Although they were guides in the conventional sense, they also provided lyrical descriptions of diverse aspects of the city, including its varied and vital street life.

ing and published in the book *Men at Work* in 1932, has a faint ring of propaganda for the heroic working man. His admiration of the men who erected the girders and controlled the derricks is more artful than the plucky newsboys he photographed two decades earlier, and more self-conscious. Hine's work was exhibited at the Photo League, where Levitt may have seen it, and it served as an example to students there. Yet Hine's work, like that of Riis, was not of formative interest to Levitt. She knew and admired the graphic, compelling photography of Weegee, however, whose raw illustrations of the pleasures and tragedies of tenement life were regularly published in New York newspapers and, in the early 1940s, in *PM*. Although Weegee was not nearly so drawn to children as she, he records some tender, some exuberant images of the younger tenement dwellers. Weegee also found the life he described there—uninhibited, throbbing, frequently violent—to be an endless theater (fig. 10).

In the 1930s, as photography became a form of description, a kind of visual counterpart to written information, its reference and relevance to literature began to be emphasized as a serious new form.[16] Photographs set alongside text could be used informationally or as a poetic union, and the 1930s hosted diverse experiments in this new form. In 1929 Walker Evans's photographs were

Some of the photographs, including many not reproduced but commissioned, share with Levitt's photographs an unsentimental, particular, and exuberant appreciation of the poetry of life in the street (fig. 11).

SEEING PICTURES
IN NEW YORK

The morning sun picks out an apartment house, a cigar store, streams through the dusty windows of a loft. The racket swells with the light. These shoes are killing me, she said, taking the cover off the typewriter. Main Central is up to forty-six. Did you read about the earthquake? Looms, shears, jackhammers, trolley cars, voices, add to the din. And in the quieter streets the hawker with the pushcart moves slowly by.

—The WPA Guide to New York City, 1939[18]

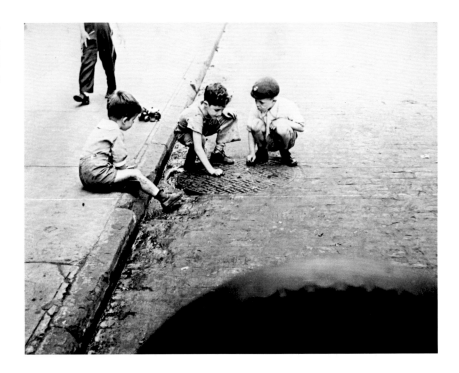

Figure 11.
CLIFFORD SUTCLIFFE
Untitled, c. 1937, from the New York City unit of the Federal Writers' Project

In the 1930s, at the time Helen Levitt was making photographs, descriptive prose writing was enjoying favor not only in literary circles but in the more populist realm of the WPA-sponsored guidebooks and, even more noticeably, in the popular magazine. The illustrated magazine came to the United States in the 1930s, and its most important manifestation was undoubtedly *Life*, founded in 1936. But the most adventurous exploration of the descriptive literary genre, allied to illustrations (both photographs and paintings), was in *Fortune* magazine. Although Levitt's work was published only once in *Fortune*, in the 1939 issue on New York already quoted, during the early 1930s *Fortune* was the most visually attractive, informed, and, rather unexpectedly, the most socially and politically adventurous. Founded by Henry Luce as the first of his picture magazines in 1930, its early editors and writers included Ralph Ingersoll[19] (who would later leave the Luce organization to found *PM*), Archibald MacLeish, Robert Fitzgerald, James Agee, and, briefly, Hart Crane—all poets—and Dwight Macdonald. It sponsored a lay attitude rather than a specialist's approach to diverse subjects, which is why this group of writers was hired. The magazine also employed artists of the caliber of Sheeler, Philip Evergood, and Charles Burch-

field. Although Margaret Bourke-White was *Fortune*'s early photographic star, soon Ralph Steiner and Walker Evans were among those the magazine supported.

For about seven years *Fortune* was the most beautifully printed, elegant picture magazine in the United States, graced not only with a liberal number of color reproductions of specially commissioned art but with some of the best journalistic writing and photography around. Amid the articles on the steel industry or meat-packing plants readers found more liberal and humanitarian essays.[20] For a brief moment during the Depression years, *Fortune* magazine served as an enlightened venue for good writing addressed to the educated lay businessman.

Fortune, however, is also remembered for commissioning Agee and Evans in the late spring of 1936 to do an article on the state of the tenant farmer—and then rejecting it. The project finally came to fruition some five years later as the book *Let Us Now Praise Famous Men*.[21] Agee was also commissioned to write an appreciation of the regional character of Brooklyn for the July 1939 issue devoted to New York, the issue in which Levitt's photograph appeared, along with other views of the city by Evans, members of the Photo League, and other photographers of social con-

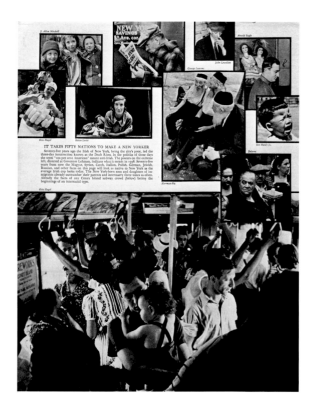

Figure 12.
July 1939 issue of *Fortune*
featuring a photograph by
Levitt (photograph of
woman directly above
text)

cern (fig. 12). In context with their work, Levitt's photograph reveals a familiarity with the FSA, and, in fact, one might have expected this article to be reproduced in Luce's other magazine, the populist *Life*, where words worked with photographs to form minifilms.

Levitt's work never appeared in *Life*, nor in any other photojournalistic context. On the one hand, Levitt was never interested in pursuing photojournalism as a career: She was too grounded in her chosen subject, too uninterested in narrative, and too personally shy. On the other hand, she was always represented as an artist-photographer, and her work was presented in this way in the strictly photographic magazines such as *U.S. Camera*, an annual, and *Minicam*, for the miniature camera enthusiast, both quality publications addressed to an interested lay audience. *U.S. Camera*, founded in 1936 and based on the European photographic annuals *Photographie* and *Das Deutsche Lichtbild*, presented well-printed photographs of artistic and journalistic merit culled from popular as well as more aesthetic sources. Steichen was affiliated with the annual, which became so successful it supported the bimonthly *U.S. Camera* magazine. In 1943 Levitt's work was reproduced in the annual and her work discussed extensively by Edna R. Bennett in the magazine. *Minicam* re-

produced the experimental work of other artists such as Lisette Model, László Moholy-Nagy, and Brassaï. It also published several sequences by Levitt and a perceptive early article by James Thrall Soby relating Levitt's work to Cartier-Bresson's (fig. 13). Of all the magazines that published her work, this enlightened and short-lived journal published her most consistently and in a most representative way.[22]

Harper's Bazaar, under Carmel Snow's direction, assisted by Alexey Brodovitch, and with Martin Munkacsi's energetic photographs and the frequent appearance of Man Ray, also became a lively forum where photographs were surrounded by contemporary fiction, art, and fashion. Operating basically as the fashion magazine that defied the more staid *Vogue*, *Harper's Bazaar* was idiosyncratic enough occasionally to publish serious lyric photographs framed and sequenced to speak for themselves. In 1944 two of Levitt's pictures were printed with a brief introduction by Soby. The magazine also published Bill Brandt, Cartier-Bresson, Evans, Brassaï, and Model.[23]

However, the most politically astute magazine to publish work by Levitt and her contemporaries was *PM's Weekly*, the Sunday magazine section of the daily newspaper *PM*, which began publication in 1940. Ralph Ingersoll's innovation was that the paper would have no advertising, therefore avoiding corruption, and it pursued a strongly liberal policy, at least in its early, lively years. The newspaper was fueled by its advocacy of social reform and common cause with the working class. It also claimed to devote half of its space to pictures. Ralph Steiner was its art director briefly, and the paper is credited with discovering and employing Weegee and reproducing the work of Model (much to her dismay, because of the context—her pictures of the habitués of the Boulevard des Anglais in Nice in 1940 were captioned, rather crudely, "Why France Fell"). Margaret Bourke-White was also briefly a staff member. Levitt's first appearance in the magazine, which was preceded the week before by pictures of Coney Island and the streets of New York photographed by Morris Engel, was accompanied by the following text:

In PM's Gallery: A New Photographer discovers New York. *The New York sidewalk photographs were made by Helen Levitt, a young*

photographer who likes to record people in relationship to their surroundings. She prefers to work in the poorer sections because they have more life and because she finds beauty in old backgrounds. Miss Levitt was born in Brooklyn, picked up technical details from a commercial photographer with whom she worked, has been taking pictures for four years. She used a Leica for those in the Gallery. She says she works primarily to please herself and often wonders how she is going to go—she can rarely afford them—horseback riding and aquaplaning. Her big ambition is to direct a movie.[24]

Later (March 2, 1941), Steiner reproduced her graffiti photographs and wrote an accompanying text (fig. 14).

The brief biography above comprises most of what we know of the artist. It accurately describes not only Levitt's aesthetic attitude (to find beauty and life) and her preferred and consistent subject but also her determination to see the streets as places of aesthetic beauty, rather than in the social context in which many of *PM*'s pictures were presented. Agee had cautioned her that professionalism might corrupt her eye, and she was determined to work on her own—and enjoy it. Levitt was described as being vivacious, modestly ambitious, and athletic—almost all her work has been made with a Leica, an instrument that requires an almost athletic sense of timing.

The documentary mode, the compelling aesthetic of the 1930s, proved to be a language adaptable to the poetic use of Levitt and Walker Evans but also an effective voice for advocacy. Although frequently couched in scientific terms, this stance was more emotional than intellectual.[25] In Washington, Roy Stryker, head of the FSA, commissioned and dispersed pictures documenting the effects of the Depression, essentially but not exclusively in the countryside. In New York there existed a tradition of photography of the poor and their conditions, mainly centered at the Photo League, and this work was often published in *PM*.

The League was originally the Film and Photo League, an organization formed to promote workers' film in the 1930s as an antidote to Hollywood cinema.[26] By 1938 its filmmakers (including Strand, Steiner, and others, as well as the original workers' newsreel filmmakers) split off in order to focus on socially motivated still

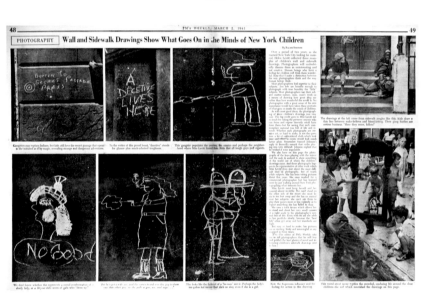

Figure 13.
March 1943 issue of
Minicam Photography
featuring Levitt's
photographs accompanied
by a text by James T. Soby

Figure 14.
March 2, 1941, issue of
PM's Weekly featuring
Levitt's photographs
accompanied by a text by
Ralph Steiner

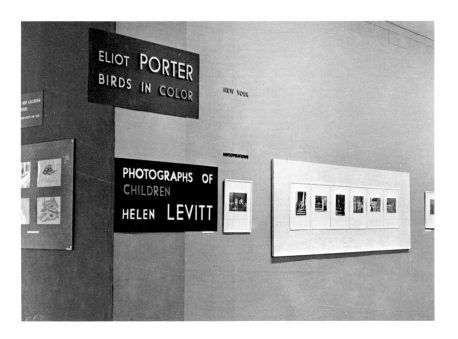

Figure 15.
Installation view from the
exhibition *Helen Levitt:
Photographs of Children*
at The Museum of
Modern Art, New York, 1943

photographs. It was then called simply the Photo League. Members believed photography could be used to effect social change. The photography espoused—in teaching and in exhibition—focused on the very kinds of people and the very same neighborhoods that Levitt photographed, and the organization's impetus at that time was decidedly leftist, although it became more aesthetically oriented in its last decade. Hounded by political demagogues in the late 1940s, it finally closed in 1951.

Although Levitt was not politically engaged, art and revolutionary politics were closely interconnected, particularly in the 1930s, and Levitt was certainly aware of the radical political issues of the times, even though she chose not to participate. Levitt's work was exhibited later at the Photo League and admired by its members, and early on she had used the Film and Photo League's darkroom, yet she rarely visited and her concerns were very different. The League's April 1943 *Photo Notes* observed, "Lisette Model tells us Helen Levitt's photographs at the Modern Museum (until April 19th) are extraordinary."[27]

Levitt's work is neither populist nor journalistic, and her photographs are too self-contained to serve easily as illustrations, as she herself recognized. They lack the kind of documentary inflection that inspires social awareness and change, and they are more concerned with bonding and a sense of community.[28] Her work is clearly an aesthetic expression, and as such it re-

lated to the art galleries that showed photography and to the then still-new Museum of Modern Art. The most important gallery to show photography extensively was the Julien Levy Gallery, which opened in 1931. Respectful of Stieglitz, Levy managed to cajole him into supporting some of his exhibitions. The Levy Gallery was the place one would go to find early American daguerreotypes and the nineteenth-century portraits of Nadar, as well as examples of contemporary European and American modernism. Levy travelled regularly to Europe and was in contact with modernists there, initially through his early friendship with Marcel Duchamp. He was also aware of the important exhibitions and of influences on the medium—in particular, the work of both the Surrealists and the Constructivists. Levy showed Henri Cartier-Bresson's work twice: once in 1933, when Evans and Shahn saw it, and again in 1935, with the work of Evans and Manuel Alvarez Bravo, when Levitt saw it. However, by this time Levy had become discouraged with the lack of sales of photographs and exhibited them less frequently.[29] Levitt was also familiar with some of the Neo-Romantic art Levy showed.

With Stieglitz's example as a gallery owner who took the medium of photography with the same seriousness as fine art, other galleries after Levy attempted the same high-minded dedication. Alma Reed's Delphic Gallery showed Edward Weston, Ansel Adams, Moholy-Nagy, and others, and the Rabinovitch Gallery showed Paul Outerbridge and F. S. Lincoln. Stieglitz's last photography exhibition in 1938 was devoted to Eliot Porter. Other, less aesthetically exclusive places also showed photographs. The Municipal Art Center and the Federal Art Gallery showed Arnold Eagle, David Robbins, and other documentary, federally sponsored WPA photographers. Romana Javitz at The New York Public Library not only developed the Picture Collection (which owns work by Levitt, Evans, and members of the Photo League) but also mounted thematic and other imaginative exhibitions that included photographs. Less available to the general public were the extensive exhibitions (as well as the lectures and film series) sponsored by the Photo League and some important though modest exhibitions at the New School for Social Research. The Art Center (where Levitt saw An-

ton Bruehl's work), the Brooklyn Museum, and the Museum of the City of New York continued to show photographs. Even the Museum of Natural History presented Pictorialist and Camera Club exhibitions, and photography was also seen in large public spaces such as the Grand Central Art Palace. (Most of these latter exhibitions were either obscure and modest or populist and directed toward amateurs.)[30]

By far the most esteemed place to see innovative photography was The Museum of Modern Art, and Levitt educated her eye by visiting its galleries frequently. Founded in 1929, the museum devoted important space to the medium in its exhibition of murals in 1932, showed Walker Evans's Victorian houses in 1933, and, in 1937, under the guidance of Beaumont Newhall and with the express support of Alfred Barr, presented the first major historical overview of the medium. Under the direction of Newhall, who was installed in 1940 as curator of the new Department of Photography, Levitt was included in many of the museum's exhibitions, including a one-person show in 1943 (fig. 15).

In a 1931 issue of *Hound and Horn* Walker Evans wrote an essay, "The Reappearance of Photography," that described a reawakened interest in "simple" or "honest" photography. In a similar vein, Lewis Mumford praised Beaumont Newhall's 1937 exhibition for displaying photography's "primitives [which] have a sincerity and a forthrightness that their more facile successors often lack."[31] This approach constituted a major difference from Stieglitz's romantic aestheticsm and elitism and introduced a new aesthetic of the 1930s, which included the work of Evans and Levitt. As the museum responded to events in the world at large, the photography department, guided briefly by Willard Morgan and Nancy Newhall during Beaumont Newhall's wartime absence, contributed "War Comes to the People: Photographs by Therese Bonney" (of the war in Belgium) in 1940; "Britain at War" and "Image of Freedom" in 1941; "Two Years of War in England: Photographs by William Vandivert" in 1942, and Steichen's first show at the museum, "Road to Victory," also in 1942. Photography was construed as a far-reaching art form and included a populist element, subject to political concerns and curatorial changes. American photography was of special interest. The emphasis on what is now considered "classic" photography did not occur until after the war, when Beaumont Newhall mounted the great Strand, Weston, and Cartier-Bresson shows. Throughout this early period, with its attention to the vernacular, populism, and early modernism, the Department was consistently interested in and supportive of Levitt's work, particularly during Nancy Newhall's tenure as acting curator; during the war Levitt was frequently included in group exhibitions. Perhaps her accessible subject matter and the constant relevance of her pictures, as well as her unqualified excellence, accounted for this.[32]

SURREALISM, THE VERNACULAR, AND THE CULTURE OF CHILDREN

(All over the city on streets and walks and walls the children, and the other true primitives of the race have established ancient, essential and ephemeral forms of art, have set forth in chalk and crayon the names and images of their pride, love, preying, scorn, desire; the Negroes, Jews, Italians, Poles, most powerfully, these same poorest most abundantly, and in these are the characters of neighborhood and of race: on an iron door in Williamsburg: Dominick says he will Fuck Fanny. . . . *And drawings, all over, of phalli, fellatio, ships, homes, airplanes, western heroes, women, and monsters dredged out of the memories of the unspeakable seajourneys of the womb, all spangling the walks and walls, which each strong shower effaces.)*

—James Agee[33]

On Halloween evening in 1939, three masked children emerged from their house onto the stoop and paused before descending into the street (pl. 8). Helen Levitt photographed that middle moment, the hesitation offstage before entering the arena. She found a moment of transfixed play, of children transformed by fantasy. Levitt was singularly devoted to the play of children in the street, especially during these early years.[34]

Levitt's sense of mystery and regard for the poetic potential of city streets, doorways, and

Figure 16.
EUGÈNE ATGET
Avenue des Gobelins, 1927

mirroring glass was reinforced by her appreciation of the work of the French photographer Eugène Atget (fig. 16). She transformed his understanding of the city with her own sense of enveloping atmosphere, of darkened passageways opening into stagelike spaces, of the personality and presence of pretend adults and imagined monsters.

Levitt and her friends were ardent in visiting galleries and museums, and she remembers seeing a show of Cartier-Bresson's work at the Levy Gallery in 1935 and being stunned by its originality and beauty[35] (fig. 17). Cartier-Bresson had arrived in New York in 1935 from Mexico, where he had befriended Manuel Alvarez Bravo (with whom he shared the Levy show), the American black poet Langston Hughes, and members of the Mexican cultural elite. At that point Cartier-Bresson was very much involved with Surrealism and left-wing politics, interests fostered in France and deepened by his Mexican experience. After he arrived in New York he made few still pictures and, until the outbreak of World War II, devoted his energies to filmmaking.[36]

Many of the pictures in the 1935 exhibition had been made during his recent visits to Spain and Mexico. Most often his subject was children,

and in these photographs he often found a stage area in which the children enacted their dramas (fig. 18); the spaces are sometimes deep and ominous, and sometimes friezelike. In one, a "bogeyman" figure casts a strange spell over the children, who dash madly about like scattered shot. Cartier-Bresson responded to the wild, primal energy of children, their freedom of expression and joyousness, their special relationship to fantasy, but also to the fearful and dark. Levitt was enchanted with the same subject.

Cartier-Bresson was also a master of the Surrealist juxtaposition: a man sleeping, head in hand, under a graffiti drawing that uncannily resembles him, or a woman looking intently at a man lying, collapsed, in the street, a visual reflection of herself. Juxtapositions are to be found in Levitt's work as well: the ominous figure of a black woman crossing the street, her unsteady feet paralleling a teetering bicycle in the distance (pl. 25); the young, joyous girl carrying home two bottles of milk while a very pregnant woman looks over her shoulder (pl. 47); or a child's drawing of a bosomy woman next to the glancing eye and jaunty shoulder of a printed poster (pl. 22).[37] Perhaps most important, by the example of the Europeans Atget and Cartier-Bresson, the modern metropolis was an appropriately mysterious subject for an American artist.

When Levitt bought her Leica in 1936, it was in response to seeing Cartier-Bresson's photographs. Cartier-Bresson is popularly known as the discoverer of the "decisive moment," a later English translation of the accurate French description of his method, *images à la sauvette*, pictures made on the run, in the midst of things.[38]

Cartier-Bresson's early photography is informed by Surrealism, by his perception of the strange elision of the real and uncanny in the actual.[39] Although not admired by a large contingent of American artists, Surrealism was not unknown in this country. Surrealist works were exhibited in New York in Alfred Barr's seminal 1936 exhibition "Fantastic Art, Dada, Surrealism" at The Museum of Modern Art (for which Levitt's good friend Janice Loeb served as a researcher). The Julien Levy Gallery frequently showed the photography and painting then current in Europe, generally favoring Surrealist work and the related art of the Neo-Romantics. Unlike most of the art movements that preceded

Figure 17.
HENRI CARTIER-BRESSON
Valencia, 1933

Figure 18.
HENRI CARTIER-BRESSON
Madrid, 1933

it, Surrealism was less a style than a state of mind. Distrusting the constraints of intellect, the Surrealists, in an effort to reach a poetic truth, sought to experience life directly, unpremeditatively, and to incorporate into their work the experience of the subconscious along with the real. Indeed, their principles provide an accurate description of Levitt's approach to her work. Many Surrealist texts are located in city streets,[40] and Levitt would have understood the Surrealists' wondrous commingling of the experience of art and life in the city. At the time of her exhibition at The Museum of Modern Art, James Thrall Soby, a connoisseur with a deep understanding of Surrealism, was an ardent participant in the museum's activities. He connected Levitt's intuitive style with Cartier-Bresson's Surrealist apperceptions in his article in *Minicam* (see fig. 13):

> Both Cartier-Bresson and Helen Levitt have taken nearly all their photographs with a miniature camera using 35mm film. At every stage of the photographic procedure they have moved in a direction absolutely counter to that of the view camera-men. To begin with, their choice of subject has been entirely different in inspiration. Whereas the view camera photographers often selected their subjects well in advance of recording them, Cartier and Helen Levitt have walked the city streets with no idea of what they were about to photograph except within broad limits. Whereas the view cameramen tried to photograph their subjects ideally even if they came upon them unexpectedly, Cartier and Helen Levitt have known that any scene likely to appeal to them would retain its form and content for only a split second.[41]

Levitt's contemporaries also recognized her sympathy with the aims and concerns of Surrealism. She was published in the context of Surrealism in the first issue of *VVV* (with a note by Roger Caillois on the treasures of childhood imagination), and the following year in Charles Henri Ford's magazine *View*, for the issue entitled "Americana Fantastica" (fig. 19). A rich infusion of Surrealism affected both these magazines, inspired by the lively expatriate European artists living in New York during World War II. Levitt's photographs reproduced in *View* resonate with haunting ambiguities. What, for instance, is the child with a dagger wearing, and of what sex is this child? Where is the child located, and why is he or she so strangely still? A pause, or moment of transition, is often evoked in Levitt's work, but this moment seems a grave metaphor for the quick, mysterious passing of time. In plate 30, the child earnestly pushing his tricycle into a broken mirror frame, which becomes a kind of doorway, is shadowed by a strange androgynous creature—a kind of clown or a statue, reminiscent of Jean Cocteau's film *The Blood of a Poet*, which Levitt admired.

Surrealism was a powerful influence for Cartier-Bresson because although it describes the exterior world in precise detail, it offers a poetic enigma rather than an intellectual understanding. Cartier-Bresson's grasp of the moment as a transfiguring force, his ability to find in a fraction of a second an amazing, magical interrelationship, on the one hand moved and inspired Levitt. On the other hand, in her work the momentary includes a sense of the eternal, as well as an empathy for those she photographs. She creates something resembling a classical frieze

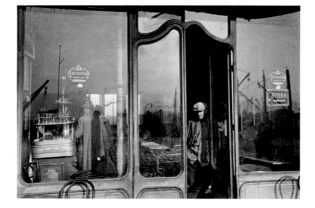

to the unconscious, farther from the conventional), Levitt's work is a kind of collection of anonymous photographs.

Writing for Levitt's first exhibition at The Museum of Modern Art in 1943, Nancy Newhall observed, "Helen Levitt seems to walk invisible among the children. She is young, she has the eye of a poet, and she has not forgotten the strange world which tunnels back through thousands of years to the dim beginnings of the human race."[43] Other writers also noticed her connection with Surrealist ideas. Agee, who wrote as perceptively as anyone about photography in general, and of Levitt in particular, noticed a kinship with her spirit to truth telling, artless artifacts of the documentary style, the "innocent domestic snapshots, city postcards, and news and scientific photographs," which are not transformed into art by the "artist's creative intelligence," as a painting is, but "reflected and recorded" from life, as is Levitt's work.[44] Agee compared her spirit to that of the folk artist: "Most of these photographs are about as near the pure spontaneity of true folk art as the artist, aware of herself as such, can come." He also observed that she found her lyric moments among the poor: "I cannot believe that it is meaningless that with a few complicated exceptions, our only first-rate contemporary lyrics have gotten their life at the bottom of the human sea: aside from Miss Levitt's work I can think of little outside the best of jazz."[45] And he noticed her relationship to the state of childhood, which he described as

> . . . *innocence . . . the record of an ancient, primitive, transient and immortal civilization, incomparably superior to our own, as it flourishes, at the proud and eternal crest of its wave, among those satanic incongruities of a twentieth century metropolis which are, for us, definitive expressions and productions of a loss of innocence.*[46]

in the photograph of the children climbing over the doorway (pl. 19), a motif she finds in other circumstances and which is appropriate to her often stagelike settings. Although she often depicts a moment of emotional intensity, it is done from a respectful distance: She observes events but does not interfere with them.

Levitt's very interest in vernacular subjects—the streets in poor neighborhoods, graffiti on walls, and even children and gypsies—resonates with Surrealist understanding.[42] Cartier-Bresson found children, especially in Spain and Mexico, to be free and wonderful subjects of his scrutiny, but he also noticed graffiti, peeling paint on walls, and marvelously lush reflections learned from Atget (fig. 20). In the spirit of the Surrealists' fine appreciation of ordinary and anonymous images, and of found objects (closer

Children were being discovered at this moment to have their own psychology and, in the United States, even their own archeology. The work of Anna Freud and her rival, Melanie Klein, became known in the 1930s and identified the child as having a unique psychology. Bruno Bettelheim had begun his study of the psychological meanings of fairy tales. In the United States this work was further advanced by the theories of

such psychoanalysts as Karen Horney, Harry Stack Sullivan, and others who interwove a child psychology with an anthropology that considered children as almost a different species, with their own development into adulthood.[47]

At the time Levitt was making her photographs of children engaged in street games, others were recording and collecting the artifacts of children. One couple, Ethel and Oliver Hale of the New York Public Library, investigated the same streets as Levitt to collect data on children's jumping-rope rhymes, the various permutations of potsy (or hopscotch), songs sung while bouncing a ball, and myriad other children's games and poems. *From Sidewalk, Gutter and Stoop*, the compilation of their efforts, never made publication, but it offers a relevant examination of childhood folk activity. The Hales recognized the dual importance of fantasy and realism to children.

> *It is rather a contradiction to maintain, as we do, that children are realists, inasmuch as they inhabit so largely the world of the imagination. In many of their games and in much of their play they project imaginary pictures and poses, invent and pretend situations, and, with themselves as the principal actors, create scenes and a world different from their own. Indeed, when we, as adults, mention the term, "a child's world," we pay a tribute, not only to that one half of it which provides him with constant play as his serious business, but to the other half which is clearly of the mind's eye, imaginary, pretended and believed.*
>
> *But when children believe, pretend or imagine, they do so as poets, relating tales or interpreting them, or flashing their sharp lights of wit and scorn upon the acts of conduct of their elders and their guardians. For like the poet who is the ultimate realist seeing the world plain and the whole rather than the parts, children have an instant eye which is never blind to the pretenses of adults. For they survey the scene and fit their activities into it, their natural selves, only in play-acting, acting other than their natural selves. Hence, they are, indeed, realists, accepting the world and changing it according to their moods and then changing back into it again, unlike adults, who, because they never accept the world are in constant confusion about it, and, finally, do not see it at all, their own selves having grown so large.*[48]

The rhymes the Hales discovered were often directly related to the children's environment.

> *Floor to let*
> *Enquire within*
> *Lady put out*
> *For drinking gin*
> *If she promises*
> *To drink no more*
> *Here's the key*
> *To her back door.*[49]

Just as compelling are the ties to ancient culture found in some of these rhymes, as, for instance, the Christian meaning of hopscotch.[50]

At this time serious interest arose in the nature and meaning of play, an irrational, precultural activity we share with animals, which connects not only child to child, but child to adult. Graffiti and children's drawings are the ancient, precivilized emblems of magical art, the original meaning and force of art. Children's drawings were studied for their archetypal information, and the art of truly primeval cultures was rediscovered by artists and studied as wondrous emanations and guidelines for their own creativity. Artists' awareness of the study of prehistoric art really began in the 1930s. Joan Miró's interest in developing a "sign" language evolved from his contact with Neolithic art. Abstract Expressionist artists began by exploring "calligraphic" art through contacts with the Surrealists fleeing Europe at this time. Mark Rothko's early work, like that of Jackson Pollock and Adolph Gottlieb, is replete with mythic creatures. Levitt's early interest in the primitive and the child were timely.[51] Evans and Agee were especially interested in children's art, and she recalls talking with Agee when she first met him about graffiti he had seen. Like a sign, a graffito or child's drawing is not consciously made as art but, like childhood itself, is archetypal.

Another important related field of interest that Levitt shared with her contemporaries was black culture. Following the interests of the early Cubist artists, Alfred Barr included African sculpture in his major exhibition of 1936, "Cubism and Abstract Art." As Pablo Picasso acknowledged, African art was important not only for its formal lessons but for its intensity of spirit, the use of art as magic. Perhaps it may seem curious to open *Foundations of Modern Art*, the 1928 book

by Purist artist Amédée Ozenfant, and see as its frontispiece a photograph by Marc Allegret of two tribal African girls, but in fact this book is full not only of modern art—the Cézannes, Picassos, and others one would expect—but images of vernacular art and architecture, prehistoric as well as tribal art, window displays, dams, radios, carnival scenes, and an anonymous photograph of a "Cigar Saleswoman in Cuba," as well as reproductions of African and other tribal arts.[52]

Levitt's depiction of black culture was thus responsive to an awakened interest by contemporary intellectuals. In Europe in 1934 Nancy Cunard published her massive anthology, *Negro*, dedicated to her friend the American black musician Henry Crowder. In the United States, the folkloristic works of the 1920s Harlem Renaissance were transformed into social concerns by the time Levitt became active. She would have known of the work of black authors generally, but she was probably more attracted to Harlem because of her affinity to jazz, the active street life, and her genuine liberalism. The Federal Writer's Project guide, *New York Panorama* (1938), which contained essays on the history of the city, its many different nationalities, its characteristic speech patterns, and its literature, art, and music (both classical and popular), included an extended discussion of Harlem as an enriching and characteristic feature of the city.

Levitt's connections to children, to the associations of graffiti, to the art of black life were part of an aesthetic appreciation of both the vernacular, awakened by New Deal writers and artists, and the appreciation of Surrealism and Cubism, specifically at The Museum of Modern Art.[53] There, Alfred Barr supported the 1934 "Machine Art" show from the Department of Design, which included an airplane propeller, a watch spring, ball bearings, and other objects from contemporary life recast as objects for aesthetic delectation. In the early years of the institution, the Department of Photography held exhibitions of snapshots, journalistic photography, and other kinds of photographs not normally considered "art." Unlike painting, photography did not yet have the connotation of preciousness (despite Stieglitz's intentions to the contrary). Both of Barr's early exhibitions on Cubism and Surrealism had demonstrated the aesthetic value and importance of nonprecious objects.[54] Photography's very commonness made it particularly interesting, because the art could be made unknowingly. The romantic notion of the "fine artist" was challenged by photography, most apparently in the difference between Stieglitz's self-involved romanticism and Evans's admiration for the anonymous artifact and for vernacular photography. Lincoln Kirstein, an early supporter of Walker Evans, was also deeply fascinated by the power of the vernacular and had encouraged both "Walker Evans: Photographs of Nineteenth Century Houses" in 1933 and his "American Photographs" in 1938.[55]

To celebrate the museum's new Department of Photography, in December 1940 Beaumont Newhall and Ansel Adams together organized an exhibition titled "Sixty Photographs" that included Levitt's image of children walking out on the stoop with Halloween masks. It was hung between Lisette Model's picture of a large woman with a flowered dress and Walker Evans's close-up of the Legionnaires, and near Cartier-Bresson's picture of unemployed workers. Above the Cartier-Bresson was an anonymous press photograph of a strike.[56]

SOCIAL DOCUMENTARY AND THE PUBLIC OR PRIVATE WITNESS

The record I want to make of this [new descriptive writing] is not journalistic; nor on the other hand is any of it to be invented. It can perhaps most nearly be described as "scientific," but not in a sense acceptable to scientists, only in the sense that is ultimately skeptical and analytical. It is to be as exhaustive a reproduction and analysis of personal experience, including the phases and problems of memory and recall and revisitation and the problems of writing and of communication, as I am capable of, with constant bearing on two points: to tell everything possible as accurately as possible: and to invent nothing. It involves therefore as total a suspicion of "creative" and "artistic" as of "reportorial" attitudes and methods, and it is likely therefore to involve the development of some more or less new forms of writing and of observation.

—James Agee[57]

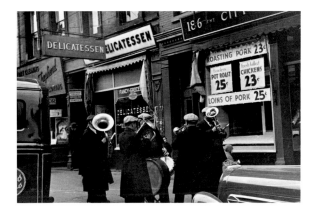

Figure 21.
ARTHUR ROTHSTEIN
Unemployed Musicians, New York City, 1936

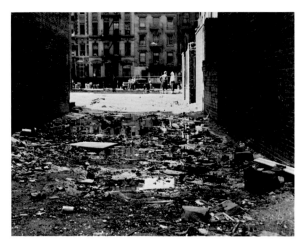

Figure 22.
ARNOLD EAGLE AND DAVID ROBBINS
Untitled (New York City), 1938, from the WPA Federal Art Project series *One Third of a Nation*

Because of the great social crisis in the 1930s, photography was seen as a tool to reveal and correct social problems. Just as artists of the 1920s had explored personal and formal aspects of art, in the 1930s the photographer was in service to the external social forces that were revealed so powerfully around him or her. Levitt was aware of the FSA by the time she knew Evans, but she never worked for it. Roy Stryker generally guided his photographers toward the small family farmer or rancher, the essentially decent person in the country who was having trouble making ends meet. Some members of the FSA, however, made photographs in cities. Some—Russell Lee, Dorothea Lange, and Arthur Rothstein, for instance—made photographs of New York. But while their work was informative, socially piquant, or even revealing, these photographers were not committed to exploring urban subject matter in any depth (fig. 21).

In New York photographers associated with the WPA documented the city, and even specifically its children, with great social perceptiveness. One of these, Arnold Eagle, hired by the

WPA as a creative artist, depicted some of the same areas of the city as Levitt, but his intentions were quite different. He was sensitive to the beauty of tenement walls and the aesthetic qualities of dirt and debris in an empty lot, but he was most interested in describing the conditions in which the children lived and played (fig. 22). Eagle's work was known and exhibited in New York in the 1930s, as was that of his contemporary, Alexander Alland. Known today mainly as the rediscoverer of Jacob Riis, Alland was fascinated by the ethnic diversity in New York and saw it as a source of great cultural richness. His is a more socially inflected consciousness than Levitt's, however, and usually more sentimental. Alland's work was exhibited at the Museum of the City of New York in 1941 and again in 1943 (fig. 23).[58]

By far the most important photographers in New York who worked with the city's streets as their primary interest were the artists affiliated with the Photo League. During the 1930s the League sponsored a number of projects to photograph some areas where Levitt also worked, and a comparison is revealing. Sid Grossman's

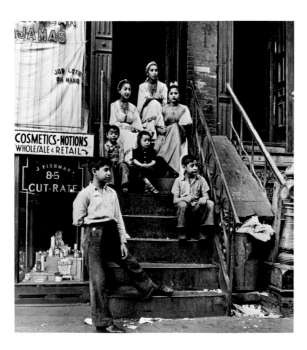

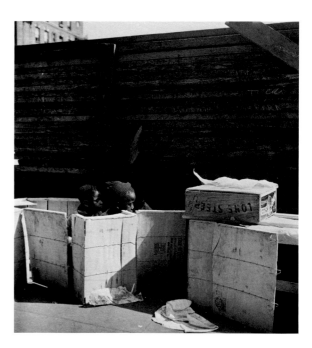

Figure 23.
ALEXANDER ALLAND
Home of the Gypsies on Hester Street, 1940

Figure 24.
AARON SISKIND
Untitled, c. 1940, from
The Most Crowded Block
series

pictures of Harlem made in the summer of 1939 for the WPA are descriptive records of the kind of life lived there; however, they are far more static than Levitt's. Aaron Siskind's work for the Harlem Document project, as well as for other projects he directed with his Features Group, is cooler than Levitt's (fig. 24). He is generally more interested in context but also in a general design, which interested Levitt not at all. Probably the photographer who shared Levitt's appreciation of childhood culture and learned most from her was Arthur Leipzig, who opened his window in Brooklyn to find children playing some of the same games found in Bruegel's painting, and investigated this phenomenon. But his approach to the subject was more anthropological than Levitt's (fig. 25). Leipzig became involved with the Photo League after the war.[59]

Some of the liveliness of the League can be gleaned from *Photo Notes*. Perhaps even more important, it served as a forum for theoretical discussion of documentary photography. In a statement published in the August 1938 issue entitled "For a League of American Photography," the authors placed their commitment to a photography of "social value" between the Pictorialists and the "so-called modernists," and declared, "The Photo-League's task is to put the camera back into the hands of the honest photographers, who will use it to photograph America." Eliza-

beth McCausland, in her essay "Documentary Photography," carried the task of these photographers a step further:

> *The fact is a thousand times more important than the photographer; his personality can be intruded only by the worst taste of exhibitionism; this at last is reality. Yet, also, by the imagination and intelligence he possesses and uses, the photographer controls the new esthetic, finds the significant truth and gives it significant form.*[60]

The presence of the artist as an intrusive personality seemed incompatible with the times and, to the critics, an affectation to be avoided. Beaumont Newhall, in the first real consideration of this subject, "Documentary Approach to Photography," also asserted that documentary work had historically been seen as antithetical to the self-conscious production of art photographs.[61]

Ben Shahn's work was of great interest to Levitt (fig. 26). He began photographing in 1930 or 1931 with a Leica in the Lower East Side of New York City, and, as Levitt was to do herself, he attached a right-angle viewfinder to his camera to better achieve the sense of gritty realism, of a document of life caught in the web of experience. His shadow facing away from his real subjects appears in at least one of his pictures (fig. 27).

Shahn's extroversion, warmth, and animated love of the particularity of all kinds of people—especially the most modest, but even the narrow or small-minded—is evident in his work. Although the subject matter in some cases is nearly identical to Levitt's, his work has a roughness and spontaneous quality that hers lacks: Shahn's work has a sense of immediacy, whereas in Levitt's we find discretion and distance. Unlike Levitt, Shahn has no sense of pause or of movement distilled and made a continuum. Where Cartier-Bresson's work is elegantly poised, Shahn is very much in the thick of things, sometimes taking great formal risks. He made his pictures cavalierly, and, clearly uninterested in photography as a fine art, considered his pictures notes for paintings. Levitt and Shahn both appreciate the demonstrative, warm culture they find represented among black people.

Levitt knew of Shahn's work through Evans, FSA sources, and also probably from the *New Theatre* magazine, where it was reproduced several times, once as "The Living Theatre—Sidewalks of New York" (fig. 28). Affiliated with the Photo League, the magazine discussed theater and film from the perspective of leftist ideals. After his initial stint of street photography in New York, Shahn worked for the FSA, where he produced his largest body of photographs when he quit the government in 1938 to do a project and moved once again to New York. He also returned actively to photographing the city, and to converting some of his earlier New York pictures into paintings. As a friend of Evans (they were roommates in the early 1930s) and aware of Cartier-Bresson since his show in 1933 at the Levy Gallery, Shahn was in a circle common to Levitt, although she met him only once or twice. His naturalness and simplicity of approach have been compared to his taste for American folksong, and Soby has called attention to his "peculiarly American loneliness."[62]

Beaumont Newhall noted that photography emanating from Roy Stryker's FSA was influenced by the combined perceptions of Ben Shahn's small-format camera and the work Walker Evans produced with a view camera.[63] Although Levitt was more responsive to Shahn's work than Evans's, she was moved to meet Evans by the illustrations in Carleton Beals's *The Crime of Cuba*. It is unclear whether Evans read

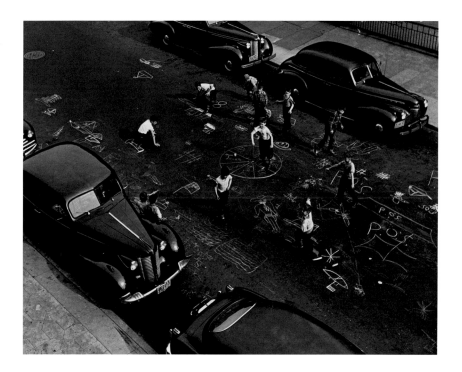

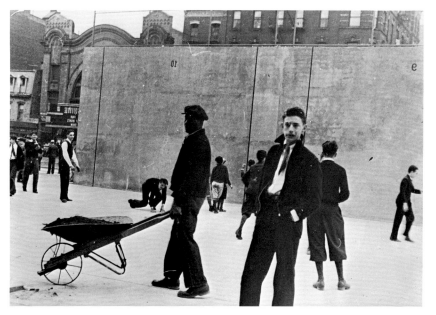

Figure 25.
ARTHUR LEIPZIG
Chalk Games, 1948

Figure 26.
BEN SHAHN
*Houston Street
Playground, New York,*
c. 1932

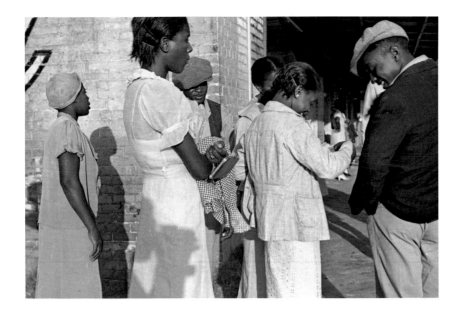

Scenes From The Living Theatre — Sidewalks of New York

Photographs by BEN SHAHN

Figure 27.
BEN SHAHN
*A Group of Young
Negroes*, 1935

Figure 28.
BEN SHAHN
*Scenes from the Living
Theatre—Sidewalks of
New York*, from the
November 1934 issue of
New Theatre

the activist, muckraking text, which examined the political and scandalous social problems of the island nation in almost personal terms. The cool, virtually captionless photographs that appear as a unit at the end of the book serve as a sort of preface to the later collaboration with Agee in *Let Us Now Praise Famous Men*.

Photographs in *The Crime of Cuba* reveal the trivialized bodies of the poor, sometimes composed into a ragged frieze, but also their energy and the often exotic and sensuous beauty of the stevedore or the black man in white duster on the street. Evans's photographs, which precede by several months his knowledge of Cartier-Bresson's work, are far more static and cool than the Frenchman's, though both discover a sexual energy in their subjects. Evans had experimented with a small-format camera as early as 1929, and had made some studies in New York, but in Cuba he first explored the hand-held camera extensively. Protected by the exotic milieu, a foreign language, and assignments to illustrate the social effects of despotism and imperialism, Evans became very much the social voyeur: He reveals people sleeping on park benches, a beggar on the street, a woman with her half-naked children in front of a closed door (fig. 29). Some similarities to both Shahn and Levitt are apparent here: the wall of beautifully arrayed movie posters, the scrawled messages on walls, the character study of the two lottery ticket vendors, and the spontaneity of figures in a breadline. Evans also includes three anonymous and sometimes brutal photographs appropriated from the newspapers which are also ambiguously beautiful. As with most of Evans's work, however, the majority of people he photographs in Cuba are cognizant of the photographer. The expressiveness of poor people touched by hardship moved him as early as 1929, when, like Levitt, he acknowledged the power of Strand's *Blind* in a note to his friend Hans Skolle.[64]

The other body of Evans's photographs familiar to Levitt was the work included in the 1938 exhibition and book *American Photographs*, since she assisted in printing photographs for the show. Some of Evans's early street pictures of New York bear the closest relationship to Levitt's style or subject matter (fig. 30). Rather than representing archetypal moments on the street, however, Evans's early New York images are

ironic, distanced, critical—as one might expect from an artist profoundly moved by Charles Baudelaire and Gustave Flaubert. His work reveals an awareness of social condition that is often not kind, and it has none of the fantasy that permeates Levitt's, none of the sense of a vital and ancient continuum. His work is more particular, more social, in fact. Both photographers are susceptible to the art of the hand-painted sign or billboard, but Levitt modifies this fascination of both Evans and Shahn by observing a child's funny and satiric adaptation of the poster lady's sensuous shrug (pl. 22). Evans's view of the same is more tragic—or more socially aware (fig. 31). While Evans appreciates the beauty of the hand-scrawled "gas" graffito, as subtle and delicate as the work of Paul Klee, Levitt finds graffiti that are more imaginative, less simply beautiful. Evans's photographs of people are seen at a distance, as part of the folk-art setting in which they were found. If they are seen close up they reveal a discordance more often than joy or pleasure. Levitt's work is mostly joyful, rarely discordant. Her photographs are usually planar and sculptural, rather like Evans's, and rarely atmospheric; the child running toward her mother in plate 36 is a rarity. Most of Evans's work is absent of people—at least living people—and his subjects are most often found in the countryside. Evans also penetrates into interiors far more often than Levitt (in fact, she used his Speed Graphic for the interior picture of the gypsy), and many of these have a certain tenderness, perhaps even a sweetness that his pictures of people often lack. His people often seem estranged, his work more invasive, finally, than hers, which maintains a respectful distance from the subjects. Levitt's photographs are those of a person appreciative of the people she depicts; they are not so ironic, lonely, or despairing as his.

After Evans's 1938 show at The Museum of Modern Art, from 1938 to 1941 he and Levitt often sat together while he used a concealed camera to make a series of portraits of subway riders. Levitt's use of indirection, of locating her subject in the right-angle finder, must have aided him in appreciating the delicacy of these faces, unaware of the camera. Since they worked so closely, their separate pictures have often been confused.[65] They are sober, purgatorial works, their darkness a reflection as much of mood as

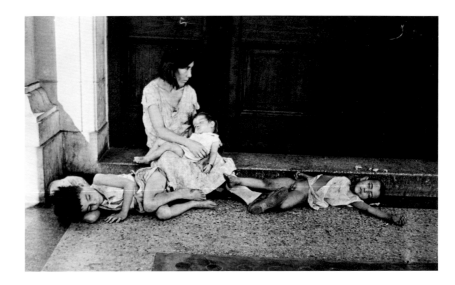

Figure 29.
WALKER EVANS
Family, 1938

technique. They are also Evans's form of staring, in the way he was allowed to stare at sleeping men and women, or Cubans.[66]

Between Evans's pictures and Agee's text in *Let Us Now Praise Famous Men* lies a poem, which is excerpted here:

> *Spies, moving delicately among the*
> *enemy,*
> *The younger son, the fools,*
> *Set somewhat aside the dialects and the*
> *stained skins of feigned madness,*
> *Ambiguously signal, baffle, the eluded*
> *sentinel.*

Agee, more than Evans, was made self-conscious and uneasy by the intrusion he and the photographer made into the lives of what he called "an undefended and apallingly damaged group of human beings, an ignorant and helpless rural family."[67] Agee was the more outwardly compassionate. His prose is intense and ecstatic where Evans's work is cool, but even in his clear respect for his hosts (Evans and Agee made sure that they were paying guests to one of the families), he still feels like a "spy" rather than an observer. For Evans and Agee both, their respective art forms were a kind of description. Agee's book is replete with the most intense and ecstatic cataloguing. If anything is consistent about this book, it is that the overwrought description, the furious seeing and describing, is broken regularly by an evaluation of this activity, demanding and justifying its importance and rightness as a creative act. Because this activity is so intrusive, rendering so

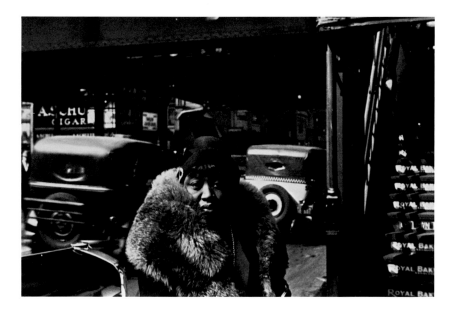

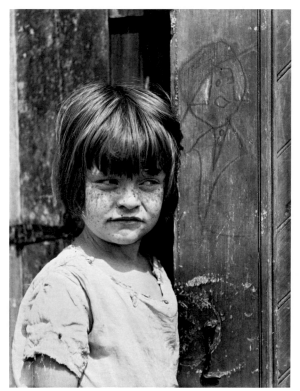

Figure 30.
WALKER EVANS
42nd Street, 1929

Figure 31.
WALKER EVANS
Child in Backyard, 1932

particular and intimate a picture of the inhabitants of these houses, Agee is remorseful for being, with Evans, a "spy." Agee cherishes his subjects, idealizes them, and wavers between this and abstract theoretical issues of the meaning of "realism" and "naturalism." He includes, besides and beyond his elegaic lists, extended quotes from the Apocryphal Bible, from Louise Gudger's geography textbook, press clippings—including a laudatory newspaper review of Margaret Bourke-White's work. In fact, the book is a collage that represents his experience of living with the three families.[68]

One reason I so deeply care for the camera is just this. So far as it goes . . . and handled cleanly and literally in its own terms, as an ice-cold, some ways limited, some ways more capable, eye, it is, like the phonograph record and like scientific instruments and unlike any other leverage of art, incapable of recording anything but absolute, dry truth.[69]

Levitt has often said that she learned as much from Agee as anyone. Evans acknowledged this influence, too: "Levitt's work was one of James Agee's great loves; and in turn, Agee's own magnificent eye was part of her early training."[70] After completing the mammoth undertaking of *Let Us Now Praise Famous Men*, Agee returned to journalism, where he was happiest in writing on film. Agee's filmic appreciation not only of detail but of the theatrical or narrative meaning of the telling gesture is shared by Levitt. It is in the strange, tentative movement of hand drawn to mouth of the haunted woman, in a street empty except for the bicycle balanced in the distance, or in the intense expression of concentration in the face of a child climbing a pole and the beautiful, calm line of sunlight inscribed on his small calf and sneaker. Levitt probably did not know the enchanted half-understanding of Rufus in Agee's posthumously published novel, *A Death in the Family*, until later, but she was aware of Agee's deep sympathy for children and of his high regard for childhood as a special state of grace intruded on by adults—a people at once comforting, frightening, and incomprehensible.[71]

In front of a doorway graced with peeling paint and chalked-in names, Levitt found four boys in homemade Legionnaires's outfit (pl. 14). Two of them are born ham actors, posing extrav-

agantly as though on some small vaudeville stage. As pendants to these two extroverts, two other littler, quieter children stand—curious, tender—observing the act of being photographed. Altogether they are seen as a perfect frieze, separate but interlocked, unfolding across their modest, ordinary, but really quite extraordinary stage.

What is forgotten by the viewer is the consciousness of the photographer, an attitude of invisible selflessness that Levitt shares ostensibly with documentary photographers. Like Evans, Shahn, Agee, and others her work is not so concerned with social justice or awareness as with a humanitarianism and a specific belief in the lyric. Levitt, more self-effacing than Shahn, more discreet than Agee, gentler than Evans, was perhaps truer than they to a passage by the poet Wallace Stevens that she noted in her scrapbook: "In the presence of extraordinary actuality, consciousness takes the place of the imagination." Helen Levitt's extraordinary gift is to perceive in a transient split second, and in the most ordinary of places—the common city street—the richly imaginative, various, and tragically tender moments of ordinary human existence.

NOTES

1. Johann Huizinga, *Homo Ludens: A Study of the Play Element in Culture* (Boston: Beacon Press, 1955), p. 119. The Foreword is dated 1938, and the German version was published during World War II.

2. Le Corbusier [Charles Jenneret], *When the Cathedrals Were White* (New York: Reynal and Hitchcock, 1947), p. 44.

3. See Marvin Hoshino and Roberta Hellman, "The Photographs of Helen Levitt," *The Massachusetts Review*, vol. 19, no. 4 (Winter 1978), pp. 729–42; and John Szarkowski, *Looking at Photographs: 100 Pictures from the Collection of The Museum of Modern Art* (New York: The Museum of Modern Art, 1973), p. 138.

4. See Brooks Johnson, ed., *Photography Speaks: 66 Photographers on Their Art* (New York: Aperture, 1968), pp. 64–65.

5. Among those interviewed, all those who remember Levitt as a young woman have remarked on her deep shyness at that time. Levitt does not recall where she learned to use the right-angle finder and conjectures that it may have been from her employer and first teacher, J. Florian Mitchell.

6. Alfred Kazin, *A Walker in the City* (New York: Grove Press, 1958), pp. 6–7. Kazin wrote this compilation of essays in the 1940s about his origins in Brooklyn for the *New Yorker* and *Commentary* magazines.

7. "The Melting Pot," unsigned article, *Fortune*, vol. 20, no. 1 (July 1939), p. 73.

8. The Depression inspired architects from Frank Lloyd Wright to Le Corbusier to invent utopian plans in both Europe and America. The effect of the machine as a metaphor for an ideal city is discussed in *The New Vision: Photography between the World Wars, Ford Motor Company Collection at The Metropolitan Museum of Art*, with essays by Maria Morris Hambourg and Christopher Phillips (New York: The Metropolitan Museum of Art, 1981), and in Jean Clair, ed., *The 1920s: Age of the Metropolis* (Montreal: The Montreal Museum of Fine Arts, 1991).

9. Moses himself is a symbol of what Levitt resisted—not the least his arrogance, his masculine fascination with power, and the transformation of the city—all originally based in liberal idealism. See not only the voluminous biography by Robert A. Caro, *The Power Broker: Robert Moses and the Fall of New York* (New York: Vintage Books, 1975), but also Marshall Berman's *All That Is Solid Melts into Air: The Experience of Modernity* (New York: Penguin Books, 1988), for example, p. 308: "Moses' projects of the 1950s and 60s had virtually none of the beauty of design and human sensitivity that had distinguished his early works. Drive twenty miles or so on the Northern State Parkway (1920s), then turn around and cover those same twenty miles on the parallel Long Island Expressway (1950s/60s), and wonder and weep. Nearly all he built after the war was built in an indifferently brutal style, made to overawe and overwhelm: monoliths of steel and cement, devoid of vision or nuance or play, sealed off from the surrounding city by great moats of stark empty space, stamped on the landscape with a ferocious contempt for all nature and human life." See also, among many other source books on New York, Leonard Wallock, ed., *New York: Culture Capital of the World, 1940–1965* (New York: Rizzoli Publications, 1988). Much of the initial impetus for these machine-like solutions to urban planning came from Europe.

10. See the vast literature of discovery of the United States in the 1930s, which centered on the rural experience, unlike Levitt, and Strand's move from observation of the city to American and then European rural communities. Some of the former is discussed in William Stott, *Documentary Expression and Thirties America* (New York: Oxford University Press, 1973), and the latter in Alan Trachtenberg's Introduction to Maren Stange, ed., *Paul Strand: Essays on His Life and Work* (New York: Aperture, 1990).

11. See Donald L. Miller, ed., *The Lewis Mumford Reader* (New York: Pantheon Books, 1986), p. 207. Lewis Mumford also worked on the script of a film, *The City*, directed by Ralph Steiner and Willard Van Dyke, 1939, which espoused these same ideals. For further discussion on the Fair's social concerns (for instance, Lewis Mumford took an active interest in the Fair's direction), see *Dawn of a New Day: The New York World's Fair, 1939–40* (New York: The Queens Museum, 1980), especially the essay by Joseph P. Cusker, "The World of Tomorrow: Science, Culture and Community at the New York World's Fair."

12. Jane Jacobs, *The Death and Life of Great American Cities* (Harmondsworth: Penguin Books, 1962), p. 60. I am indebted to the brief but very cogent review of the history of modern city planning found in her introduction. See also Thomas Bender and William R. Taylor, "Culture and Archi-

tecture: Some Aesthetic Tensions in the Shaping of Modern New York City," in William Sharpe and Leonard Wallock, eds., *Visions of the Modern City: Essays in History, Art and Literature* (Baltimore: The Johns Hopkins University Press, 1987), pp. 189–219, in which New York's architecture as attentive to its public is contrasted to a city like Chicago, where modernist architecture ignores the role of people.

13. Mention should also be made of the highly aesthetic, romantic, but almost dehumanized view of New York in the Strand-Sheeler film, *Manhatta* (1921).

14. Abbott was also much concerned with the dehumanizing aspect of city building; notice especially her work devoted to Rockefeller Center. See Michael G. Sundell in *Berenice Abbott: Documentary Photographs of the 1930s* (Cleveland: The New Gallery of Contemporary Art, 1980), p. 6. Abbott's photographs were much enriched by the text by Elizabeth McCausland, a critic well versed in modernism and radical social ideas.

15. See John R. Lane, "The Meanings of Abstraction," in John R. Lane and Susan C. Larsen, eds., *Abstract Painting and Sculpture in America, 1927–1944* (Pittsburgh: Museum of Art, Carnegie Institute with Harry N. Abrams, Inc., 1983); and also Cecile M. Whiting, *Antifascism in American Art* (New Haven: Yale University Press, 1989).

16. See Alan Trachtenberg, *Reading American Photography: Images as History, Mathew Brady to Walker Evans* (New York: Hill and Wang, 1989), especially the chapter on Evans.

17. *The WPA Guide to New York City* (New York: Random House, 1939), was sponsored by, among others, Van Wyck Brooks, Malcolm Cowley, Rockwell Kent, Alfred Kreymborg, and Mark Van Doren. An example of a book produced at this time with photographic examination of the city would be Richard Wright's *12 Million Black Voices: A Folk History of the Negro in the United States*, photo-direction by Edwin Rosskam (New York: The Viking Press, 1941). But this is a social tract, and most of the photographs which depict black life in the city are made by Russell Lee, of the FSA, and are of Chicago. For a discussion of a body of documentary and descriptive writing reflecting this period, that was particular, visual, and similar to the observations found in the guides, see Alfred Kazin, *On Native Grounds: An Interpretation of Modern American Prose Literature* (New York: Harcourt Brace Jovanovich, 1982; originally published 1942), especially pp. 489ff. Kazin was editor of *The New Republic* in 1942, and he also worked for *The Partisan Review*. He was part of the generation of literary intellectuals who made a living writing for magazines, addressing, at the time, an educated lay audience, not an academic one, at least not until later.

18. *The WPA Guide to New York City*, p. 50.

19. Ray Hopes, *Ralph Ingersoll: A Biography* (New York: Atheneum, 1985).

20. Some such articles included one on a family in which the husband had been on relief for a number of years; another, called "Vanishing Backyards," illustrated by Ralph Steiner's photographs; and James Agee's text on the American roadside, with illustrations by John Steuart Curry. Of all the articles that appeared in *Fortune*, this one of September 1934 is one of the most interesting, for its illustrations, archetypically depicting the American scene that would concern Evans, and for its gloriously written essay, by Agee, which begins: "The characters in our story are five: this American continent; the American people; the automobile; the Great American Road; and—the Great American Roadside. To understand the American roadside you must see it as a vital and separable part of the whole organism, the ultimate

expression of the conspiracy that produced it.

"As an American, of course, you know these characters. This continent, an open palm spread frank before the sky against the bulk of the world. This curious people. The automobile you know as well as you know the slouch of the accustomed body at the wheel and the small stench of gas and hot metal. . . ." Not all of *Fortune*'s essays were of liberal humor. One, on southern agriculture, which incidentally used FSA photographs, was decidedly anti-FSA. See "The Industrial South," *Fortune*, November 1938.

21. *Let Us Now Praise Famous Men* was first published in 1941 by Houghton Mifflin.

22. Edna R. Bennett, "Helen Levitt's Photographs: Children of New York and Mexico," *U.S. Camera Magazine*, vol. 6, no. 4 (May 1943), pp. 14–17, and James T. Soby, "The Art of Poetic Accident: The Photographs of Cartier-Bresson and Helen Levitt," *Minicam*, vol. 6, no. 7 (March 1943), pp. 28–31, together with Nancy Newhall, "Helen Levitt: Photographs of Children," *The Bulletin of The Museum of Modern Art*, vol. X, no. 4 (April 1943), p. 8, comprise the only critical writing on Levitt until the 1970s. See also Harvey V. Fondiller, "Tom Maloney and U.S. Camera," *Camera Arts*, vol. 1, no. 4 (July/August 1981), pp. 16ff.

23. See the letter in the correspondence files at The Museum of Modern Art, Department of Photography, dated June 23, 1942, probably from Soby, to Alexey Brodovich.

24. *PM's Weekly*, sect. 2, August 11, 1940, p. 40. *PM* sponsored an exhibition, "The Artist as Reporter," at The Museum of Modern Art. See *The Bulletin of The Museum of Modern Art*, vol. VII, no. 1 (April 1940), p. 6.

25. For the general emotional nature of documentary, more than an intellectual, reasoned approach, see the William Stott book cited above, pp. 8–9. See also Milton W. Brown's analysis of the appeal of Cubism to American artists in his book *American Painting from the Armory Show to the Depression* (Princeton, N.J.: Princeton University Press, 1970), pp. 103–4: "Cubism appealed to the American artist because of its rationalism. Fauvism and Expressionism demanded a basic faith in one's esthetic sensibilities, a 'wildness' in relation to accepted mores, a wildness whose rightness was never rationally demonstrable." The interest in popular culture, the serious hold of leftist politics on the part of the 1930s intellectuals, and a photography of real, modest, and ordinary people had its mirror image in a new popular interest in the artist. As Archibald MacLeish said in an essay written for *Fortune* on the Federal Art Project, "In less than a year from the time the program first got under way the totally unexpected pressure of popular interest had crushed the shell which had always isolated painters and musicians from the rest of their countrymen and the American artist was brought face to face with the true American audience. . . ." Unsigned article, "Unemployed Arts: WPA's Four Art Projects: Their Origins, Their Operation," *Fortune* (May 1937), pp. 108–17. Francis V. O'Connor identifies this as MacLeish's writing in *Art for the Millions: Essays from the 1930s by Artists and Administrators of the WPA Federal Art Project* (Boston: New York Graphic Society, 1975), p. 39.

26. Information on the Photo League can be derived from its publication, *Photo Notes*; from Anne Tucker, "The Photo League," *Creative Camera*, no. 223–24 (July/August 1983), pp. 1013–17; and Louis Stettner, "Cézanne's Apples and the Photo League," *Aperture*, no. 112 (Fall 1988), pp. 14–35, among other sources.

27. Levitt exhibited her work at the Photo League twice, in June 1943, "Pictures of Children," and in November 1949, with John Candalario. The quote from Lisette Model is

from *Photo Notes* (April 1943), p. 3. Her second exhibition at the Photo League was reviewed by Joseph Solmon in the Spring 1950 *Photo Notes*, pp. 13, 15.

28. Max Kozloff, "A Way of Seeing and the Act of Touching: Helen Levitt's Photographs of the Forties," in *The Privileged Eye: Essays on Photography* (Albuquerque: University of New Mexico Press, 1987), pp. 29–42.

29. In 1941 Levitt received a letter from Eugene Berman, one of the Neo-Romantics, thanking her for sending her photographs, telling her he had shown them to Igor Stravinsky, who also admired them, and suggesting she show them to James Thrall Soby. He also bought a print and supported her for a Guggenheim. Janice Loeb introduced Levitt to him.

30. This information is gleaned from contemporary reviews in *The New York Times*, *Photo Notes*, and other sources, including the appendix in David Travis, *Photographs from the Julien Levy Collection: Starting with Atget* (Chicago: The Art Institute of Chicago, 1976).

31. Lewis Mumford, "The Art Galleries," *The New Yorker*, April 3, 1937, p. 67. The Evans essay appears in *Hound and Horn*, vol. 5 (October–December 1931), pp. 125–28.

32. Aaron Siskind, in an interview with the author, described Newhall's "great service" at that time as discovering the "classic" in photography. Steichen, and Willard Morgan, who was briefly the director of the department during the War, were seen as populists. It is also interesting to note that "Road to Victory," Steichen's first show at the Museum, contained poetic texts by his brother-in-law, Carl Sandburg—a kind of foreshadowing of "The Family of Man" and certainly related to the layout of pictorial magazines, uniting photography and captions in sequence. For an analytic overview of the aesthetic ideas of the Department of Photography at The Museum of Modern Art, see Christopher Phillips, "The Judgment Seat of Photography," in *October*, no. 22 (1982), pp. 27–63. For shows of American photography: "Charles Sheeler," 1939, and "Seven American Photographers," the photographic component to *Art in Our Time*, also 1939; "American Photographs at $10" (which included Levitt), 1941–42; "Photographs of the Civil War and the American Frontier" and "Alfred Stieglitz," both in 1942, and "Eliot Porter" and "Helen Levitt" in 1943. Since Newhall was overseas contributing to the war effort, his wife Nancy, the acting curator, organized many of these shows. Levitt's photographs were exhibited as early as 1940, in "Sixty Photographs: A Survey of Camera Aesthetics" (she was represented by the children in Halloween masks coming onto the stoop) and prints of her photograph "Tacubaya, Mexico City" were offered for sale in the above-mentioned "American Photographs" in 1941. In 1943 she was given a show of her own alongside Porter's. She was included later that same year in the shows "Mexico: 8 Photographers," "Portrait Photography," and in "Action Photography," and was included in the circulating show "Masters of Photography." In 1944 she was included in "Art in Progress" with four prints: *Children with Broken Mirror, Cops and Robbers, Two Girls in Window*, and an untitled print from Mexico City. In 1945 she was awarded the museum's Photography Fellowship and was included in "Photographs from the Museum Collection."

33. James Agee, "Southeast of the Island: Travel Notes" (unpublished essay on Brooklyn written for *Fortune* but not published), in Robert Fitzgerald, ed., *The Collected Prose of James Agee* (Boston: Houghton Mifflin, 1969), p. 189.

34. These observations are from conversations with Levitt and her friend Edna Meyers.

35. Besides her own account, this information comes from Edna Meyers and notes of Jane Livingston's conversations with Levitt. Meyers remembers visiting the Levy show of Cartier-Bresson also.

36. See Peter Galassi, *Henri Cartier-Bresson: The Early Works* (New York: The Museum of Modern Art, 1987), especially p. 21.

37. Other fascinating interrelationships occur. For instance, the Martin Munkacsi photograph that Cartier-Bresson so much admired of nude boys at Lake Tanganyika, the Congo (1929–30, and later widely reproduced in Europe) bears an uncanny similarity to Levitt's black children running into the hydrant in this exhibition. Also, Cartier-Bresson made photographs of children playing in Yorkville, which were published in *New Theatre*, vol. 2 (September 1935), p. 9. See Galassi, fn. 59.

38. David Travis has discussed this in his essay in *André Kertész: Of Paris and New York* (Chicago: The Art Institute of Chicago, 1985), p. 87.

39. Galassi, pp. 32ff.

40. Louis Aragon's *Paysan de Paris (Nightwalker)* is an eccentric, discursive, and disturbing vision of the dark, unclear experience of a walker in the passages and parks of Paris. Ultimately, it is self-reflective, an excursion not so much through the city as into Aragon's consciousness and unconscious.

41. James T. Soby, "The Art of Poetic Accident: The Photographs of Cartier-Bresson and Helen Levitt," *Minicam*, vol. 6, no. 7 (March 1943), pp. 29–30.

42. Galassi, pp. 33–34, discusses the meaning of vernacular for Cartier-Bresson, and quotes, appropriately, Pierre Naville's essay on Surrealism in the magazine *La Revolution Surréaliste*: "The cinema, not because it is life, but the marvellous, chance grouping of elements./ The street, kiosks, automobiles, screeching doors, lamps bursting in the sky./ Photographs." He also rightly notes that it was not only the Surrealists who were interested in expanding the photographic medium, and mentions, besides Moholy-Nagy's interest in nonart photographs, the illustrations in Ozenfant's *Foundations of Modern Art*.

43. "Helen Levitt: Photographs of Children," *The Bulletin of The Museum of Modern Art*. Barbara Morgan also made photographs of children in wild and free dance; see her "Children Dancing by Lake," 1940, in *Barbara Morgan* (Hastings-on-Hudson, New York: Morgan & Morgan, 1972), pl. 81. See also Edna Meyers, "Sidewalk Art That Blooms in the Spring," *Parent's Magazine* (March 1962), pp. 58–59, 150.

44. *Helen Levitt: A Way of Seeing*, with an essay by James Agee (Durham, N.C.: Duke University Press, 1989), pp. v, vi. The Agee text was written in 1946.

45. *A Way of Seeing*, pp. viii, xi–xii.

46. *A Way of Seeing*, pp. xii–xiii. Agee also recognizes the Surrealist aspect of her work, p. xii.

47. For much of this discussion I have relied on the advice of Dr. Joseph Church of Brooklyn College and Dr. Lynn Ponton, formerly of the University of California at San Francisco, whose field is child and adolescent psychiatry. See also the populist fascination with childhood in film (Shirley Temple, The Little Rascals, etc.). Anna Freud was forced to move from Vienna to England in 1938 with her eminent father, and although she had established herself in the field of child psychiatry before, because the circumstances of war led her to study children in institutions isolated from their parents, she was able to make important contributions about the specific characteristics of childhood and how they were in themselves different from those of adults. She explores specifically the developmental stages of childhood. Her work subsequently be-

came known in the English-speaking community as well as to her fellow immigrant intellectuals, both in England and America. See Raymond Dyer, *Her Father's Daughter: The Work of Anna Freud* (New York: Jason Aronson, 1983), especially pp. 175ff. Another admirer of childhood, the poet Henri Michaux, wrote appreciatively of this special, primitive, and transient state. His work was illustrated by the photographs of Cartier-Bresson and Bill Brandt, among others, in *Verve*, vol. 1, no. 2 (Spring 1938), pp. 114ff.

48. Ethel and Oliver Hale [Esther and Oscar Hirshman], "From Sidewalk, Gutter and Stoop: Being a Chronicle of Children's Play Activity," unpublished typescript dated 1955 (though internal evidence suggests much of it was collected in the 1930s), The New York Public Library, Manuscripts Division, box 1, p. 97.

49. Ibid., p. 207. Some rhymes clearly come from the black South and are influenced by jazz, such as, "Don't you like it / Don't you take it / Don't you, Alabama / Shake it / Shake it high / Shake it low / Shake it down / Uncle Joe," p. 263. Also see Dorothy Mills and Morris Bishop, "Onward and Upward with the Arts: Songs of Innocence," *The New Yorker*, November 13, 1937, pp. 32–42, on children's songs and games, and Carl Withers, comp., *A Rocket in My Pocket, The Rhymes and Chants of Young Americans* (New York: Henry Holt and Co., 1948).

50. As on p. 19 where they note that the Hot Cross Buns jump-rope rhyme refers to the Christianized version of an ancient fertility observance, and was found in Herculaneum, just as hopscotch was originally a game intended to represent the player's passage from Hell to Purgatory to Heaven. Ralph Ellison was also collecting children's poems for the Federal Writers' Project in Harlem. See *Harlem Document, Photographs 1932–1940, Aaron Siskind* (Providence, R. I.: A Matrix Publication, 1981), p. 79. See also Huizinga, *Homo Ludens* (cited in footnote 1). "Now in myth and ritual the great instinctive forces of civilized life have their origin: law and order, commerce and profit, craft and art, poetry, wisdom and science. All are rooted in the primaeval soil of play" (p. 5). It is also secret and holy (pp. 12–19), and at the origin of poetry (p. 119ff).

51. "Small Fry Compete with Moderns," *Cue*, no. 17 (April 1948), pp. 20–21, specifically compares a Baziotes painting with one of Levitt's graffiti photographs. For further insights into the importance of graffiti as well as the broader area of vernacular art and its implications, see Kirk Varnedoe and Adam Gopnik, *High and Low: Modern Art and Popular Culture* (New York: The Museum of Modern Art, 1990). See also Sidra Stich, *Joan Miró: The Development of a Sign Language* (St. Louis: Washington University Gallery of Art, 1980). The Museum of Modern Art, New York, held an exhibition, "Prehistoric Rock Pictures in Europe and Africa," April 28–May 30, 1937.

52. The 1931 English translation by John Rodker of the original 1928 version has been reprinted by Dover Publications, 1952. See the latter, p. 95. It was cited in Barr's Cubist catalogue and also by Peter Galassi. The Allegret photograph comes from his collaboration with André Gide entitled *Voyage au Congo*. Sheeler and Evans made photographs of African art (Sheeler photographed other kinds of art as well) and Evans's were exhibited and published by The Museum of Modern Art in *African Negro Art*, James Johnson Sweeney, ed. (New York: The Museum of Modern Art, 1935).

53. As Meyer Schapiro has made most clear, the serious appreciation of folk art began in earnest in the mid-nineteenth century, and similarly the idealization of the artist as a simple, natural being. It was said of Courbet that he produced paintings as simply as an apple tree bears fruit. See his "Courbet and Popular Imagery: An Essay on Realism and Naiveté," in *Modern Art: 19th and 20th Centuries, Selected Papers* (New York: George Braziller, 1978), pp. 47–85. Alfred Stieglitz had three exhibitions of children's art at his gallery, the last in 1915.

54. Holger Cahill had also included photographs (by Berenice Abbott) and folk and children's art along with the other WPA art. See his catalog *New Horizons in American Art* (New York: The Museum of Modern Art, 1936). Another example is Carol Aronovici, ed., *America Can't Have Housing* (New York: The Museum of Modern Art, 1934), where photographs and a reconstruction of a tenement room and a modern apartment were set up to demonstrate the need for modern public housing.

55. Kirstein had reproduced Evans's New York photographs in his magazine *Hound and Horn* in 1930 and had included his work in the Harvard Society for Contemporary Art exhibition held concurrently. But although Kirstein included European experimental photography in this show, he balked at reproducing Atget's work in his magazine, contending that it was not "American." Kirstein was fascinated with the American implications of the vernacular—Atget was simply too foreign. Kirstein was by his own admission a Henry James enthusiast, and perhaps closer to the Stieglitz artists of the 1920s in his search for "Americanness" in modern art. According to Edna Meyers, she interested Lincoln Kirstein and Frederick Ashton in making a street ballet using Levitt's photographs of children. Paul Magriel was also interested; as Balanchine was not, the idea was dropped. For Kirstein on Atget, see Mitzi Berger Hamovitch, ed., *The Hound and Horn Letters*, Foreword by Lincoln Kirstein (Athens: The University of Georgia Press, 1928), pp. 3, 94–95.

56. See the checklist published in the Bulletin of the Museum of Modern Art, vol. 2, no. 8 (December–January, 1940–41), pp. 6–7. The Cartier-Bresson photograph of unemployed workers is paired with the news photograph of the "Republic Steel Riot," no. 27. Levitt's photograph is here dated 1940. Soby is listed as lending Cartier-Bresson's "Children Playing in Ruins," and MacLeish is listed as a member of the Committee on Photography. On p. 5 the authors note, "This exhibition is intended not to define but to suggest the possibilities of photographic vision." The "Republic Steel Riot" photograph was also reproduced in MacLeish's *Land of the Free* and in *U.S. Camera*.

57. Robert Fitzgerald, ed., *The Collected Short Prose of James Agee* (Boston: Houghton Mifflin, 1969), p. 133. This was from an extended proposal to the Guggenheim Foundation which also comprised what would become *Let Us Now Praise Famous Men*.

58. For a discussion of the FSA response to city poverty, and especially poor urban black culture, see Nicholas Alfred Natanson, "Politics, Culture and the FSA Black Image," Ph.D. Dissertation, University of Iowa, 1988, pp. 138 ff. See also Merry A. Foresta, "Art and Document: Photography of the Works Progress Administration's Federal Art Project," in *Official Images: New Deal Photography* (Washington, D.C.: Smithsonian Institution Press, 1987), pp. 14–93. One of Levitt's photographs of a child drawing in the street is illustrated here. On Alland, see Bonnie Yochelson's essay in the recently published catalogue, *The Committed Eye: Alexander Alland's Photography* (New York: Museum of the City of New York, 1991). *Photo Notes* also mentions a talk held by him at the Photo League in April 1938 and an exhibition at the Anderson Galleries. Eagle is mentioned with Daniel Robbins for the exhibition they had at the Municipal Art Gallery, which "excited

so much favorable comment in the press," as they were "fellow-members of our organization" in *Photo Notes*, October 1938, p. 1.

59. Walter Rosenblum's photographs of Gypsy children in his Pitt Street project share some of her interests. Siskind and his group were extremely important and interested in similar subjects. According to *Photo Notes*, there was an exhibition called "City Child" and another called "City Streets" in 1935, and Siskind organized a show on miniature camera photography at the New School the same year. See also Carl Chiareza, *Aaron Siskind: Pleasures and Terrors* (Boston: New York Graphic Society, 1982), especially pp. 25ff and Chapter 3. Rosenblum reviewed the Levitt, Loeb, Meyers, Agee film, *The Quiet One*, in *Photo Notes*, Spring 1949, pp. 23–24.

60. *Photo Notes*, January 1939, p. 7.

61. He notes, for example, that Henri LeSecq's documents of the exterior of Chartres cathedral were produced at almost the same moment as Rejlander's "Two Paths of Life," and leaves no question as to which is the more valuable. Although she did not share the social aims of the documentary photographers, Levitt's work is similarly self-effacing, and her prime concern is her subject. Beaumont Newhall's essay is in *Parnassus*, vol. 16, March 1938, pp. 2–6. In fact, this essay is an important aesthetic statement. "Within the last decade a number of younger photographers, sensing the artistic strength of such photographic documents as these (i.e., the Civil War pictures attributed then to Brady, the U.S. Geological Survey photographs, the work of Marville, Atget and Hine) have seen in this materialistic approach the basis for an esthetic of photography. . . . Walker Evans, Ralph Steiner, Margaret Bourke-White in the East—Ansel Adams, Willard Van Dyke in the West—together with others have produced simple, straightforward photographs of great technical excellence interpreting not only the world nearest to them, but also its social significance." Ibid., p. 4. Newhall also speaks of the relationship to words that this kind of photography has. Adams was most interested in documentary, in fact, as can be seen in his support of Lange, in his correspondence reproduced in *Photo Notes* (June–July 1940), pp. 4–6, and in the documentary project on Manzanar, exhibited at The Museum of Modern Art by Nancy Newhall after some political difficulties.

62. James T. Soby, *Ben Shahn* (London: Penguin Books, 1947), p. 12. According to his widow, Bernarda Bryson Shahn, he had a strong distaste for the political nature of the photographs coming out of the Photo League (from an interview with the author, November 1990). Levitt may or may not have been aware that some of Shahn's photographs were studies for paintings. The Houston Street playground was made into *Handball*, 1939 (collection of The Museum of Modern Art, New York), and *Vacant Lot*, 1939 (collection of The Wadsworth Atheneum), comes from the earlier New York pho-

tograph of c. 1931–32. Soby was a great admirer of these paintings, which sometimes have a Surreal quality.

63. Newhall, *Parnassus*, p. 4.

64. *Walker Evans at Work* (New York: Harper and Row, 1982), p. 24. He used an early roll film camera in Cuba, according to Jerry Thompson, p. 10. Soby speaks of Evans's admiration for Cartier-Bresson's 1933 exhibition at the Levy Gallery, "and said that for the first time he could understand the immense potentialities of the hand camera used at split-second speed. There followed a number of Evans's own Leica photographs of people on the streets and, most especially, a superb series of snapshot portraits of people riding in the subway." *Saturday Review*, February 18, 1956, p. 29. In 1933 Soby studied photography with Evans briefly. See also *Walker Evans: Havana 1933*, essay by Gilles Mora, sequencing by John Hill (New York: Pantheon Books, 1989).

65. But most of them are Evans's. The intent (and the result) are essentially invasive and, while tempered, they are more characteristic of Evans than Levitt. Besides using Evans's Speed Graphic for her interior pictures of Gypsy children (pl. 24), she also made the graffiti study, "Bill Jones' Mother Is a Whore" (pl. 11).

66. A series of photographs is attributed to Evans and published as work made with a hand-held camera in New York in 1938 for the FSA. See *Walker Evans: Photographs for the Farm Security Administration 1935–1938* (New York: Da Capo Press, 1973), pls. 451–88. This work may be misattributed, and one of the photographs has been discovered to bear a credit to Shahn, which, stylistically, would make more sense. Also, for the curious, an undated note in the Evans estate lists possible WPA projects in New York City, among them: "1. national groups 2. types of the time (b & w), 3. children in streets, 4. chalk drawings, 5. air views of the city, 6. subway . . ." *Walker Evans at Work*, p. 107, dated 1934–35. See also the same, pp. 160–61, on the subway pictures.

67. James Agee and Walker Evans, *Let Us Now Praise Famous Men: Three Tenant Families* (Boston: Houghton Mifflin, 1941), p. 7. The poem is on p. 5.

68. Agee describes the new form the writing of this book entailed in the already quoted passage from "Plans for Work: October, 1937," Fitzgerald, *Prose of James Agee*.

69. *Let Us Now Praise Famous Men*, p. 234.

70. From Louis Kronenberger, *Quality: Its Image in the Arts* (New York: Atheneum, 1969), p. 204.

71. Agee's "Knoxville: Summer of 1915," in *The Partisan Review*, vol. 1 (1937), became the preamble for *A Death in the Family*. One writer's work that Levitt did know and admire was Delmore Schwartz's, whose eloquent early story, "In Dreams Begin Responsibilities," was also published in the first issue of *The Partisan Review*, a magazine all her friends read. As with Agee, Schwartz's story reflects early childhood memories and fears.

HELEN LEVITT: A LIFE IN PART

Maria Morris Hambourg

I RECENTLY SAW Helen Levitt seated among friends in a neighbor's Greenwich Village apartment on a Friday at midnight. Only the stacks of red and blue chips on the green felt by her elbow revealed her command of the table. Beneath her purple visor her dark eyes were watchful, her expression opaque. Yet she was thoroughly if surreptitiously relishing the evening—not just because she was in good company and was winning (as usual), but because she was wholly present in the present, immersed in the game.

When asked why she played poker, she replied simply and justly that she enjoys it. Poker, she explained, is not a question of brains but of touch or feel. You use your wits to judge very finely the personalities around you, the open and the concealed cards, and the odds. The play depends upon experience and luck—on predictability and unpredictability. The rules are clear but not official, and, since they can be varied, each deal is a separate game.

Levitt says that she plays for fun and out of respect for Luck, but play is more than diversion for her. Play is central to her notion of society; it is a proposition that animates life. Of itself, play has no moral consequence; it is disinterested. It is not serious, but its rewards are: In its temporary freedom a limited perfection can be achieved. Ordered yet flexible, play takes shape in a magical realm where chance dances and skill is borne on wings; in play nothing is still.

For Levitt photography is a form of serious play. The New York street is her arena. Although the rules of her game change with each venture, the goal is to capture momentary psychic conditions in apt and graceful embodiments. Since chance has the upper hand, the odds are that Levitt frequently must lose. Yet she has won often enough to make her skill legendary among those who know the probabilities.

Even now, fifty years after the first of her three exhibitions at The Museum of Modern Art in New York, Levitt remains what is known as a "photographer's photographer." The term means that the subtleties of her skill may not be recognized by the general public but are prized by her colleagues. Despite the accolade, the elitism implied in the phrase is foreign to Levitt: She has no pretense of being highbrow in her art or in her person.

Levitt's photographs are still little known for several reasons. The most important of these is that the pictures offer nothing sensational, overtly stylish, or conventionally beautiful to the casual viewer. In addition, the artist is more interested in the pictures than in their reception, she has little faith in opinions or interpretations other than her own, and she wishes to live without the intrusions of publicity. She firmly believes that biography is irrelevant and allows the following account only reluctantly, and with this caveat: Trust the pictures, not the words.

It is unlikely that those who knew Helen Levitt as a girl foresaw that she would become an artist. She was born in 1913 in Bensonhurst, a comfortable Italian-Jewish neighborhood in Brooklyn. Her family was Russian and Jewish on both sides, although neither the national nor the religious heritage counted for much in the Levitt household. Her father, Sam, had immigrated at sixteen and, after peddling small wares in the

Figure 32.
May Levitt with daughter
Helen, 1914

South, established a prosperous business in wholesale knit goods in New York. Her mother, May, was born in New York. Like many children of immigrants, she was enthusiastically American.

Smart, practical, and strong-willed, May Levitt was a woman of independent ideas; she was a natural-born feminist who needed no help in directing her exceptional energies. After graduating from high school she dropped the Old World from her name (from Kanevsky to Kane), taught herself bookkeeping, and took a job with Sam Levitt's firm. She married her boss (some fifteen years older than she) and bore three children whom she raised to excel and look after themselves.

Helen was the middle child, flanked by two brothers. She inherited her father's compassion and tidy, resistive composure, her mother's wits, humor, and disregard for convention. Perhaps it was to Grandpa Kane, who worshipped Rosa Ponselle at the Metropolitan Opera, that young Helen owed her fascination with sound. If today she recalls the family's account of a babe in a high chair blowing on a harmonica while plunking the piano keys with her toes as a source of amusement, she also retains it as proof: Through music, Helen first became attuned to herself.

Levitt's native landscape was composed of flagstone sidewalks, front stoops, and small backyards, punctuated by an occasional empty lot that interrupted the regular geometry of blocks of neat houses. A couple blocks away, on Eighty-sixth Street, there were bakers, butchers, commuters, and housewives at their marketing in the striated shadow of the elevated train platform. The kids played in the tree-lined street in front of the houses where cars rarely interrupted games of punchball, jump rope, and "potsy" (hopscotch), or skating, bicycling, and sledding.

The most vivid of Levitt's early memories involve physical activity. Her delight in rollerskating and bicycling was in the freedom of the moving body. She found a similar pleasure in her favored summer camp activities: swimming, tennis, and especially horseback riding. Her love of animals may have drawn her into the saddle, but what made her an excellent equestrienne was not only her feel for fluid movement and her sensitivity but her unusual ability simultaneously to ex-

perience the ride and to project an external visualization of it.

Moving spectacles mesmerized her. Her mother took her to the vaudeville theaters in Brooklyn, which fed her interest in dancing. However, just as piano lessons brought home her frustrating incapacity to produce the music she heard so keenly, she was ultimately dissatisfied with her performance in ballet class, not to mention the sessions in tap, jazz, and the Highland fling. In the pursuit of aesthetic excellence her self-criticism apparently had little tolerance: no handicap for youth and only a partial allowance for pleasure.

The Levitts were great readers. Most afternoons when Helen returned from school she climbed into a chair and entered adventures passed on from her brother: *The Swiss Family Robinson*, the *Frank Merriwell* books, and all of Horatio Alger. Animal stories were equally absorbing: *Black Beauty*, and others by Zane Grey and James Oliver Curwood. Levitt still reads rapidly and voraciously and is more interested in narrative flow than in style. Yet the elegant expression of a hidden truth stops her in awe; she saves the best phrases on scraps of paper.

Her other haven was the neighborhood movie house, a dark dreamy place where laughter, suspense, romance, and moving images enveloped her. She adored the comic shorts of Mack Sennett, Charlie Chaplin, Harold Lloyd, and Buster Keaton, and she sat impatiently through the newsreels for the much anticipated next episode of a serial, such as *Winners of the West*, with Art Accord, or *Plunder*, starring Pearl White. Even a good friend's birthday party could not deter Helen from the ritual Saturday matinée. If her friends thought her daft, she was unmoved; the spectacle was better than anything.

Under the pressure of adolescence, immersion in cinema and literature offered two new satisfactions. On one hand, the glamorous movie stars, alluring and larger than life, were sufficiently unlike the adults she knew so that they could be admired distantly. By writing to Hollywood, Helen collected glossy "signed" portraits of the stars; the smoothly handsome face of Ramon Novarro was her favorite. On the other hand, books were about people whom one might hope to know or be—if one didn't happen to be a teenage

girl half-heartedly attending high school in Brooklyn. *The Golden Book*, a magazine digest of literature, led her to the public library for Somerset Maugham's *Of Human Bondage* and John Galsworthy's *The Forsyte Saga*, followed by multiple volumes of H. G. Wells, F. Scott Fitzgerald, Ernest Hemingway, and others. In the maze of ideas expressed, Levitt followed a thread of her own sensitivity into realms of resistance and longing for which she had no handy map. She knew only that she was different and, vaguely, that others who were different in similar ways had become artists.

Finding nothing in her studies that persistently stimulated her, Levitt dropped out of school in 1930, one semester before graduation. From that point on she taught herself, intuitively finding her way along stepping stones invisible to others.

She benefited, for example, from a course on recent European literature given at Brooklyn College. Although it was a friend who attended the class, not she, Levitt recognized the reading list as an aperture to a larger world. Of the mostly proletarian, realistic works she digested, she has no recollection: Maxim Gorky, Martin Andersen Nexö, Arthur Schnitzler are but names. Yet she clearly remembers Alfred Döblin's *Berlin Alexanderplatz* and Thomas Mann's *Magic Mountain*. Expressions of ideological sympathy for the worker, the renegade, and the dispossessed were perfectly comfortable (and forgettable); the indelible impressions were not made by politics but by art.

In the early 1930s Levitt also took advantage of free performances of Shakespeare at the Davenport Theater, and of classical chamber music at The Metropolitan Museum and Hunter College. By consulting the newspaper listings, such as the "What's On" column in *The Daily Worker*, she learned which union halls and downtown lofts were hosting dances and who was playing at the Savoy Ballroom in Harlem. If she spent weekdays behind a sales counter in Gimbel's Department Store and still slept under her parents' roof, her interior life was hardly defined by these activities.

At a time when liberals, socialists, and communists banded together in a strong popular front of political unity, Levitt's decidedly leftist sentiments were essentially private or, at least, publicly timid. She recalls picketing D. W. Griffith's film, *The Birth of a Nation* (1915), to protest its attitude toward Negroes. While her colleagues resisted orders to disband, Levitt followed the officers' instructions: Handing over her picket to an incredulous friend, she went right home. Her sympathies have resisted organization ever since. Similarly, her easy relations with Negroes on the dance floor or in the street were only partly a reflection of Harlem's vogue as the mecca of "primitive" culture and the locus of "the Negro Problem," a term used as a rallying cry against bias and oppression. Just as Levitt joined no political party, so she was socially colorblind.

In 1931, at the age of 18, Levitt began to work for a photographer in the Bronx, J. Florian Mitchell, the son of a friend of her mother's. His business was primarily to make portraits for standard occasions: confirmations, bar mitzvahs, graduations, marriages, and the like. This ordinary fare, the chemical processes of the darkroom, and other routine photographic procedures—such as spotting print defects—were of no real interest to Levitt. But she applied herself to the procedures with a certain diligence and patience, and something like hope. She earned six dollars a week in what she refers to as an apprenticeship in a skill that she thought had promise. She does not remember how, but she had glimpsed in photography an avenue to art that circumvented her inadequacies in dance, music, and drawing.

During the next four years Levitt acquired the basic techniques of camera and darkroom and began to think that she might become a professional photographer. By 1934 she had acquired a used Voigtlander camera and was photographing her family and friends, testing the idea of a possible career as a commercial portraitist. She abandoned this future as she learned more of other kinds of photography. Her boss belonged to the Pictorial Photographers of America, an organization devoted to the "promotion of photography as an art." Accompanying him to the association's monthly meetings at The Art Center on East 56th Street, Levitt saw prints by the commercial photographer Anton Breuhl and a "picture of a wave" by a Japanese photographer. Perhaps these prints demonstrated plas-

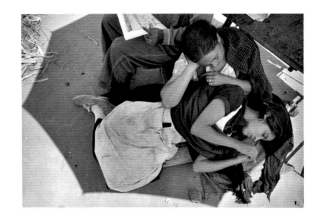

Figure 33.
HENRI CARTIER-BRESSON
Mexico City, 1934

tic and temporal dimensions of the medium that she had not known, or perhaps she was swayed by the technical mastery and the pictorial freedom they exhibited. In any case, Levitt remembers being impressed.

She also became aware of the Film and Photo League, and was more drawn to this body of young, socially conscious photographers and filmmakers than to the Pictorialists. Levitt recalls that she occasionally hung around the League, and that when she shot some film in The Seamen's Institute, she developed it in the League darkroom. Her experiment failed from lack of experience working outside the studio and from lack of light in the hall. Yet the intention was already characteristic of Levitt's maturity: She was in pursuit of people in their context, in unposed situations.

Although choosing to photograph working men in their social club was a significant departure for Levitt, this sort of subject was then current, and more the rule than the exception. During the Depression many photographers worked in the welter of governmental projects that kept artists from starving by employing them in various sorts of documentation. Others pooled their energies in common cause with social good, in informal associations. But whether they were paid by the Federal Art Project (FAP) or the Resettlement Administration, or worked altruistically to expose social and political ills (as at the Film and Photo League), their subject was apt to be broadly generic: Most of the photographs taken by American artists in the mid-1930s depicted the poor or working class citizen in his or her unfortunate situation.

Characteristically, Levitt did not join the Film and Photo League, but she enjoyed the for-

eign films the League showed in the auditorium of the nearby New School for Social Research. And through the League, during 1934 and 1935, she met Sidney Meyers, a film editor better known as the critic Robert Stebbins of *New Theatre Magazine*, Ben Maddow, Willard Van Dyke, Leo Hurwitz, and other photographers and filmmakers.

One evening in 1935, at Willard Van Dyke's studio, a newcomer attracted Levitt's attention. The pictures made by this young Frenchman had interested and somewhat mystified her.[1] Now she was further intrigued, for he spoke with a rare clarity of intellect. When he criticized the technically perfect photograph Van Dyke placed on the easel as a structurally inadequate expression of political sentimentalism, Levitt instantly recognized that Henri Cartier-Bresson had named her truth: She saw that polish and polemics were tangential to the way of seeing she was seeking, and that her way also might lie in provinces of indirection and subtlety.

During 1935, the year that Cartier-Bresson lived in New York, Levitt took no photographs. Rather she seems to have tried to absorb what the Frenchman's art represented. Once Levitt accompanied Cartier-Bresson as he worked along the waterfront in Brooklyn; on another occasion he showed her some prints and gave her one (fig. 33). Although she saw him infrequently, these contacts gave her privileged access to a new mode of photography and to surrealism, an aesthetic strategy that she thought he might have invented but in any case embodied. His work taught her three valuable lessons: that a blunt photographic record of ordinary facts could reveal the mystery and fantasy within daily life; that the poetry in such pictures turned its back on conventional value systems and notions of beauty; and that this art, which trafficked in the momentary, was not haphazard. Rather, each frame was constructed so that the content and form were coherent, indivisible, and instantaneous.

The magical condition of prosaic experience was obvious to Levitt; her ability to perceive it fueled her desire to be an artist. Unconcern with traditional codes of beauty was equally easy; with no interest in art at home, and no artistic education to overcome, she had escaped stunting

hierarchies of style or presentation. But she recognized that she must learn how to compose what she perceived in a glance into a picture that conveyed her understanding—with all its delicacy, verve, and delight intact.

Levitt therefore consciously set about becoming the responsive instrument of her eye. To absorb some elements of composition, she frequented The Museum of Modern Art, The Metropolitan Museum, and the Fifty-seventh Street galleries. She stayed with works by van Gogh, Gauguin, Cézanne, and Matisse until she grasped their structural logic; Daumier and Toulouse-Lautrec she understood immediately. She was also fascinated by sculpture but was more comfortable with the two-dimensional picture plane where activity was presented within fixed parameters and in relation to the horizon, as on a movie screen.

For a few months Levitt ushered at The Civic Repertory Theater on 14th Street, home to the unabashedly left-wing Theatre Union, which performed plays of vivid social protest. The Theatre Union's productions, like those of the Group Theatre, were based on Konstantin Stanislavski's acting methods, which replaced stylized declamation with realistic emotional involvement and whole body movement rooted in the actor's recollection of personal experience. Thus, what Levitt witnessed nightly was contemporary life convincingly re-presented through selected incidents, mimetically replayed.

Another principal absorption was foreign cinema. Having grown up with American silent films, Levitt entered adulthood with Russian and French imports. She vividly remembers a score of films as being particularly instructive. Although she saw Sergei Eisenstein's great epics, she was more excited by Dziga Vertov's *Man with a Movie Camera* (1929). While most prize the film for its dizzying technical feats, Levitt was struck by Vertov's close shots of real people moving about the city unaware of him. The French films *Zero for Conduct* (Jean Vigo, 1933) and *The Blood of a Poet* (Jean Cocteau, 1932) also entranced her—the first for the devilish schoolboys engaged in rebellious pranks that are funny, anarchic, and (in the closing slow-motion pillow fight) balletic; the second for its surprising dislocations of normal vision—as when gravity is suspended—and for the boys' bittersweet snowball

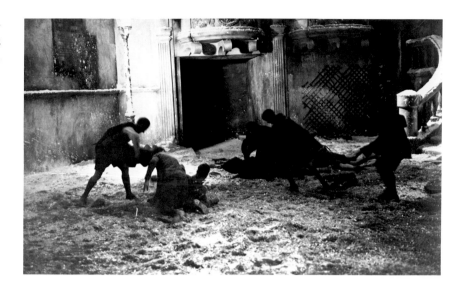

fight at the end (fig. 34).

In theater, in film, in dance, and until 1939 in politics, Russia represented to the West an avant-garde of artistic and social strategies in solution—a heady mixture of bold expressions of intensely felt experience, humanitarian aims, collective action, and the promise of a new political order responsive to the people. For those with leftist sentiments, among whom could be counted many artists and intellectuals in New York during the Depression, Hollywood's general mode of extravagant entertainment seemed as politically bankrupt as the American financial structure. To this group Russian film was a potent alternative that proposed, among other things, realistic settings, consequent motives, and innovative cinematic techniques.

Of the Russian films shown in New York in the mid-1930s, Levitt most esteemed *Man with a Movie Camera*, V. I. Pudovkin's *Mother* (1926), Nikolai Ekk's *The Road to Life* (1931), and Aleksandr Dovzhenko's *Aerograd* (1935). While she acknowledges their influence, she does not isolate the specific impact of each. *Aerograd*, a film recommended to Levitt by Cartier-Bresson, surpassed all others; she saw it half-a-dozen times.

Aerograd is a poetic film about the construction of an ideal Soviet city in Siberia. It was filmed mostly out-of-doors and had an impressive soundtrack that paralleled the imagery with an eerie, even hallucinatory auditory equivalent that lifted some passages toward visual music. Although the film moves within realistic scenery, it uncannily occupies some territory beyond or-

Figure 34.
JEAN COCTEAU
Film still from *Blood of a Poet*, 1932

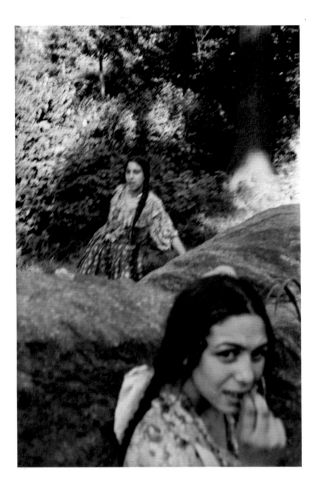

Figure 35.
HELEN LEVITT
Central Park, New York,
1936

obtrusively. Compared to the architectural photographer with a big $8 \times 10''$ view camera on a tripod or the press reporter with a bulky $4 \times 5''$ Speed Graphic, the photographer with a miniature Leica was inconspicuous.

Levitt's earliest Leica pictures show her selecting a playing field and gradually establishing the rules of her game. Her first photograph was of two Gypsy girls in Central Park (fig. 35). It was unsatisfactory, of course, but not just because it was out of focus; the idyllic setting was also wrong, for the gypsies looked less like natives than visiting tourists. Levitt left the park and began searching for neighborhoods where an indigenous population conducted life where she could see it, in the street.

Most of her early pictures depict a gritty urban stage on which the players seem small and disempowered. In one a man lies prone on the sidewalk (fig. 36) in a posture of lumpish oblivion. Above him, and at an angle to the curb that is the answer to his, stands a moving van, its dark interior empty as a tomb. Although the man only sleeps and the van awaits some household cargo, the way Levitt pairs their shapes and joins them along the curb persuades us of the finality of his dream.

Other photographs display a similarly disquieting analogy of man and habitat. In an industrial no-man's-land (fig. 37) we see a silhouette that seems to dance lightly in place like a marionette dangling on invisible strings—like the wind that wafts a plume of smoke across the lonely scene. These photographs reveal Levitt's clear-eyed recognition of death and desolation, the edge of darkness that would become the imaginative outer boundary of her work. But the desperation is not yet pushed back to the edge; it surrounds the actors and leaves them no exit.

In other early pictures Levitt catches pairs of people distinctly related to their place but only slightly related to one another. Two women frame a blank window (fig. 38): One armored in a black coat is planted before a black door; the other crouches on steps before a half-door that parallels her half-stature, its window occluded as she shields her face, its white painted moldings repeating her hands. In another two boys play in the street. One is stretched on his belly parallel with the curb; the other intersects his horizontal with a standing vertical, as the line painted in

dinary experience, as in a dream where everything is familiar but tensely charged with a higher truth. Perhaps this elliptical, imagistic film challenged Levitt to fashion her own visual poetry—to make images that move like music and apprehend within a given face value the trace of its deepest meaning.

In early 1936 Levitt purchased a second-hand Leica camera. It was not just that Cartier-Bresson used this small hand-held model and that Levitt aspired to make pictures in a similar mode; rather, in adopting this instrument Levitt accepted her own readiness to channel what she had learned into pictures. The Leica marked the end of apprenticeship; Levitt was twenty-three years old.

The camera was an offshoot of early cinema. It used the same 35-millimeter film as movie cameras, but instead of exposing multiple frames per second to render movement, it exposed single frames on command, to stop it. Small, silent, and rapid in response, the Leica could be wielded un-

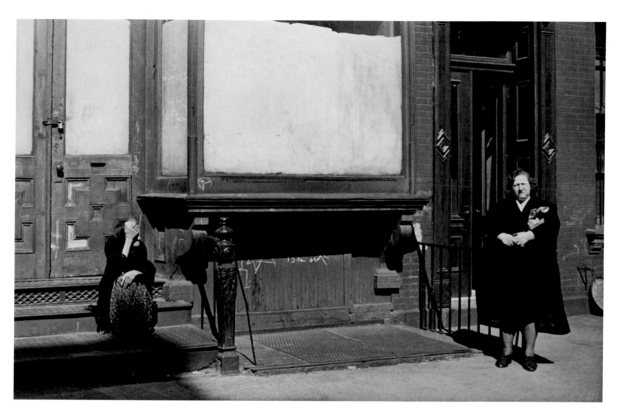

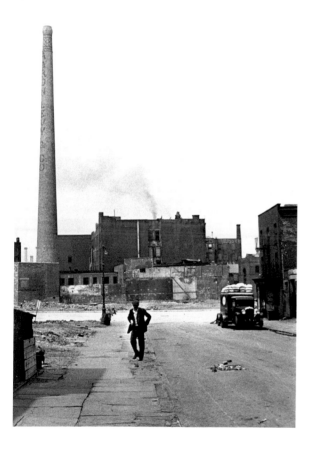

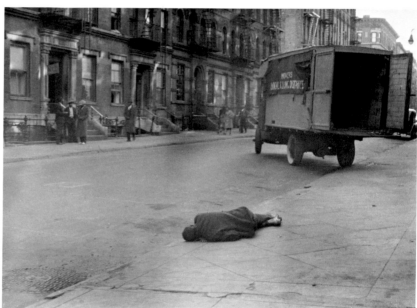

Figure 38.
HELEN LEVITT
New York, 1936

Figure 37.
HELEN LEVITT
Untitled, 1936–38

Figure 36.
HELEN LEVITT
Untitled, 1936–38

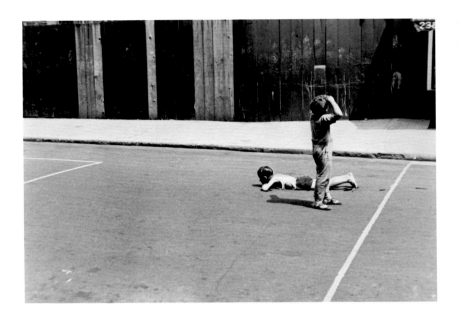

Figure 39.
HELEN LEVITT
New York, 1936

Figure 40.
HELEN LEVITT
New York, 1936

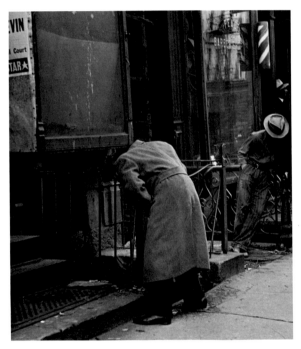

the street bisects the curb and delineates their corner (fig. 39). If these human/architectural correspondences seem too neat, this is not because they are not deft, but because in the absence of meaningful emotional ties they are forced to hold the pictures up alone, like unfleshed bones.

Either Levitt recognized the need to move closer to bring the pictures alive or she became bolder the better she knew her equipment and terrain, or both. In any case, she moved in on people, hunting for the means of describing psychology through posture. She learned to inscribe the angle of difference between derelict loiter and drunken deliverance (fig. 40), and the invisible barriers separating focused intellect from self-absorption (fig. 41). None of these photographs was to Levitt's unforgiving eye yet good enough, but if the images lacked a certain animation and generosity of spirit, they brought her to the brink of her initial goal: to frame the telling gesture.

Walking to a school in East Harlem, where she taught children art under a Federal Art Project program briefly in 1937, Levitt began studying and saving the best of the children's chalk drawings she found along the way.[2] She was delighted by the serendipity of these images as well as by their innocent whimsy, but what she found instructive was their exemplary adequacy of means. With breathtaking graphic economy the children indicated immemorial themes; the youngest did so without the abstractions and conventions of adult art but rather with a literalness inseparable from liveliness. Levitt saw that even as the relationship between the graffito and what it signifies is immediately apparent, so that essential meaning is individually characterized by linear gesture and spatial relation.

From cowboys shooting it out in plate 17 to boys playing in an empty lot in plate 34 might seem a short step, but this move from pictorial script to gestural sign language shifts the problem from the relative ease of copying a flat, unmoving picture to the daunting difficulty of making one from the fluid chaos of the urban scene. Once Levitt had accomplished the latter, documenting children's drawings seemed to her but child's play. Instead she set about recording those fleeting moments of childhood when the self is most self-forgetful and extroverted—when absorbed in play.

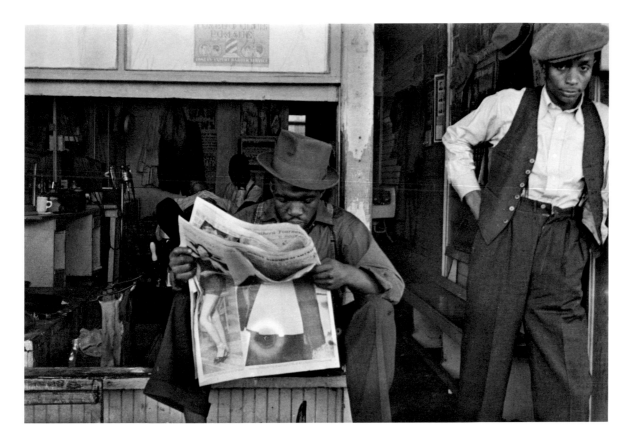

Figure 41.
HELEN LEVITT
Florida, c. 1938

It is interesting that she did not choose to depict routine or organized play such as the hopscotch, jump rope, and stickball of her youth, but rather exclusively the play of the imagination. Levitt's kids mask, climb, mime, dance, and dream—all transitional activities creating temporary worlds existing solely for the players. On stoops and sidewalks, on fire escapes and in vacant lots, she isolated the extraordinary moments when these rude places became theaters, battleships, forests, badlands. This transformation was not merely invisible but also fragile; more than one picture represents the dissolution of the charm, when the magic circle is broken by defection or the accidental intrusion of reality. Thus the wild beasts are skittery and bold in their jungle habitat but deflated and uncertain back home (pls. 6 and 5), and a broken mirror shatters illusions essential to the game (pl. 30).

Levitt makes it clear that the stuff that makes up the scene is important. She instinctively avoided streets too regular, "boring" facades, playgrounds with lines and goals. Just as she preferred games that were spontaneous and shaped by the players' fancy, so she preferred buildings with decoration—with the architect's balusters, pilasters, and cornices, the inhabitants' curtains and laundry, everyone's trash and graffiti. Her interest in the sites had nothing to do with documenting social conditions and everything to do with expressive stage scenery. If we compare a view of "slum conditions in the congested East Side and Chelsea districts of New York City" made for the Federal Art Project by Arnold Eagle and David Robbins (fig. 42) with a similar scene by Levitt (pl. 18), we see that the twelve boys on the wall in the FAP document are extras, while the centerpiece is the stage itself. In Levitt's picture the subject is a junior troupe of the commedia dell'arte, which is divided, at the moment, between buccaneering and love. The five boys own the space with their bodies, articulating its depth and height, pinning it together from right to left in an amazing simultaneous performance con brio. And, if we compare plate 34 with Ben Shahn's photograph of a similar site (fig. 43), we quickly see that Shahn's picture is about the grim physical and psychological texture of the place, while Levitt inscribes a poem about freedom. Invoking joyous frenzy, music, and paganism, she proposes this fleet, modern alternative to the three ancient graces.

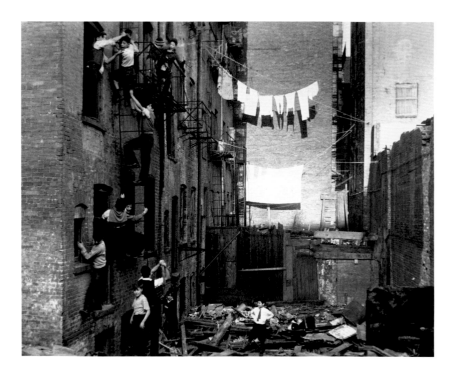

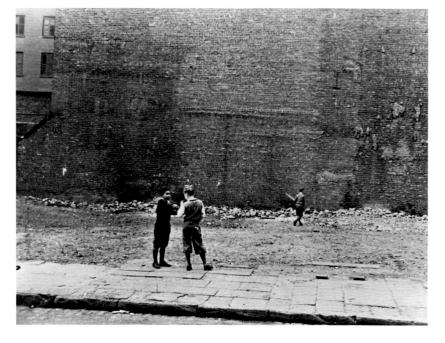

Figure 42.
**ARNOLD EAGLE
AND DAVID
ROBBINS**
Untitled (New York City),
1938, from the WPA
Federal Art Project series
One Third of a Nation

Figure 43.
BEN SHAHN
Untitled, c. 1934

Because of their unself-consciousness, children are uncommonly good subjects for the photographer who wishes to capture instinctual, unstaged response. To extend this operation beyond the parameters of play or into the world of adults requires extra discretion, almost invisibility. To this end the small camera is a boon, but even this inconspicuous instrument is a liability if one wants, as Levitt did, to photograph people, as Vertov wrote, "at a moment when they are not acting and letting the camera strip their thoughts bare."[3]

In her desire to photograph people in the street "as if they were inside," Levitt found the right-angle viewfinder a valuable device. With this attachment on her camera she could stand close to the action but appear to be shooting something a quarter of a turn away. In terms of the photograph reproduced as plate 44, for instance, Levitt would have appeared to be shooting in the direction of the boy's gaze. This technical feint alone hardly accounts for the picture. But coupled with a modesty that amounts to self-effacement and a sensitivity that obviates the conscious part of tact, it allowed Levitt an extra turn of indirection and let her look across the threshold of another's soul.

In 1938 Levitt looked up Walker Evans and showed him her photographs. The pictures he had made in Havana, published in Carlton Beals's *The Crime of Cuba* in 1933, had caught her attention. They showed that Evans had worked in the streets in somewhat the same manner as she, suggesting an artistic kinship she had not found except with Cartier-Bresson. Not only did Evans appreciate what Levitt showed him, so, too, did his friend James Agee, who dropped in during her visit.

Levitt may have learned about the angle viewfinder from Evans, for he and Shahn (who had been roommates from 1934 through 1936) had used the device. During 1938–39, when Levitt and Evans shared a darkroom, she also witnessed Evans's concern with the "correct and crucial definition of his picture borders."[4] Interpreting his notion was problematic, however, for when accompanying Evans in the subway, she saw him shoot without ever placing the camera to his eye, releasing the shutter by a cable hidden in his sleeve. The margins of these pictures were decided afterwards, on the printing easel. When

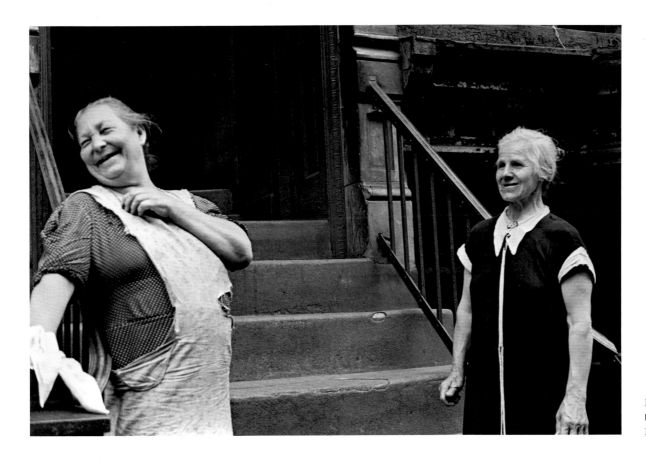

Figure 44.
HELEN LEVITT
New York, 1946

Evans worked with a view camera on a tripod he arrived at a more exact placement of the camera. Although with this method what was contained within the edges of the picture might more neatly approximate the photographer's precise idea, Evans sometimes cropped these images, too.

The drawbacks of the larger camera were its slowness and obviousness; it made anonymity virtually impossible. Levitt borrowed Evans's $4 \times 5''$ view camera, and with it made a handful of photographs (pls. 11 and 24). This instrument and a flash allowed her to work inside for the first time since her unsuccessful experiment in The Seamen's Institute. Although the photographer is partial to it, the picture of the Gypsy boy in his apartment appears staged and airless to this viewer; it is the antithesis of Levitt's uncanny ability to capture unhampered expressiveness on the wing.

Working close to Evans, and helping him with his exhibition "American Photographs" at The Museum of Modern Art in 1938, was surely valuable. It sharpened Levitt's consciousness of her distinctive vision and made her more attentive to the crop of her pictures. More important,

Evans's accomplishment, artistic stature, and web of colleagues and friends—especially James Agee and Janice Loeb—confirmed the value of her native standards of excellence. To accept their praise and become one of their group Levitt had to admit her maturity as an artist, as well as the possibility that her art might be worth their high regard.

Once Levitt's art blossomed in 1938–39 with the photographs of children playing, she made few changes in her approach. Excepting the pictures made with Evans's camera, she continued to work with the Leica in the street. The correspondences between person and surroundings that had characterized her work of 1936–38 continued to appear but were now vitalized by emotional response. The two Polish women in figure 44 echo the two women by the store window in figure 38. While their postures again rhyme with their respective places, their personalities now chime as well. The center of the picture is no longer vacant as before but filled with the one's delight at the other's mirth. Similarly, the people in plate 40 are but small silhouettes, like the marionette-man in figure 37. And while these

Figure 45.
Helen Levitt with movie
camera, 1944–45

players move on almost as bleak a stage, they are not its subjects but its citizens. Here, too, the empty space is no void; it is intangibly furnished by the couple's attention.

While Levitt's structural strategies remained fairly constant, as she entered increasingly into the psychic state of her subjects her work naturally took on more complex emotional shading. Four photographs taken in the early 1940s show Levitt treating essentially the same material—two people on a doorstep—with individuated subtlety. In plate 44, the emotional content hovers between mutual alienation (as of magnets repelling) and the intense inwardness of the self cocooned. The two people in plate 3 define a couple—a four-footed being coordinated in trust. The girls in plate 26 are interdependently enchanted, like celestial bodies perpetually circulating in each other's gravitational field. In plate 12, we see sweet humor and tenderness embracing but not quite soothing the bruised ego of adolescence. In each case the content is rendered through the same family of ingredients differently weighed. The first picture relies most on position, the second on posture, the third on drawing, and the fourth on gesture, but each utilizes all these elements to characterize affective relation.

As Levitt's work unfolded the variety of the relations she depicted broadened and the intensity of the emotions perceived deepened. If the concern of the younger boy for the older in plate 12 is touching, how much more moving is the connection revealed in plate 42, where the pain and compassion defy description other than Levitt's wordless sympathy. And though the woman with the marvelous bosom is grandly entertained in

figure 44, her joy is no match for the pealing glee of the baby in the pram (pl. 21).

In all these pictures, both those of children and adults, one has the impression that Levitt's moral and dramatic sense were in perfect equilibrium. She never took advantage of her subjects, neither ennobled nor belittled them, was not frightened or awed. Rather, standing on the same ground, she recognized them through a common language of expression. This sensitivity to others was drawn as surely from the photographer's experience of herself as from a comfortable familiarity with her place.

In 1941 Levitt went to Mexico with Agee's wife, Alma. With the exception of a couple trips to Florida to visit her parents, she had not traveled. In addition to the fact that it lay safely this side of the war that had broken out in Europe, Mexico offered exoticism, beauty, poverty, adventure, innocence—a mystique enhanced by Eisenstein's epic film *Que Viva Mexico!*[5]

The allure evaporated upon arrival, however, and Levitt worked little in Mexico. Her recollections are characteristically pointed. In the *zócalo* (the town square) of Veracruz she observed the girls walking in one circle one way, the boys in another circle the other way. This ritualized form of social behavior depressed her; it was wholly devoid of spontaneity and communicated no individual feeling. This "dance" in no way intersected the kinetic language she instinctively knew—that intrinsic language of motions and emotions that was the principal resource of her art. The youths of Veracruz were not freely improvising, shading the count, or in any way that she could see integrating their minds and feelings in movement.

In the absence of a common cultural expression, Levitt worked desultorily. On the one occasion when she found children in free play, she was not intimate with their mood (pl. 51). She saw them distanced, as from a seat in the theater too far from the stage. The emotional tenor of most of her other Mexican pictures is sentimental, pathetic, or savage (pls. 49, 50, and 52). The experience proved that this artist was not at home with her creative impulse unless, as Eudora Welty said of herself, she was "locally underfoot."

Levitt returned to New York City and has rarely left it since. She has no fear of the un-

known, only an earned respect for the natural parameters of her endowment. Within the boundaries of the familiar she knows she can find what others spend their lives traveling to seek.

Upon her return from Mexico Levitt found a job as an apprentice film cutter through her friend Janice Loeb. A painter and art historian trained at Vassar and Harvard, Loeb had lived in Europe until the war forced her home in 1939.[6] She introduced Levitt to her European acquaintances, among them André Breton, Eugène Berman, and Luis Buñuel. The latter hired Levitt, on the strength of her photographs, to help edit pro-American propaganda films he was producing to send to South America through the sponsorship of The Museum of Modern Art.

Levitt found the work interesting. The editing skills she had developed in still photography she now applied to continuity, her knowledge of film history and technique both coming into play. Within a short time she was commissioned by an independent firm to make a film about China, which she produced from stock footage. From 1944 until the armistice was declared, she worked as an assistant editor in the Film Division of the Office of War Information. On one occasion she shot some scenes around New York: at the races, at Jones Beach, in the street. Although her material was not used because the project came to a close, Levitt's footage was admired by her colleagues.

With a home movie camera belonging to Loeb, Levitt and Loeb began to shoot for their own pleasure. They found three gypsies, took them by car to a deserted stretch of marshy riverfront in the Bronx, and followed them as they gamboled, wrestled, climbed trees, parried with reeds (fig. 46). The experiment is notable primarily because it shows that the filmmakers were not concerned with directing but with following the boys' uninhibited play. On another day they worked in Yorkville during a parade. Here the camerawork is more selective, comes in close, searches out those who are mindful only of the parade. While half a dozen physiognomies are worthy of Daumier (fig. 47), rarely is the movement as compelling as the expressions, which one feels might have been captured with a Leica with more precision.

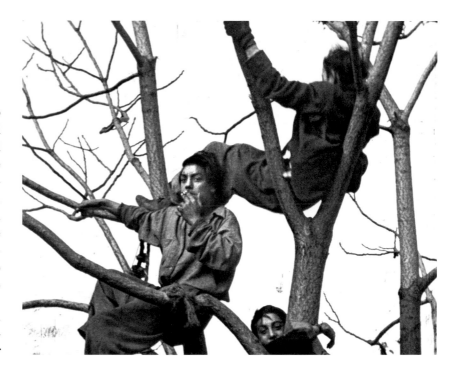

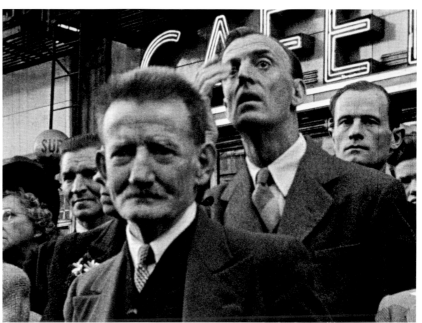

Figure 46.
**HELEN LEVITT
AND JANICE
LOEB**
Untitled detail from film
footage of three gypsy
boys, 1944–45

Figure 47.
**HELEN LEVITT
AND JANICE
LOEB**
Untitled detail from film
footage of Yorkville
parade, 1944–45

At this juncture Levitt, Loeb, and Agee decided to make a film that was a cinematic version of Levitt's photographs: not children in picturesque marshlands or flag-waving parades but children and adults moving in their normal urban environment. A film addict since youth, and the passionate reviewer of film for *Time* magazine since 1941, Agee had the notion of making a "new form of movie short roughly equivalent to the lyric poem" as early as 1937.[7] He had met Levitt at about that time and had immediately understood her work. He was assembling the photographs into a brilliant essay on her way of seeing when the idea of the film was hatched. The essay, finished in 1946, became the poetic, Jungian introduction to *A Way of Seeing*, which remained unpublished until 1965.[8] The idea became the short lyric film *In the Street*, released in 1952.

Levitt, Loeb, and Agee worked on the film intermittently in 1945–46. Agee wrote the prologue, but he actually used the camera only once or twice. Most of the film was shot in East Harlem by Levitt and Loeb, frequently working as a team. Each would reconnoiter a block, perhaps East 102nd and 103rd streets, and then meet to see if either had found an animated theater. If so, they returned to the scene of promise together and worked around each other. When they had sufficient footage, Levitt made a rough cut. After showing it to friends, they decided it required a musical track. Arthur Kleiner, a pianist who accompanied the silent films shown at The Museum of Modern Art, worked up a score.

Like Levitt's photographs, the film is not "professional," if by this is meant a smooth, technically seamless presentation. However, equally like her photographs, it captures unfettered life with such understanding, humor, and dearness, and does this so artlessly that the witty decantation seems but the natural product of native conditions. It is as if the macadam had produced this inebriating fruit. There is no trace of a director, no proscenium. *In the Street* seems to be life itself: funny, tender, without artifice, yet emotionally condensed. This little film of great affect recalls the comic shorts that Levitt best loved as a child. That Charlie Chaplin viewed it with enthusiasm and perfectly repeated the antic dance of the infant gypsy is fit accolade.[9]

While America's greatest cinematic poet and one of its best lyric poets thought the film marvelous, Levitt views *In the Street* as a good piece of work and a felicity. As she has no regard for the polish and compromises of the commercially acceptable product and draws her creativity out of a private emotional realm, she refuses to attribute her success to talent. Whereas those of a professional temper will assign their achievements to proficiency or tenacity, and those of a philosophical or religious bent may recognize a spiritual gift, Levitt tends to disclaim anything other than total involvement in the scene before her and a degree of luck.

Indeed, Levitt's modesty is wholly implicated in her art. She has never presumed to challenge authority, overturn tradition, define the next wave. She does not advance herself or play to the audience, would much prefer that this essay not be published and that the exhibition it accompanies be without fanfare. For her art does not grow in public, nor is it produced primarily for the public, but out of private need. Levitt is an amateur in the original sense: She exercises her talent for fun and from love, and because this work, or play, gives her extraordinary perceptions the gratifying luxury of longer life.

Levitt's reserve of dissatisfaction with her subsequent films lies in the compromises they represented for a self-directed amateur. Her response to her next film, *The Quiet One*, is characteristic. The film was made in 1946–47 by Loeb, Levitt, and Sidney Meyers, with commentary by Agee.[10] It tells the story of a delinquent Negro child and of his psychological and social rehabilitation at the Wiltwyck School. Financed by Loeb, directed by Meyers, and shot in Harlem and Esopus, New York, by Dick Bagley, Loeb, and Levitt, the film was partly intended as a gesture of support for the school. But in demonstrating what the school tried to do and why the children needed help, Loeb, Levitt, and Meyers also wished to make a film that would demonstrate their abilities as documentary filmmakers using their own script. *The Quiet One* won awards at the Edinburgh and Venice film festivals, and its acclaim won validity for its makers and interest in the school. Yet Levitt doesn't much like the film, apparently because the story shackled the free play of the imagination. In addition, the re-

sult was necessarily a compromise among several opinions, rather than, as in her still photographs, the delicate impression of one knowing eye. Although Levitt continued to work in film through the 1950s, she has all but disinherited this part of her work.

Levitt may prefer her still photographs to her moving ones for deeper reasons: The movies are intellectual vehicles, while the photographs are sympathetic expressions. If Levitt consciously turned to photography because she could not draw, surely she came to see that it allowed her to share her feelings without having to abstract, define, or name them. For her, the nets that caught and held the visual world were not verbal, rational, or analytical, but empathic, somatic, and instinctive. This is why Levitt's principal subject is the human figure, and why her art approaches the condition of dance. Her still photographs, not her moving pictures, most fully incarnate this condition because it is not just movement that mesmerizes Levitt but its transient epiphanies.

The photographer's interest in dance was hardly left behind in childhood; as an adult she sporadically took dancing lessons, and even attended Charles Weidman's demanding sessions in modern dance. Although she found herself incapable of choreography, she loved observing Weidman as well as an exceptionally talented fellow student, José Limón. And in the early 1940s she frequently attended classical ballet performances with Janice Loeb and her friend Paul Magriel.[11]

Although Levitt's interest in ballet was minor compared to Loeb's and Magriel's, she has no difficulty reeling off the names of the ballerinas she admired: Tatiana Riabouchinska, Tamara Toumanova, Alexandra Danilova, and, above all, Alicia Markova. The poet Edwin Denby, who wrote dance criticism for the *New York Herald Tribune*, also thought Markova the most remarkable of the prima ballerinas. He wrote of her ability to project an amplitude of emotional meaning through her self-effacing investment in a role, and of her perfect musical instinct. Comparing her exceptional rhythmic sense to that of the lindy dancers at the Savoy Ballroom, Denby noted how Markova attacked "her steps a hair's breadth before or after the beat," and exquisitely

balanced her dance phrases on neither impulse nor recovery, but on "their point of rest."[12]

Likely it was not the formal rhetoric of classical ballet that interested Levitt but those transcendent moments when the dancer's mimetic ability unleashes a sympathetic understanding in the viewer—when the dancer and the dance overstep the threshold of style and meld art into living images of real life. In her photographs Levitt worked toward that magical moment from the opposite direction. Instead of beginning with an ordered performance and waiting for it to draw a living line, Levitt started with the inchoate movement of life in the street and waited until she caught an evanescent assemblage of related movements—a naturally occurring coalescence of choreography and meaning.

Levitt rarely exposes more than one frame of any scene or incident. In view of the unrepeatable enjambment represented in plate 47, we immediately understand that the relation of the smug milkmaid to the disdainful mother-to-be, the balance of their burdens and the swing of their lifting skirts, was so brief that Levitt had time for only a single exposure. But Levitt does not work in single frames out of necessity; she works in this incisive, highly selective fashion because of who she is. The procedure accords with her discretion and her risk-taking mentality, challenging her to pinpoint the precise moment when the dance is in equipoise.

Much of the skill lies in recognizing the underlying sense of a movement or gesture instantaneously. This recognition is wrongly termed a skill, however, for it cannot be learned. It is rather a capacity we all possess but which is more or less operative in different individuals. Certain callings and avocations require the sensibility and refine it. Experienced bird-watchers and butterfly collectors can identify a species in a glance and know from the rhythm, pattern, and direction of flight something of its purpose. Levitt's sensitivity to animals, to human gesture, music, and dance are similar endowments, and all of a piece. Short-circuiting words and categories, her perceptions balance on a synaptic bridge of primal understanding, which, through continual use, is exquisitely attuned.

Another perhaps less apparent requirement of this art is an intuition of "the secret reality of

proportions in space."[13] Levitt has this gift, as well. Note how she positioned the clutch of boys dancing like bear cubs in plate 29. Waltzing elsewhere, this goofy ganglion might be only charming, but as the young couples rehearse the adult relations farther up the avenue, the meaning of the dance expands to fill the space. While the backstage for the dancing bears is appropriately broad and relatively empty, Levitt could use the near foreground just as effectively. Take, for example, the narrow channel of space that flows between the raised arm and the lamppost in plate 27; tensile as a lithe snake, it rivets attention on the gesture.

Levitt generally preferred to present a single dance phrase limpidly, as in plate 48. Because she shows us how, we instantly see that the attitudes of the four girls to the bubbles are as distinct as notes on a staff, and that as a group they are entirely consonant with the floating tune. Because Levitt made the parallelism of the upper and lower registers graphically clear, we know that the airy descant (albeit with five beats) is in perfect harmony with the melody below. Pervading this moment, an uncommon sense of wonder flows like a river in the empty street.

Levitt's intuitive pursuit of a fine poise is a personal preoccupation: It is a way of crystallizing life. Because her subjects are largely poor, her disinterested purpose has been mistaken for social cause. But this artist is not working toward political ends; she is elucidating the collective and personal conditions that constitute existential truths. If Levitt's accent is streetwise and saucy, if she takes humor as seriously as distress and prefers the vernacular to the fashionable, her goal is not unlike T. S. Eliot's focus on "the still point of the turning world."[14]

After more than a decade of working in film, Levitt returned to still photography in 1959, this time in color. She received a Guggenheim Fellowship to support her new endeavor that year, and it was renewed in 1960. With the exception of a handful of images, her early color work was stolen in the late 1960s by a burglar, who could only have been dismayed by the uselessness of his booty. Happily, the color photographs from the 1970s still exist. In the 1980s Levitt returned to black and white, temporarily dissuaded from color by laboratory costs as well as by the infinitely various errors of another's interpretations of hue and intensity. Today she works in either mode.

Levitt's later photographs are variations on the themes of the early period. She found that her former haunts in East Harlem were mostly altered and so turned to other neighborhoods, such as the East Village, the Lower East Side, and the garment district, where she hoped to find the unguarded response that is the lifeline of her art. More elderly persons appear in the late work and, although the rhythms of movement could still be sprightly (pl. 84), many of the pictures are slower, more settled. Levitt, who reached nominal retirement age in 1978, also had slowed down.

She turned to color to edge closer to the illusion of presenting reality itself on paper. As the black-and-white process reduces all colors to the gray scale, it is an inherently nonrealistic graphic abstraction. Working in color, the photographer not only must transcribe the scene into a flat pattern whose structure makes the content legible, he or she also must make the chance colors of the subject matter contribute to the same expressive end. Many photographers find it difficult to juggle the extra variable of color, and quite a few drop one of the balls, often mistaking the color palette for their subject. Levitt is not interested in color for its own sake, nor, in fact, even in beauty, but in the life around her. Perhaps it is because of her clarity on this point that her color work is exceptional. She is not distracted by a red shirt or seduced by an apricot wall; they are simply part of her experience of the world.

Because she considers color but a natural aspect of her material, there is no characteristic Levitt coloration. She works with the whole spectrum, including black, and her intensities run the gamut from pale tints to vivid saturations. Similarly, there is no symbolism or consistent emotional pitch for any single color; they are variably construed.

Homogeneous rock-pigeon hues of gray, cream, and beige in plate 68 give the old woman's choice of ledge an organic rightness. Slight touches of color in an otherwise monochromatic scene, such as the amber beer and the green curtain in plate 74, become satisfying events. Like bits of slang in a proper poem, these inadvertant

notes clinch the authenticity of the elegance. A thin gash of carmine in a predominantly black-and-white picture (pl. 77) has the sharp sting of a slap in the face; the red of the chickens' crests is impertinent (pl. 82); the violent vermilion in plate 78 further bloodies the scene. The black of the woman's coat in plate 79 is ominous; the rose and gold in plate 67 is sumptuous enough for a queen. Leggings of purple and garnet turn garment workers into Shakespearean knaves (pl. 72), the green glow of a television in its recess is as cool as a shaded pond (pl. 69), and the pink, blue, and yellow hues of Tiepolo's ceilings (pl. 84) make dancing cherubim of the playing children. That these pictures do not translate well in black and white is not surprising, for they are not graphic compositions overlain with local color but amazing vessels that hold color, subject, and form in solution. Their full significance can be appreciated only in the full brew.

Levitt's recent photographs have caused her to re-evaluate her early work. In addition, teaching at Pratt Institute in the mid-1970s brought her into contact with a younger generation of photographers. Whereas the first important books of photographs for her were Evans's *The Crime of Cuba* (1933) and *American Photographs* (1938), her younger colleagues treasured Cartier-Bresson's *The Decisive Moment* (1952) and Robert Frank's *The Americans* (1959). These books encouraged their belief in the sanctity of 35-millimeter vision. It required not only hair-trigger reflexes and incisive seeing but also an acceptance of anomalous events and incomplete descriptions within a given frame. As such elements seemed to make the complexity of life (and of the art that seized it) more visible, this generation tended to print the entire negative.

In the 1930s and 1940s, Levitt had worked with a rather more flexible notion. While she adopted the 35-millimeter camera, she worked out her own rules as she learned to use the instrument. Like Evans, she wielded it rather freely, netting the substance of her image within the camera's rectangular frame. Sometimes the whole image was coherent, but as often as not Levitt decided the exact content of her picture afterwards, in the crop. In this way she sheared her images of extraneous elements, refined their expression, concentrated their impact. The first edition of *A Way of Seeing* largely reflects the way

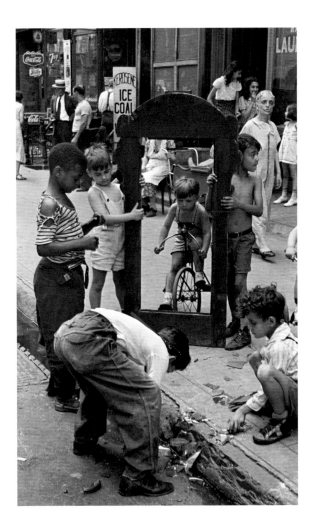

Figure 48.
HELEN LEVITT
New York, c. 1940

she configured her pictures in the mid-1940s, just as *American Photographs* displays the version of Evans's photographs that he believed, in 1938, to hold their most cogent truths.[15]

Today Levitt prefers to use the whole negative, or something approximating its original fullness. In her recent work, she frames to the edge and, in reprinting earlier pictures, she enjoys replenishing what she now conceives as their spareness, with a greater ambiguity of context. She also prints larger, lighter, and with less contrast. For instance, the version of "Broken Mirror" reproduced as figure 48 represents one of Levitt's original conclusions, while plate 30 represents her current preference. In the latter she enjoys the shoe repair sign and the way it tops off and complements the shoe in the bottom third of the picture. She also likes the way the chaos at the right and left borders emphasizes the coalescence of the drama in the center. The earlier version she now believes to be too reductive, as if

its focus on the central scene and ghostly sleep-walker were a form of outright stage direction and its crop a mutilation of the viable life at the picture's edges.

Levitt would prefer that all the prints in the accompanying exhibition be recent, that they demonstrate her current notions of the best crop and tonal range. However, when possible, we have included certain of the early prints that represent to our eyes better-knit pictures in which the proportions of the figures to the space, the tonal scale, and the print color have an undeniable integrity, rightness, and mystery.

Levitt's shift in judgment draws on long study of the pictures and of what they conceal and reveal. If perfection once seemed concision and suggestiveness, and now requires completeness and clarity, perhaps this represents not only her present mastery but also her habitual gamesmanship reemerging; she may be changing the stakes to advance a new game. "I don't like to say the same thing twice to the same audience," Flannery O'Connor wrote, "and I have found, over the years, that on subjects like this, a slight shift in emphasis may produce an entirely different version, without endangering the truth of the previous one."[16]

One evening in the summer of 1990, I visited Helen in her tidy apartment four flights above a Greenwich Village street. She had just quit the darkroom, which is set up permanently in her bathroom, after a long day of trying out yet another brand of paper. She was only half-satisfied with the results and lamented the old papers with their high silver content and reliable consistency. She was nonetheless pleased, having made new sense from old negatives.

The subject of music came up. She was always more musical than visual, she said, and after reminiscing about the jazz of her youth, she surprised me by pulling out a stack of 45 rpm "singles" from the 1960s by James Brown, Ray Charles, Sam Cooke, Aretha Franklin, The Temptations, and others. My enthusiasm was no match for Helen's; I recalled the words, but she was an antenna receiving the emotional messages moving in the music. Not only was she swaying by the record player (as I sat), but she was also editing these already brief songs. Scarcely a record did she allow to play through. In one, she liked the introductory bars; in another, a witty phrase; in a third, an unexpected syncopation. I had never before seen anyone crop a record.

On my way home I pondered, again, why Levitt's pictures are not touchstones for everyone but for only a few. Perhaps it is because they look like ordinary life and we haven't eyes to see even that clearly. As her photographs catch the essence without flamboyance, and as what they fix is as transient as the flickering images in our minds, we pass by the pictures as we survive the constant draining away of the reality we have just lived. If they are not easy because they remind us of what we refuse to acknowledge we have lost, they are valuable in the same degree: They restore our humanity.

Levitt is not concerned with the popularity of her work now, nor has she ever been. She knows that what separates her from others is what makes her an artist, and, circularly, that what brings her into closest intimacy with them is her art. If the photographs, not the relations, are the point, then they will prevail, for while born of Helen Levitt, they no longer depend on her, much less on any version of her story. As Marianne Moore said, "That which is able to change the heart proves itself."

NOTES

1. Probably she had seen Henri Cartier-Bresson's work, together with photographs by Walker Evans and Manuel Alvarez Bravo, in an exhibition at the Julien Levy Gallery in April–May, 1935. Levitt thinks it unlikely that she would have seen Cartier-Bresson's first exhibition two years earlier at the same gallery.

2. Levitt's involvement with the Federal Art Project was tangential and did not lead to solidarity with the other photographers on the project nor identification with the agency or its goals. After teaching for a brief period, she then independently produced approximately 160 photographs of children's chalk drawings as a self-directed "Creative Assignment." The prints, transferred from the Library of Congress in the late 1950s, are in the Still Pictures Branch of the National Archives, record group 69.

3. Dziga Vertov, "Fragments," cited in M. Ali Issari and Doris A. Paul, *What Is Cinema Verité?* (Metuchen, New Jersey, and London: The Scarecrow Press, 1979), p. 25.

4. Walker Evans, "Photography," *Quality: Its Image in the Arts*, Louis Kronenberger, ed. (New York: Atheneum, 1969), pp. 169–70.

5. The film, intended as four episodes, was not edited by Eisenstein. Levitt saw one episode, *Thunder over Mexico*, edited by Sol Lesser, which was released in 1933.

6. In Paris Loeb had assisted Alfred and Margaret Barr with their work on The Museum of Modern Art's exhibition "Fantastic Art, Dada, Surrealism." Visiting New York in 1937, Loeb met Walker Evans, whose work was included in the exhibition. When she returned to New York in 1939, Loeb met Levitt through Evans and became her fast friend.

7. "Plans for Work: October 1937" (submitted by James Agee with his application for a Guggenheim Fellowhip) in *The Collected Short Prose of James Agee*, Robert Fitzgerald, ed. (Boston: Houghton Mifflin Co., 1968), p. 132.

8. The book was under consideration for publication in 1948 at Reynal and Hitchcock, but a principal partner in the firm died, and the project was shelved. Levitt did not pursue the project further until a friend of Loeb's asked to see it.

9. When the next film Levitt worked on, *The Quiet One*, was nominated for the second time for an Academy Award in 1949, Loeb, Agee, Meyers, and William Levitt, Helen's younger brother (who had joined the filmmakers to market and distribute their work), went to Hollywood. They showed *In the Street* to Chaplin at that time. Both Loeb and Bill Levitt recounted Chaplin's admiration and his mimicry of the dance.

10. Dick Bagley was the chief cameraman, Ulysses Kaye wrote the score, and Gary Merrill spoke Agee's commentary. The film was made with both trained and untrained actors.

11. A student of ballet under Michel Fokine, Magriel was assisting Lincoln Kirstein with The Museum of Modern Art's Dance Archives when he met Loeb around 1940. His enthusiasm for and deep knowledge of classical ballet infected Loeb and Levitt, who accompanied Magriel to numerous performances of George Balanchine's American Ballet and Ballet Theatre.

12. Edwin Denby, *Dance Writings* (New York: Alfred A. Knopf, 1986), pp. 84, 105–6, 147.

13. The phrase is Denby's. Op. cit., p. 69.

14. From T. S. Eliot, "Burnt Norton," *Four Quartets* (New York: Harcourt, Brace and World, Inc., 1943), p. 15.

15. Although Levitt's early prints correspond closely with the plates in the book, she remembers being dismayed that the photographs were sometimes "bled" at the edges, which changed the frame.

16. Flannery O'Connor, "The Regional Writer," *Mystery and Manners*, Sally and Robert Fitzgerald, eds. (New York: Farrar, Straus, and Giroux, 1961, 1989), p. 52.

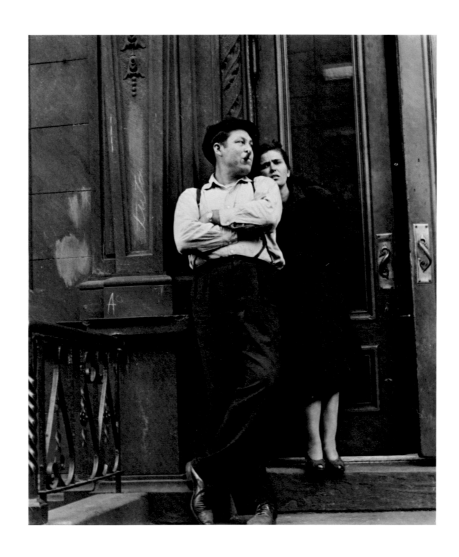

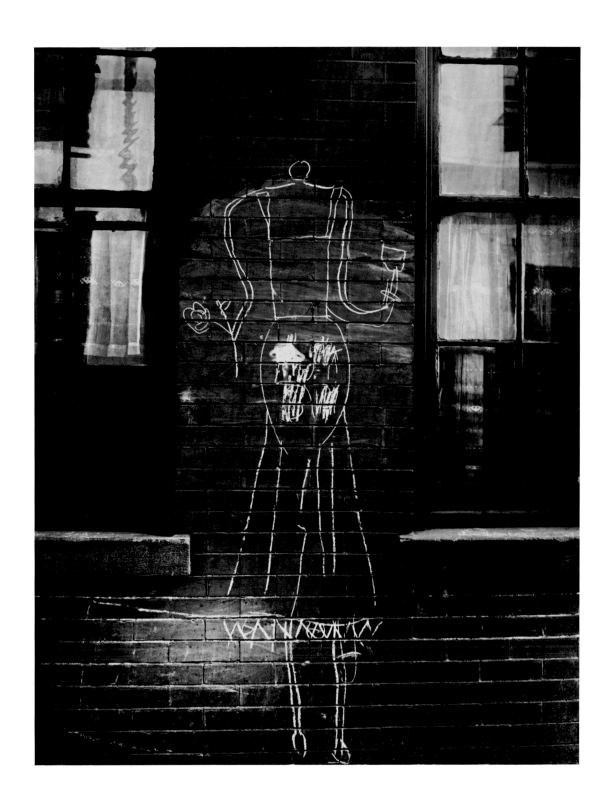

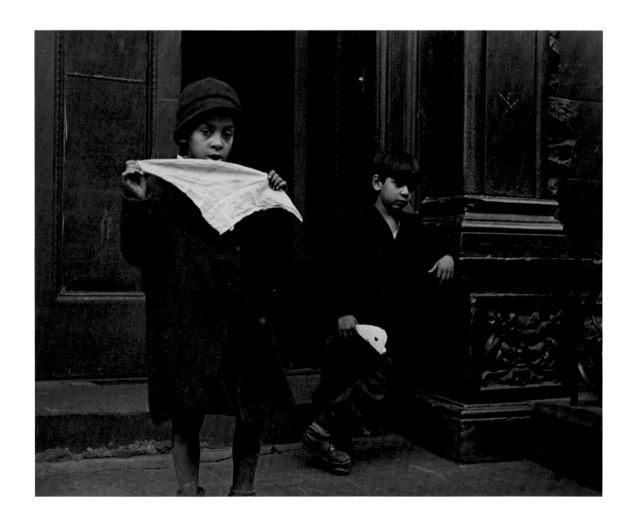

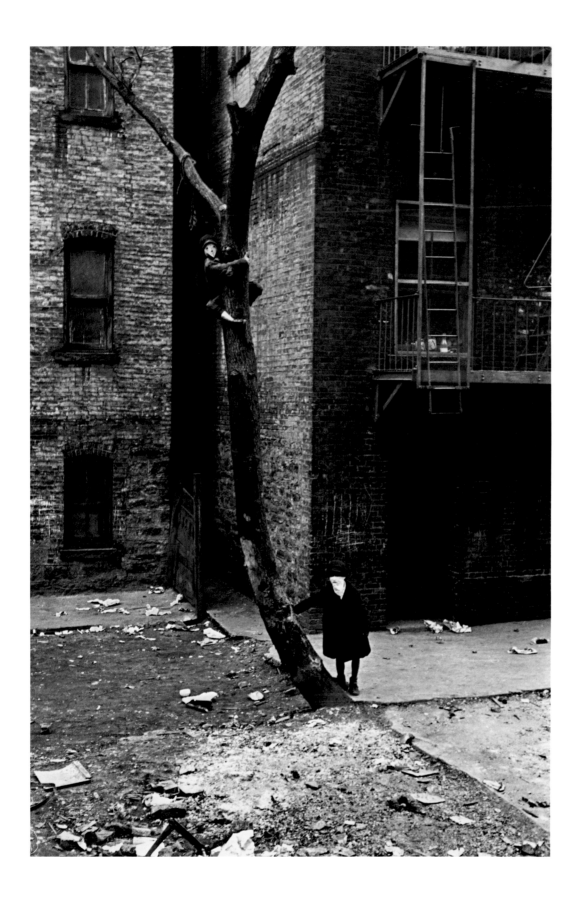

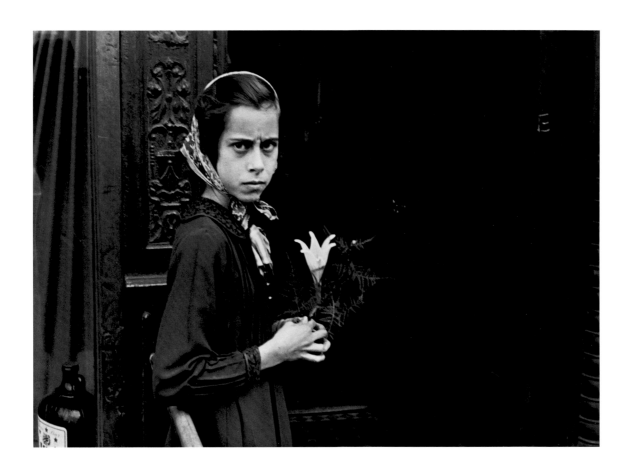

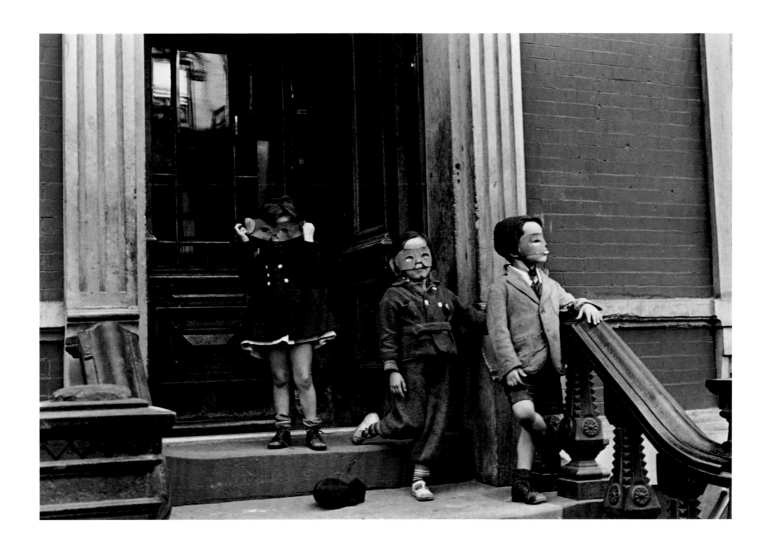

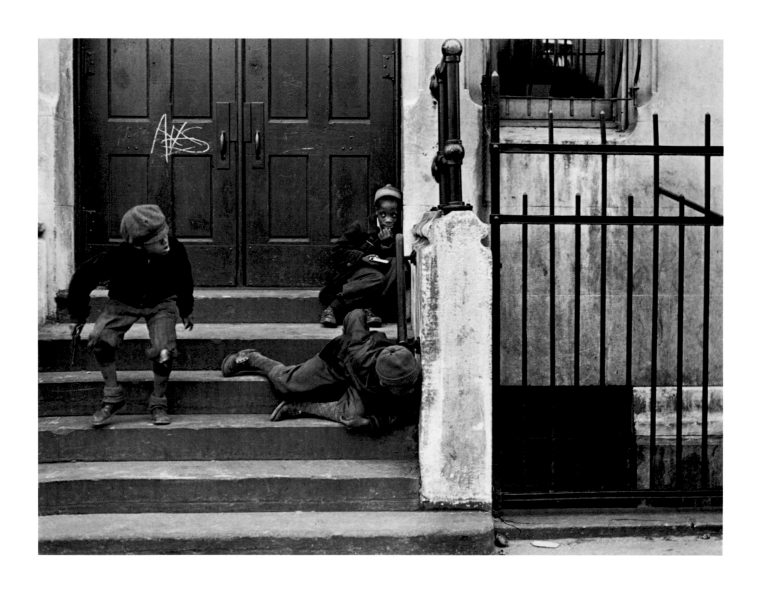

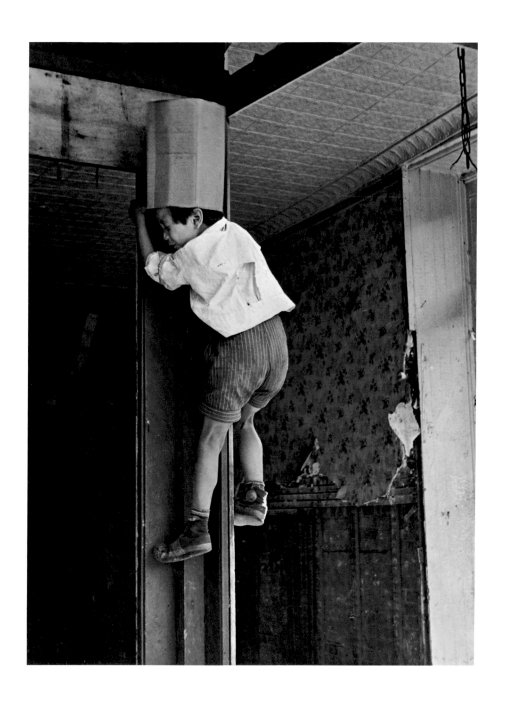

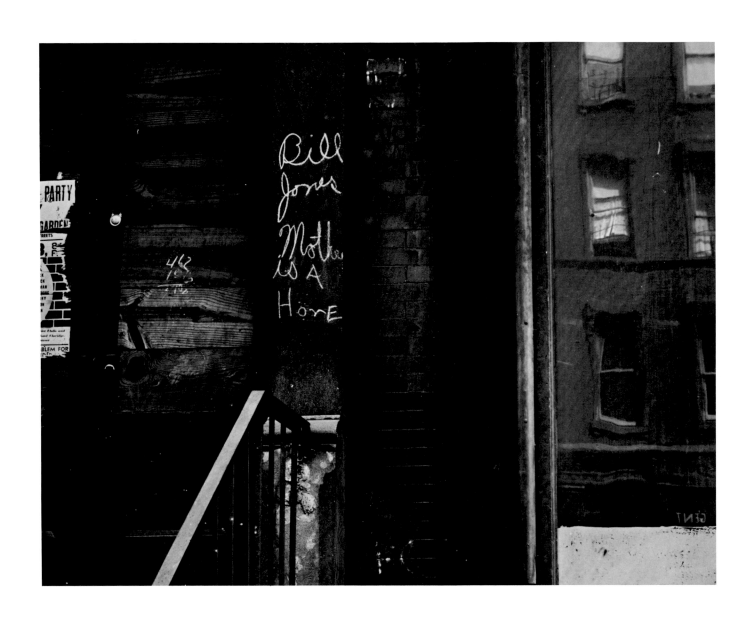

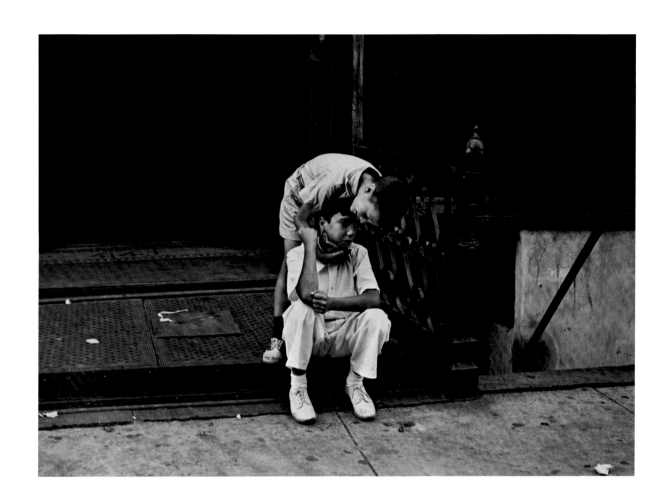

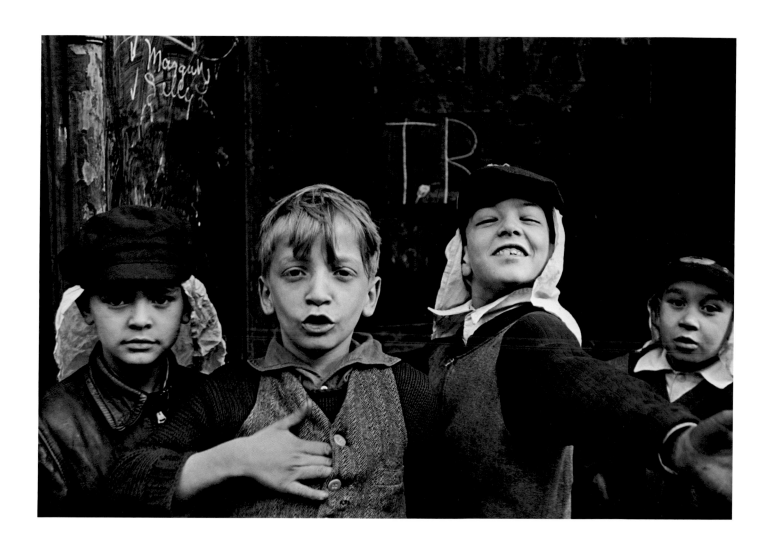

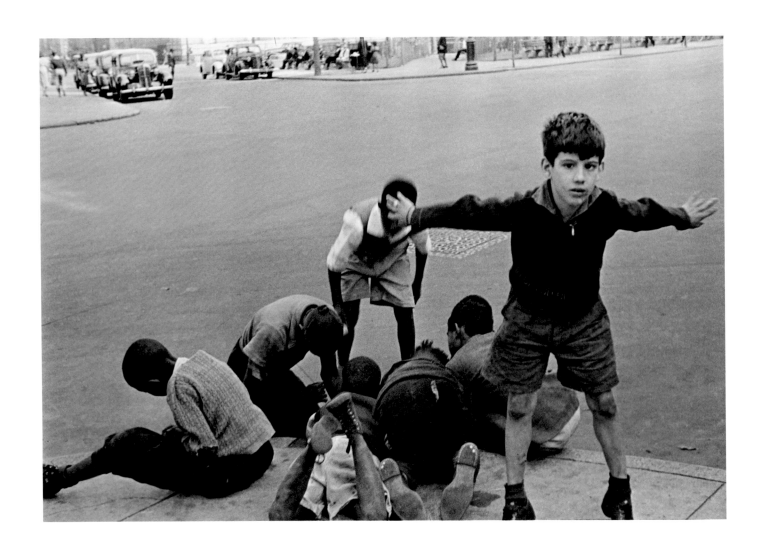

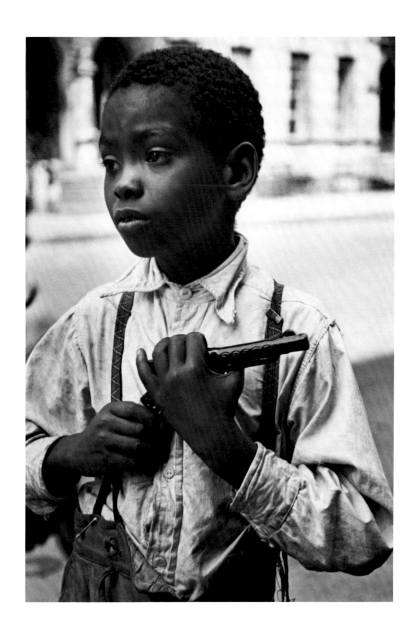

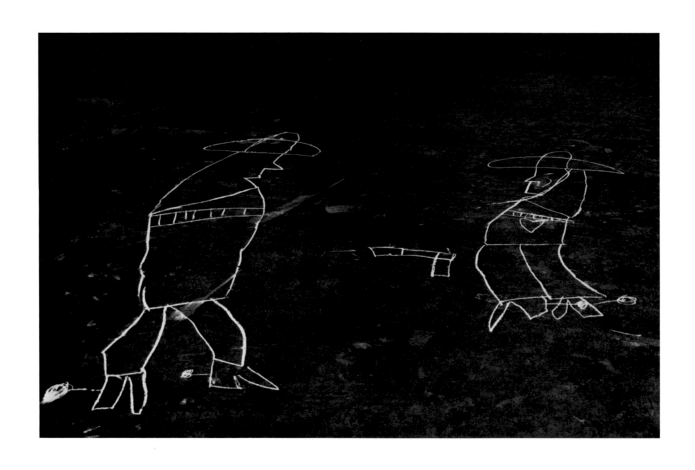

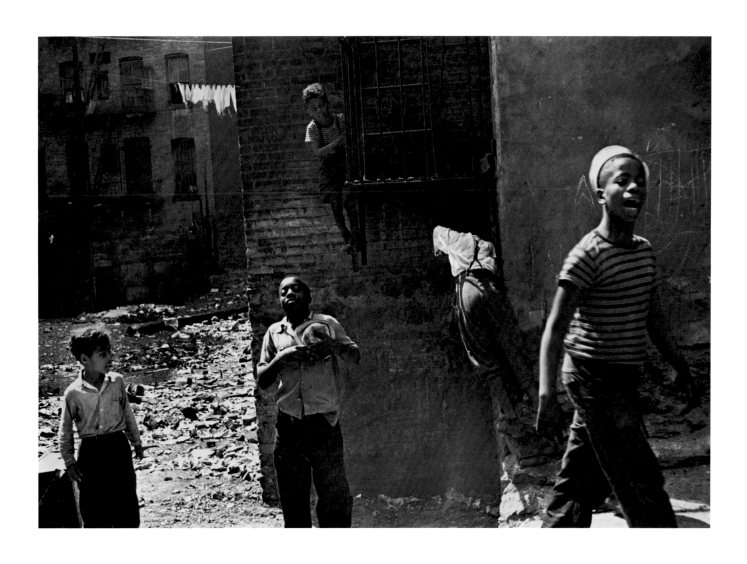

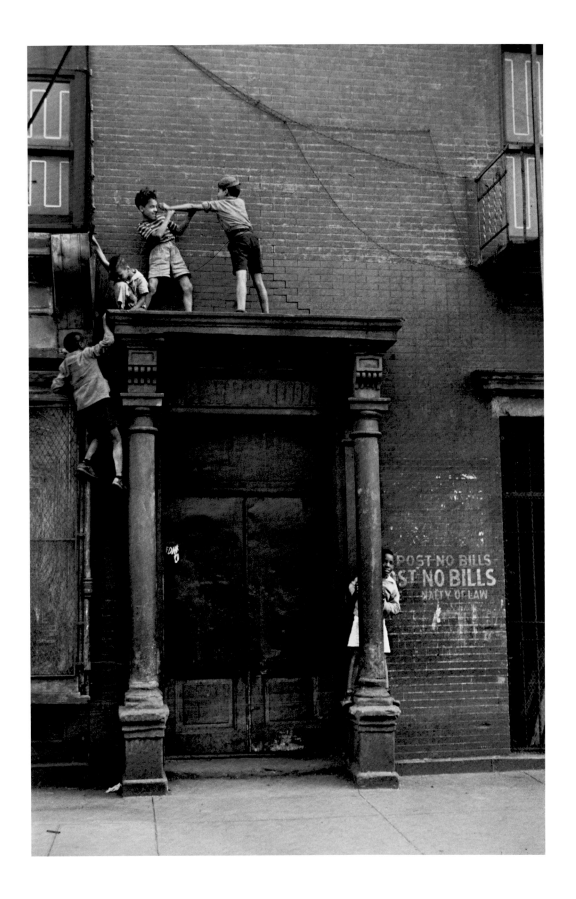

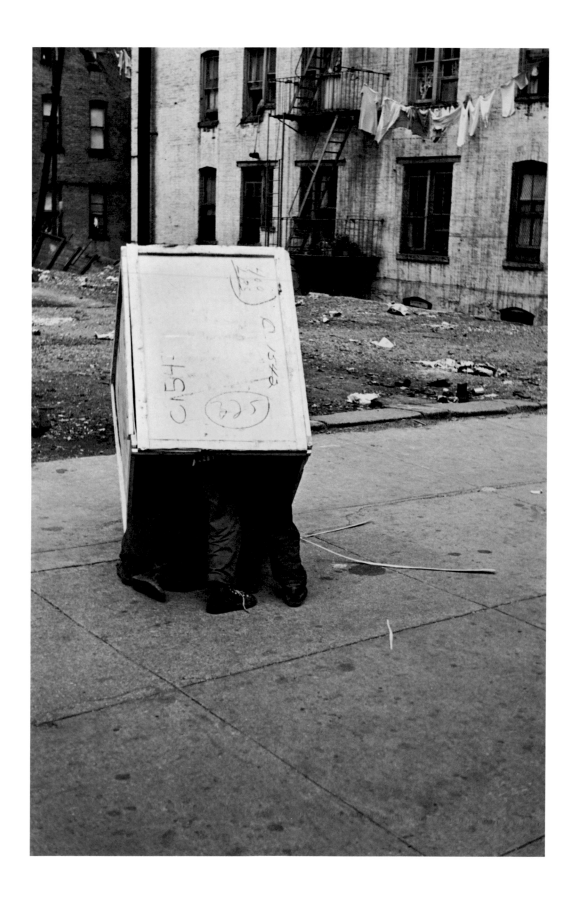

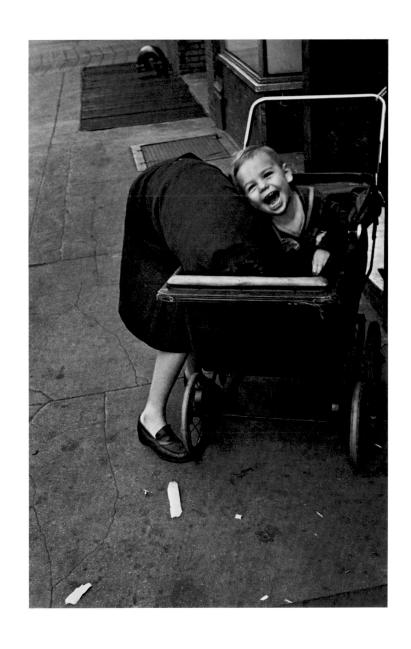

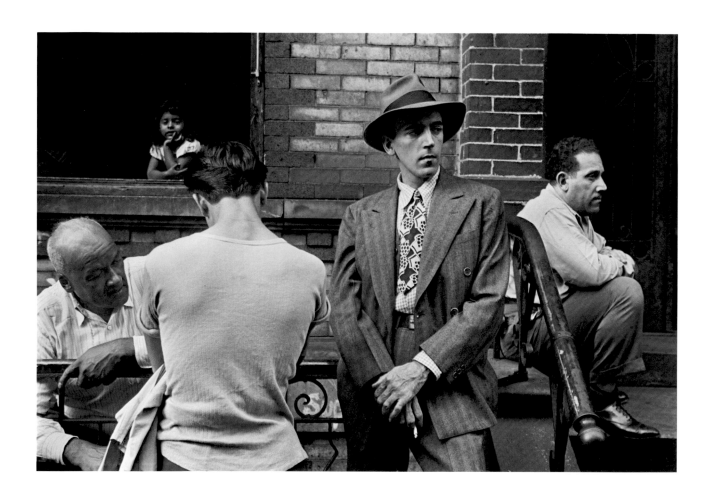

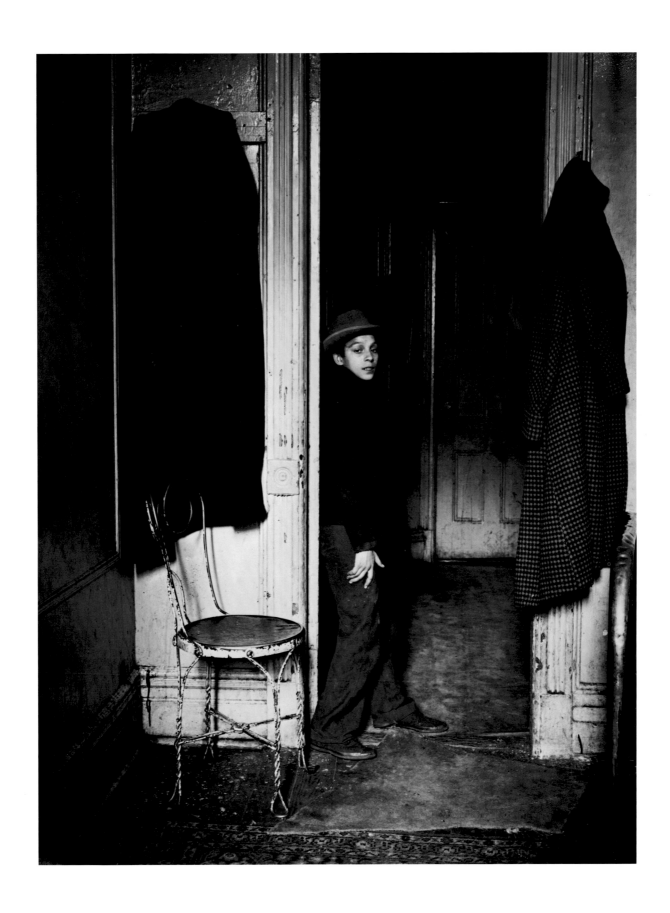

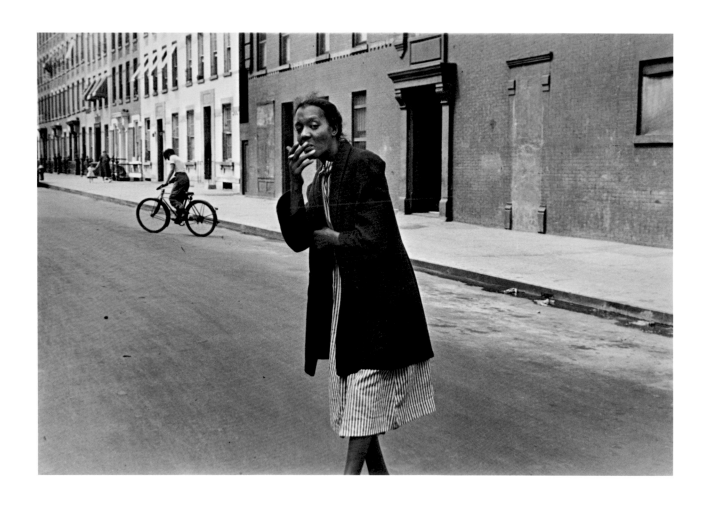

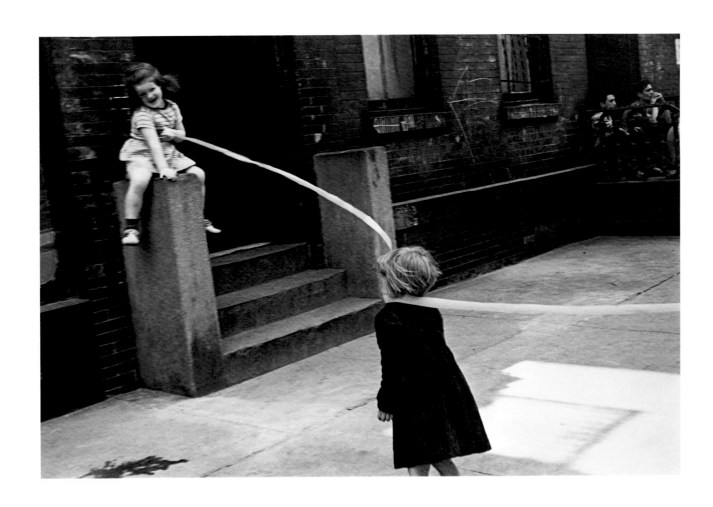

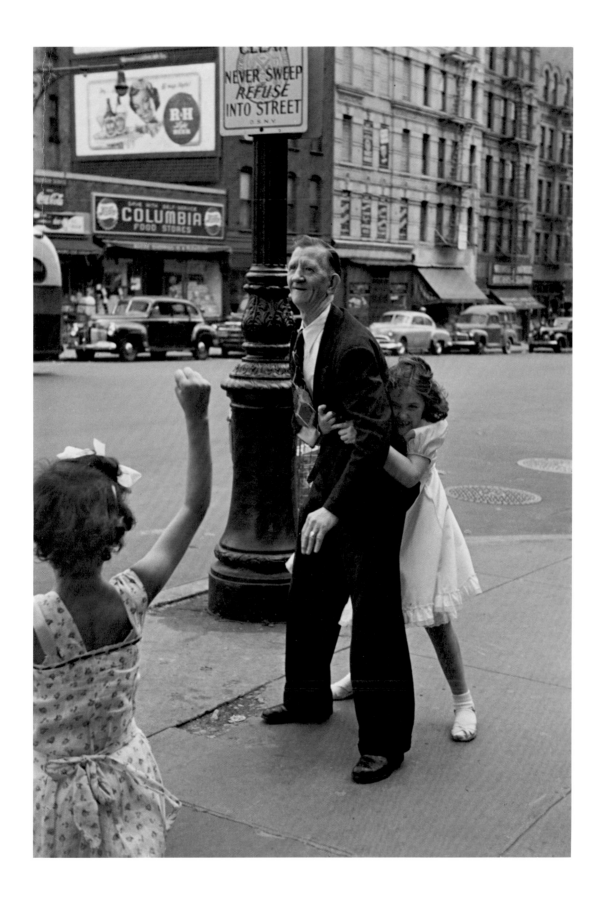

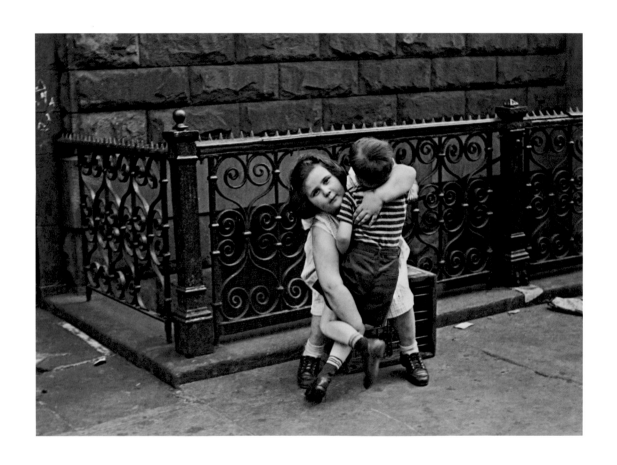

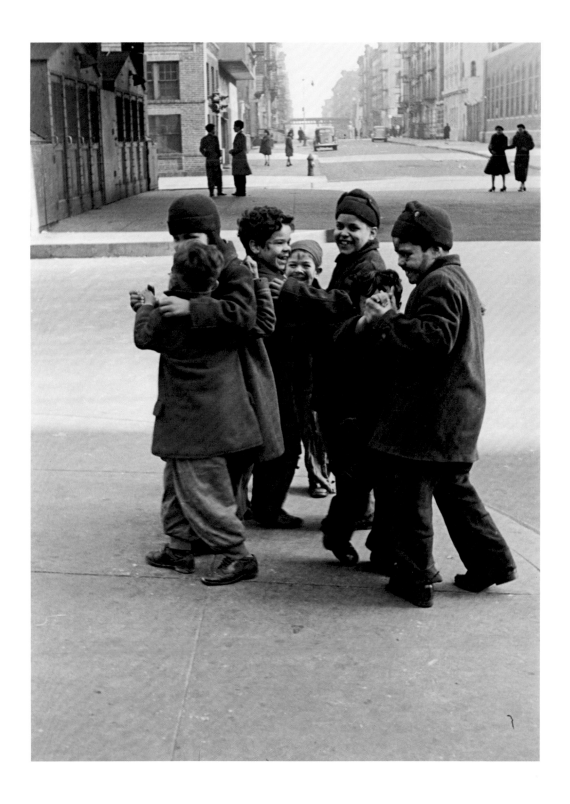

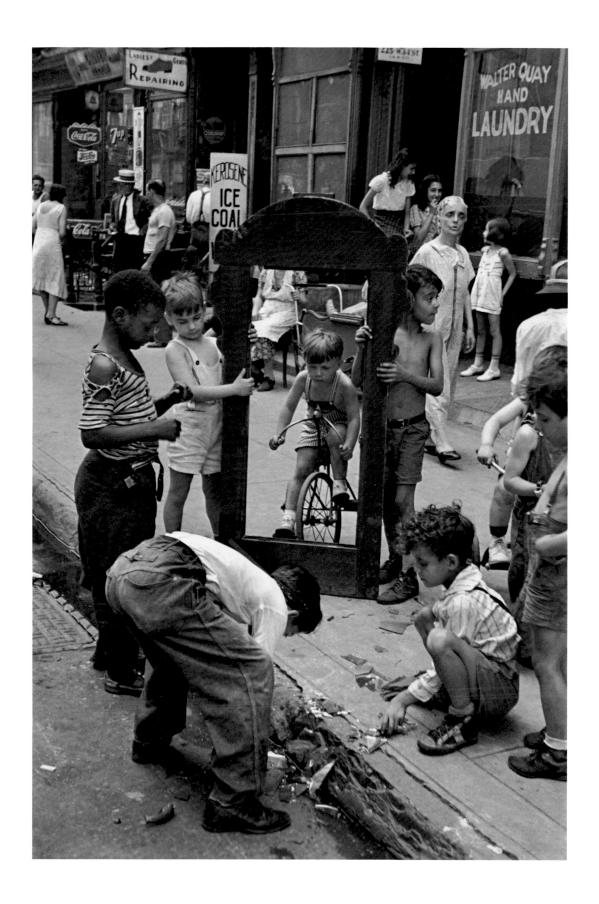

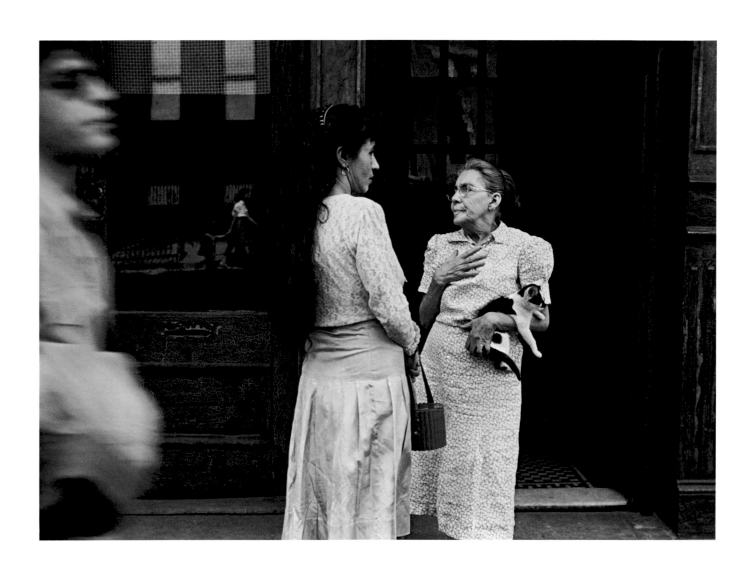

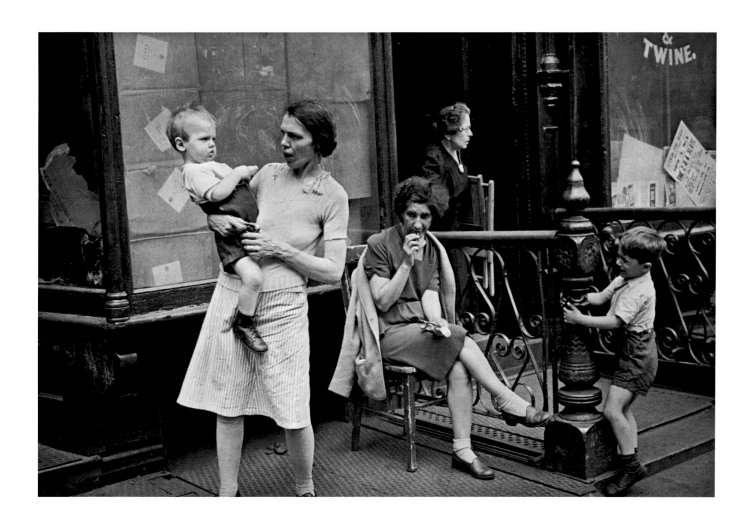

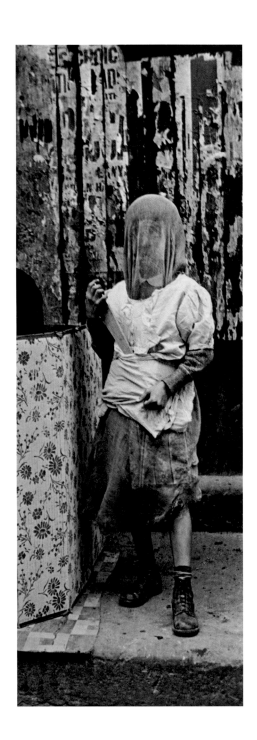

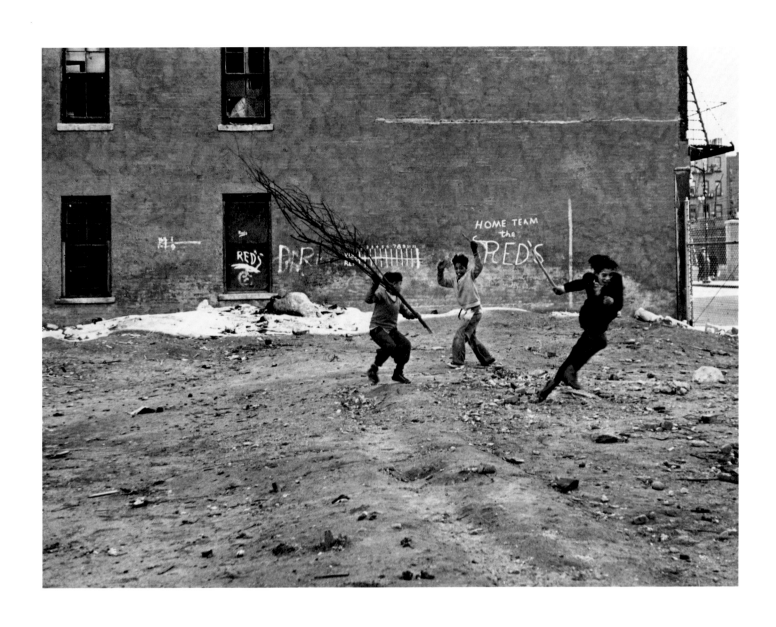

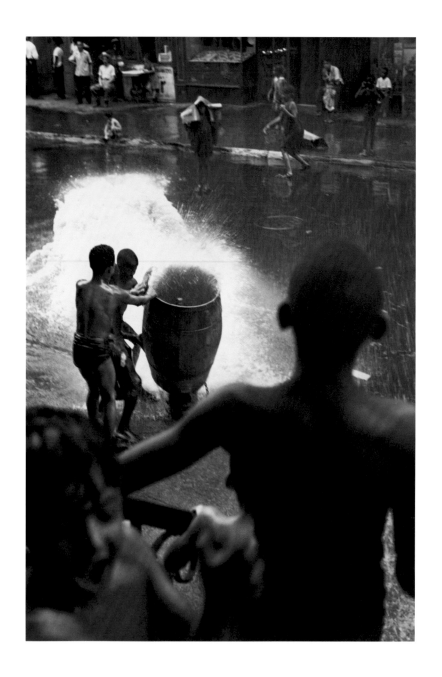

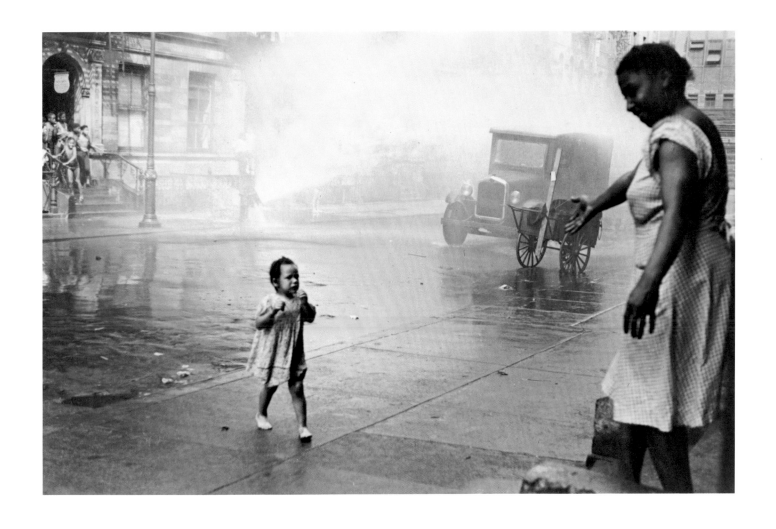

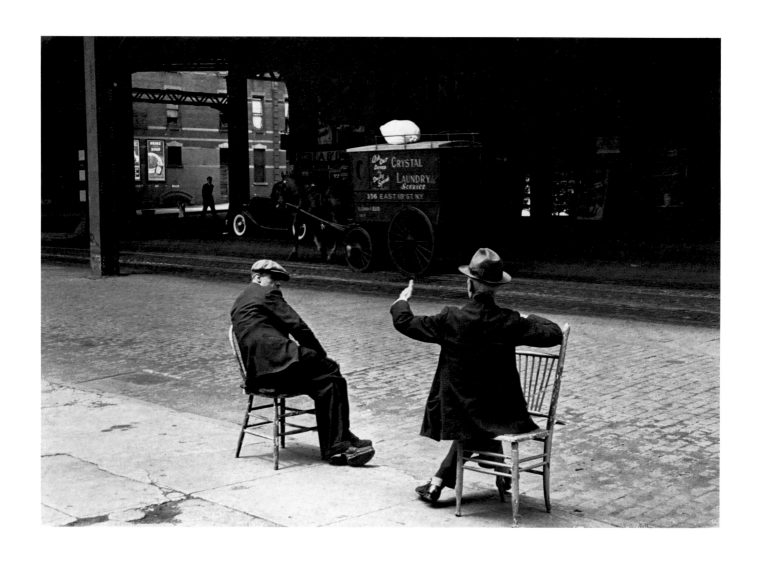

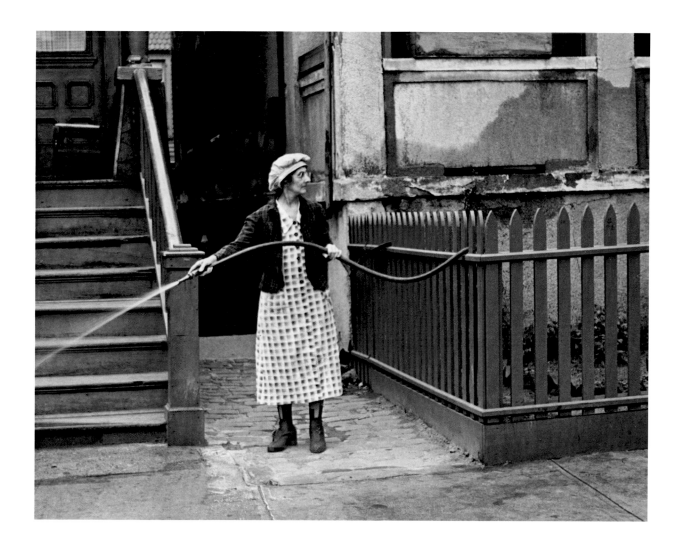

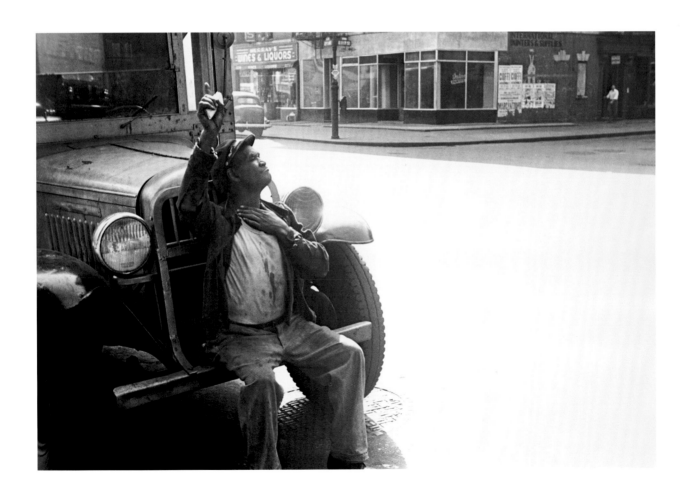

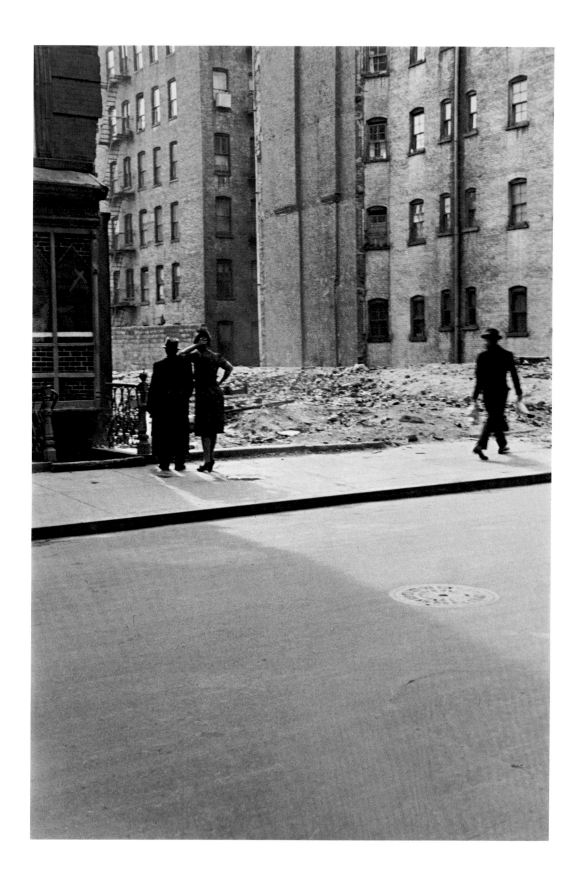

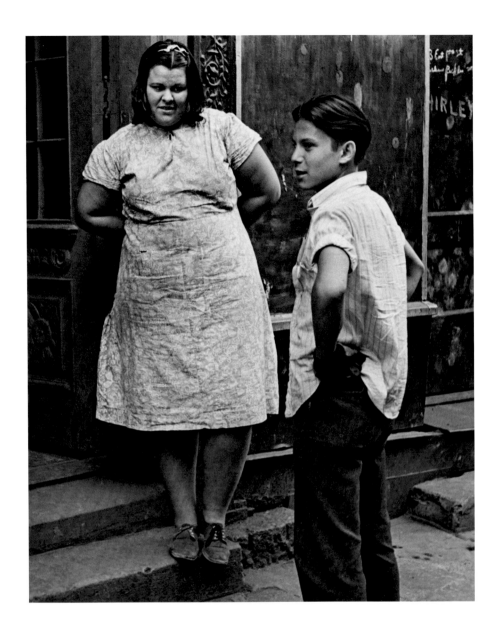

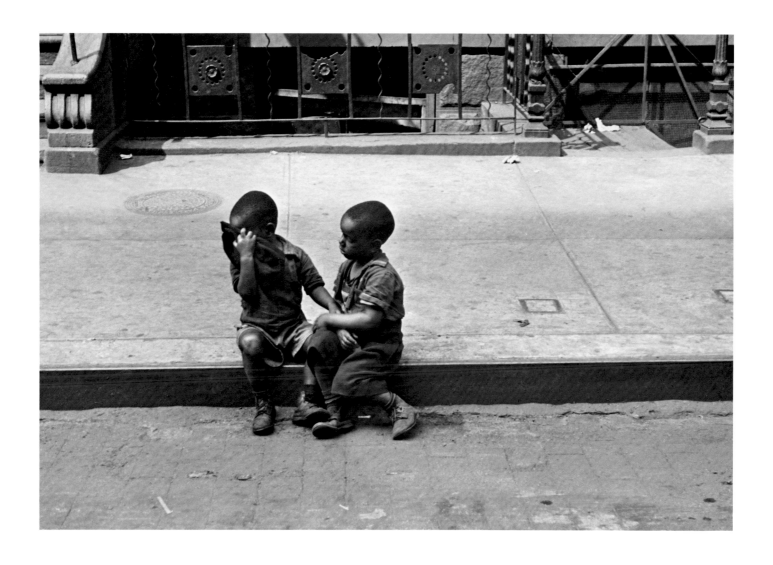

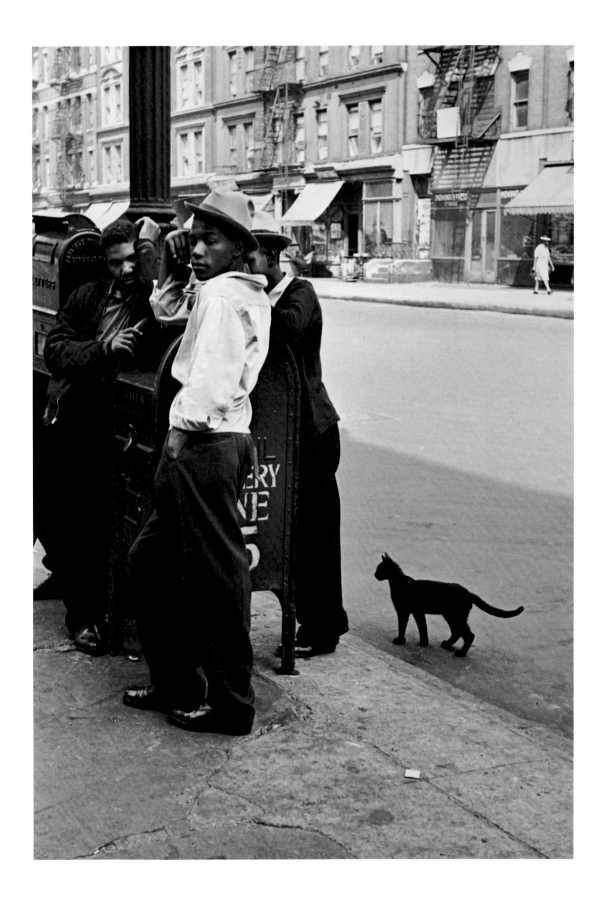

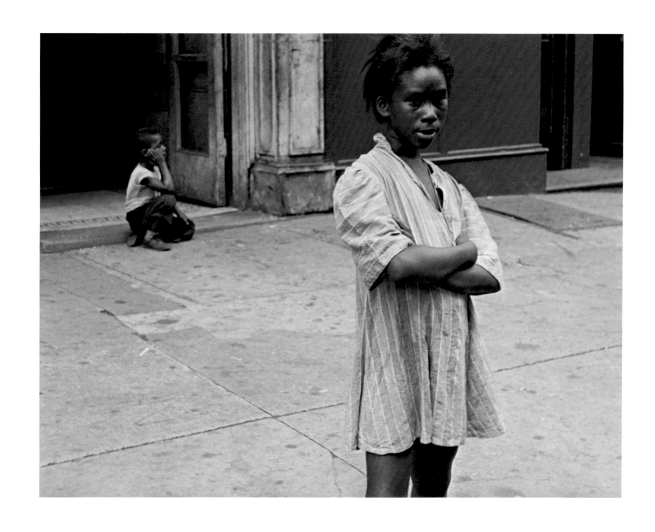

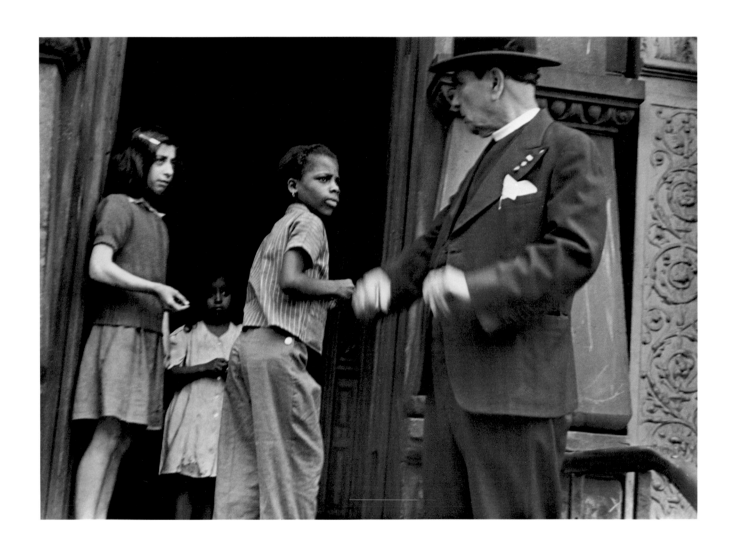

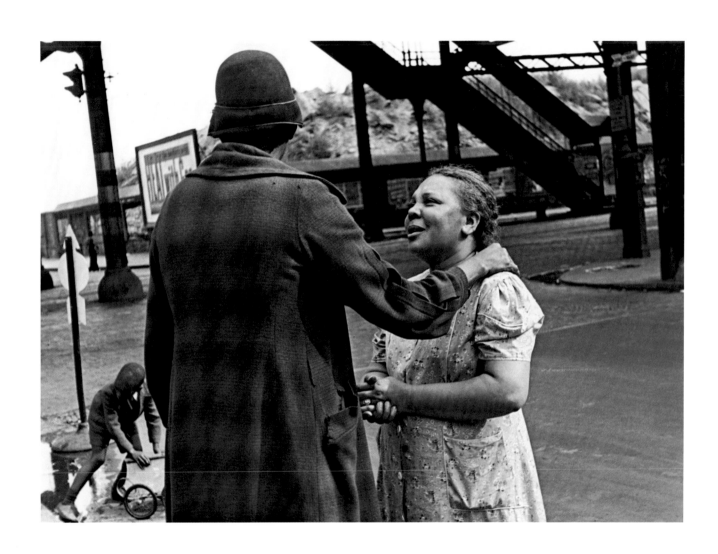

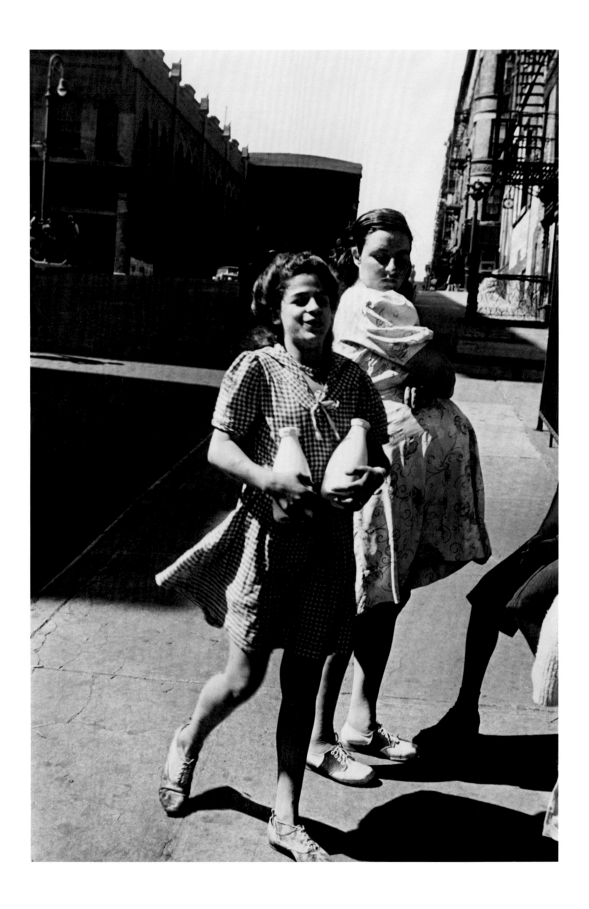

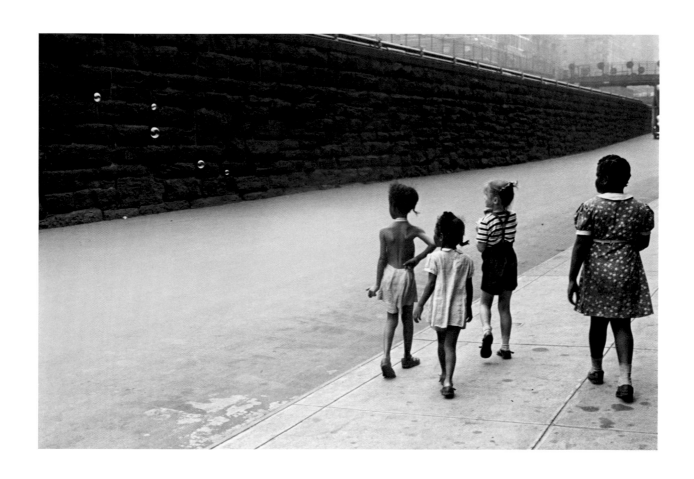

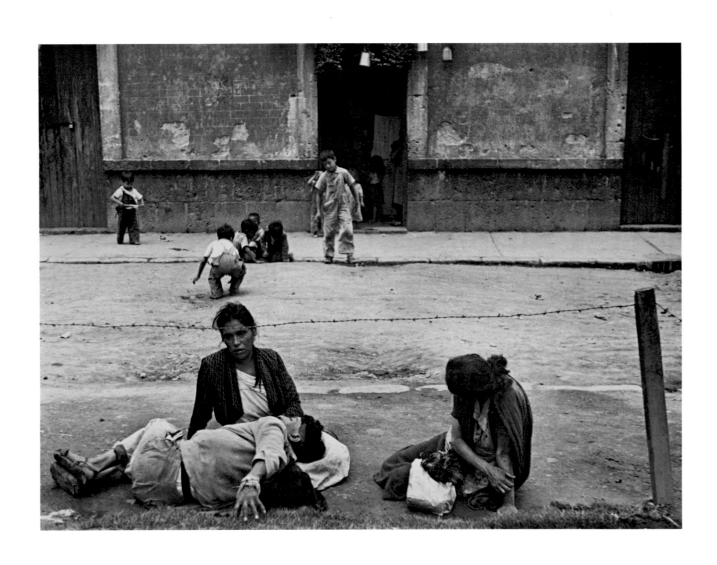

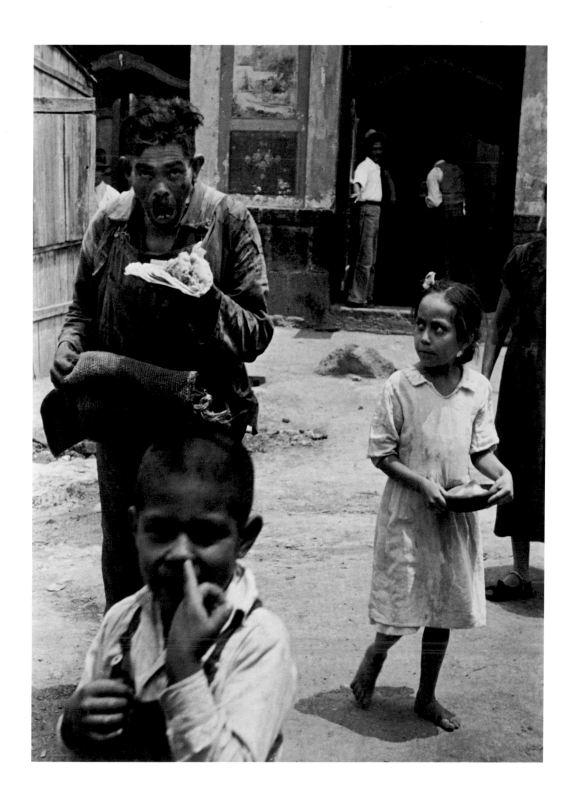

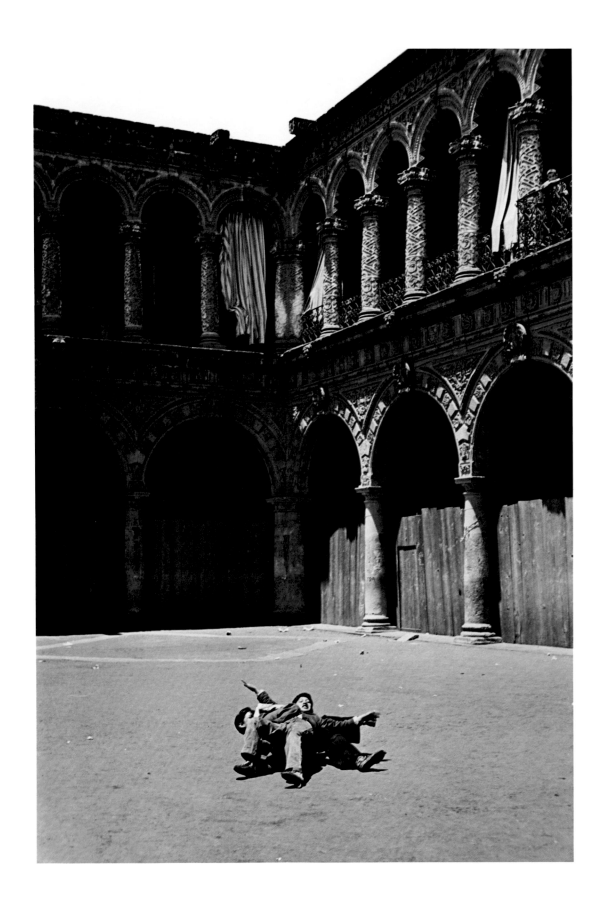

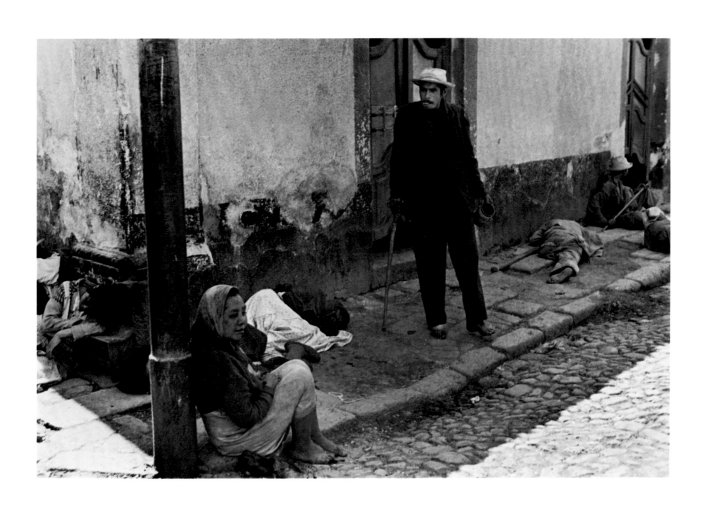

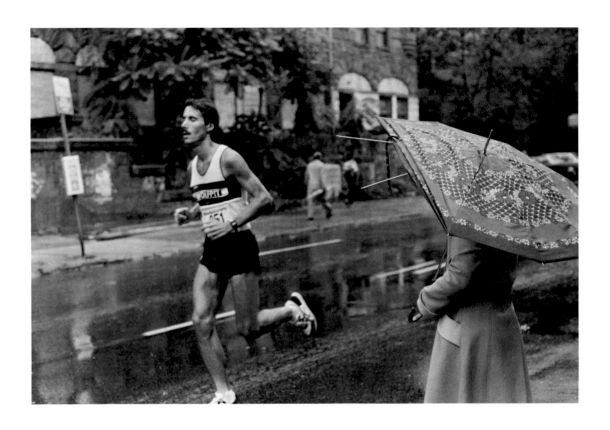

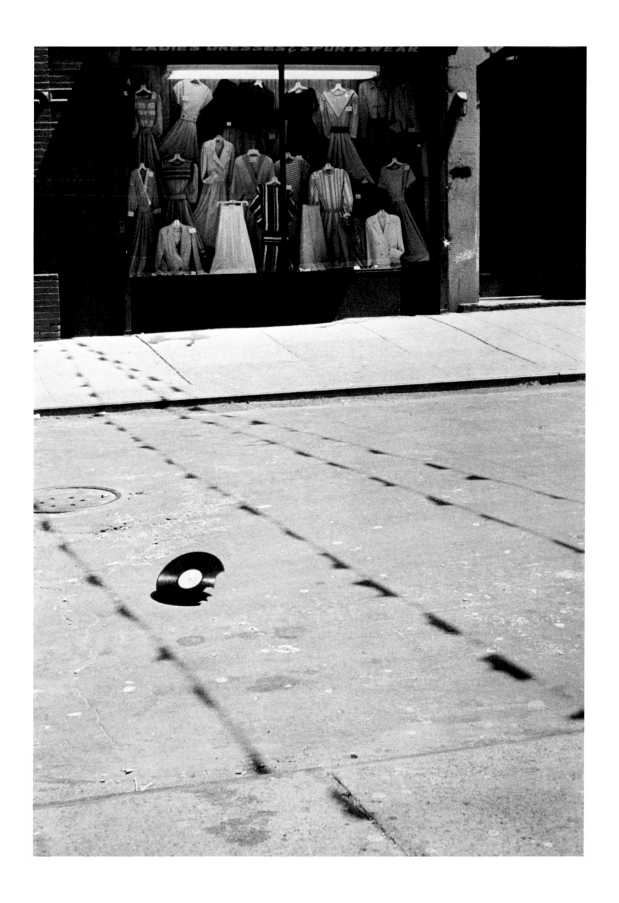

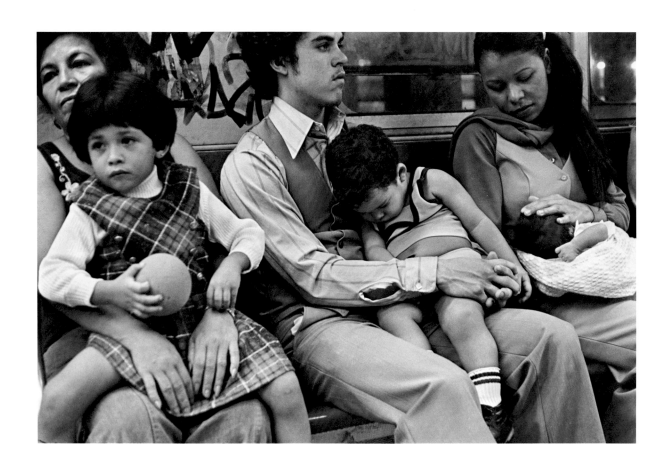

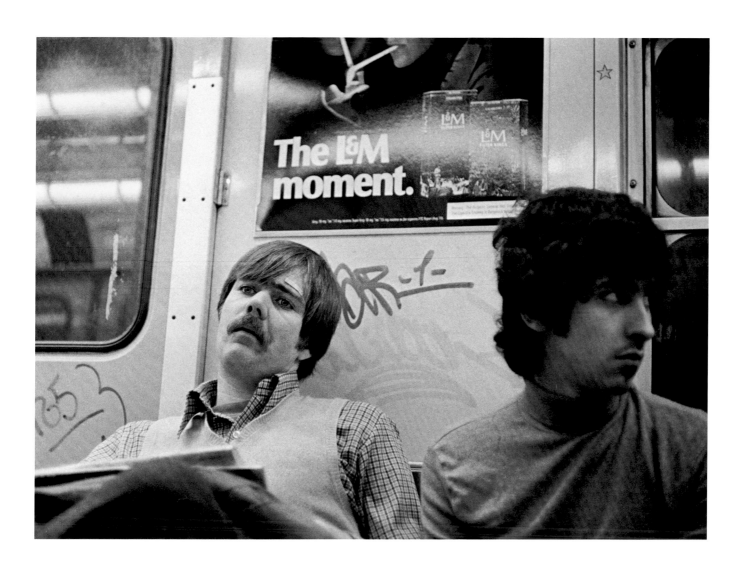

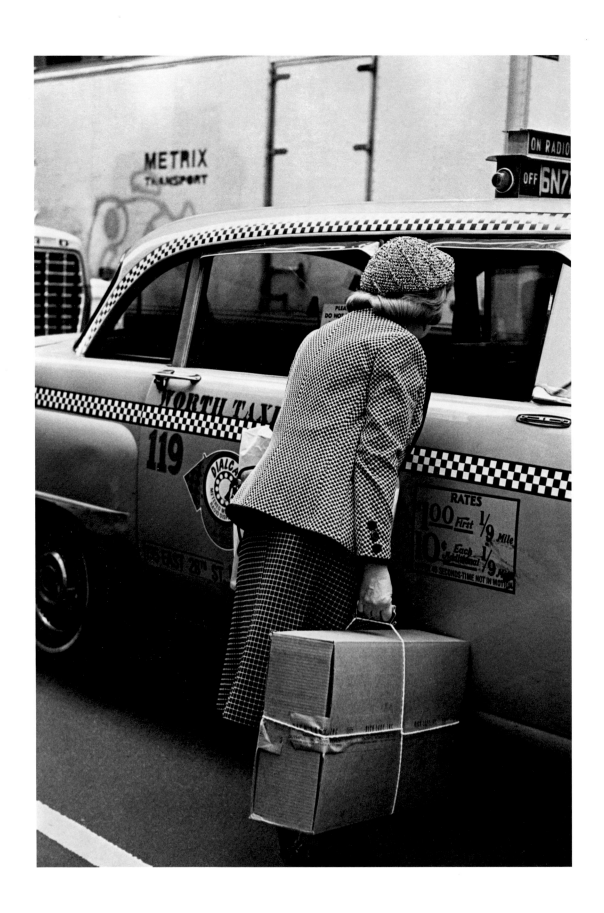

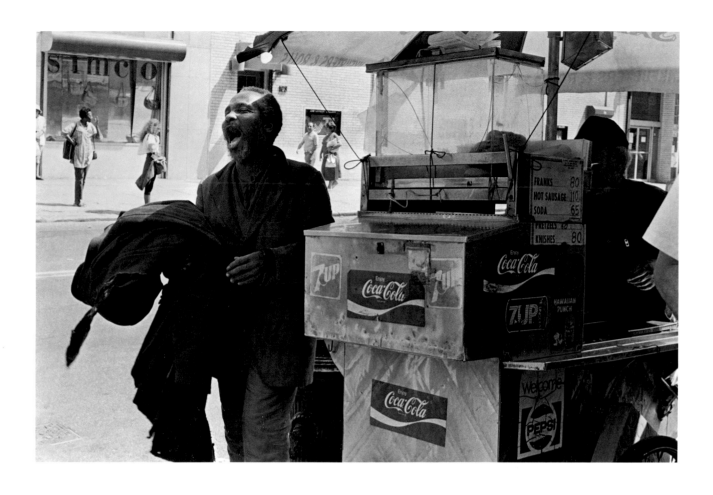

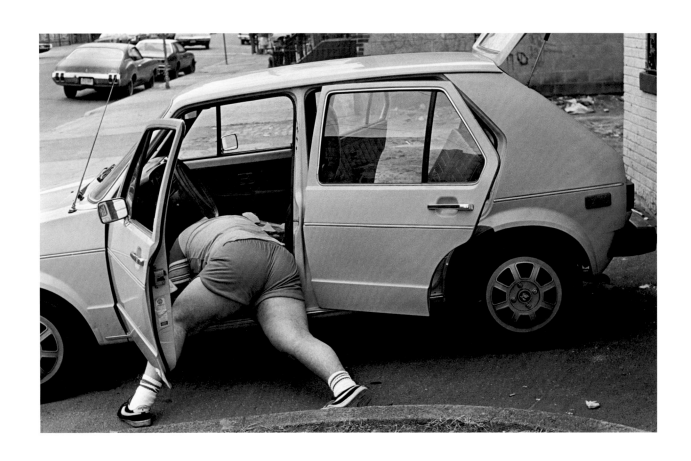

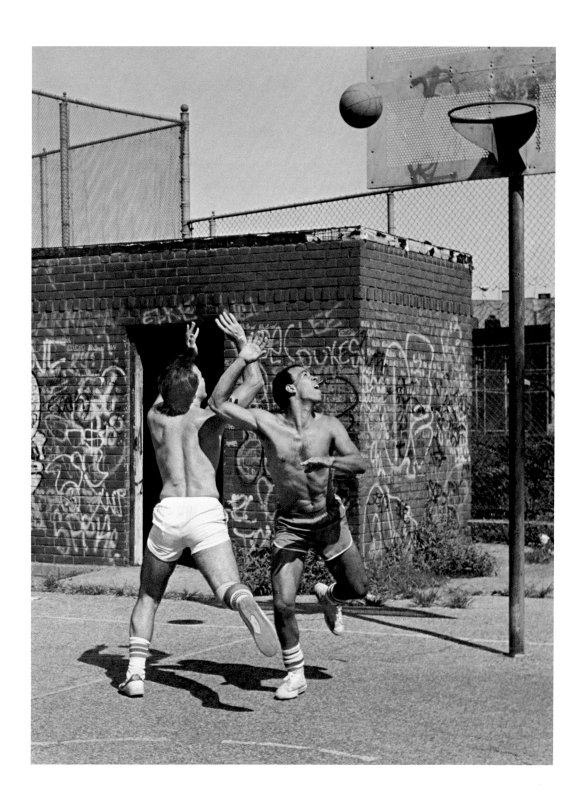

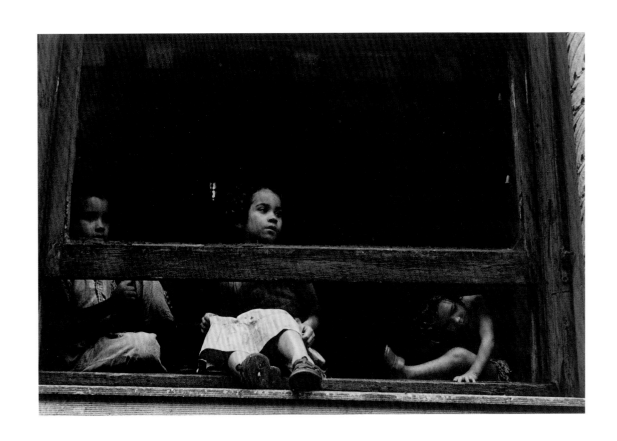

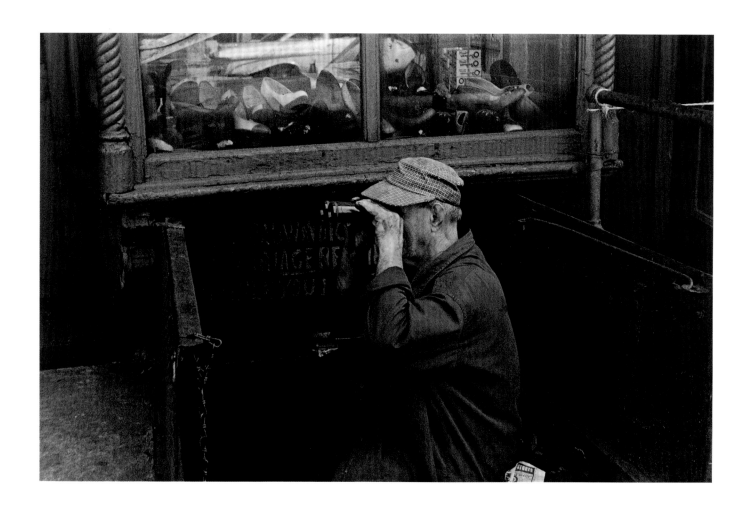

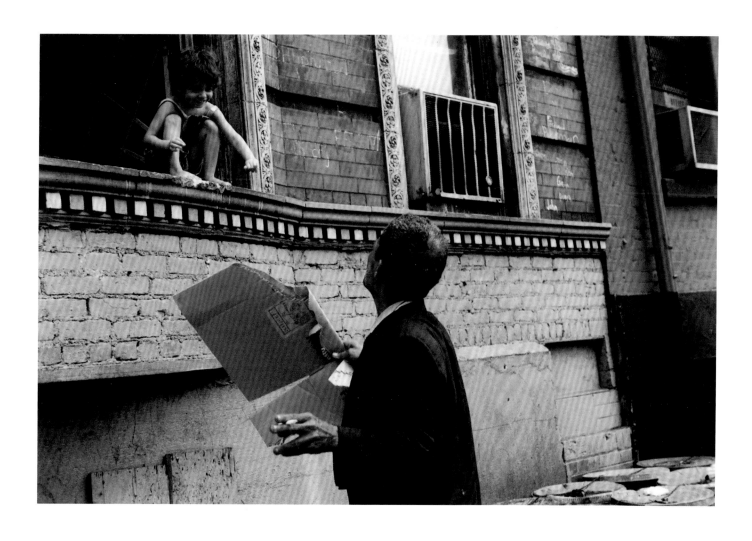

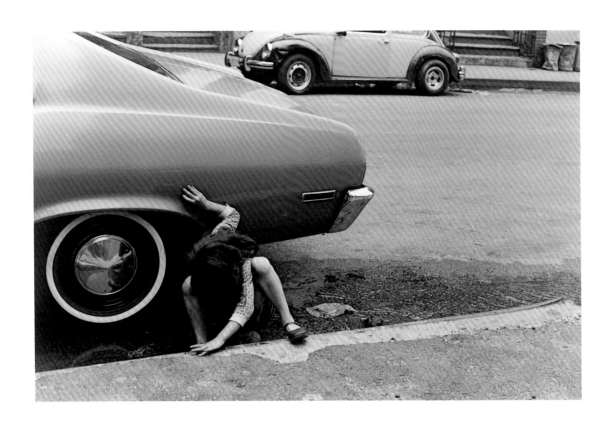

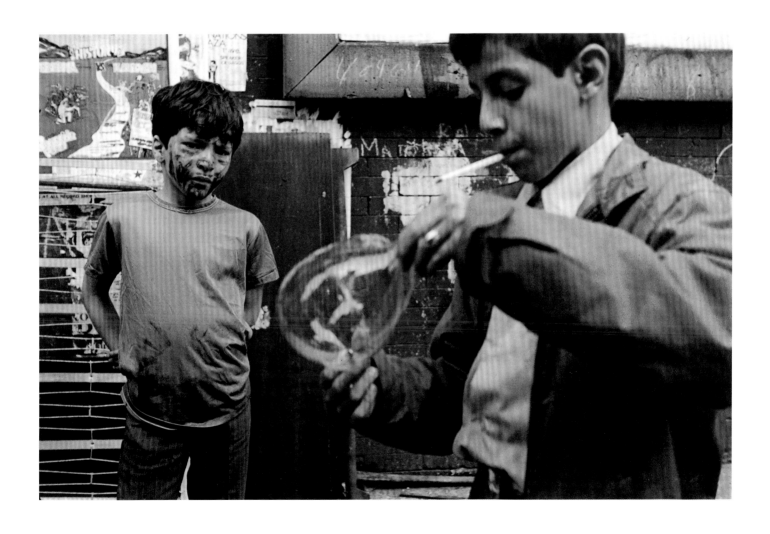

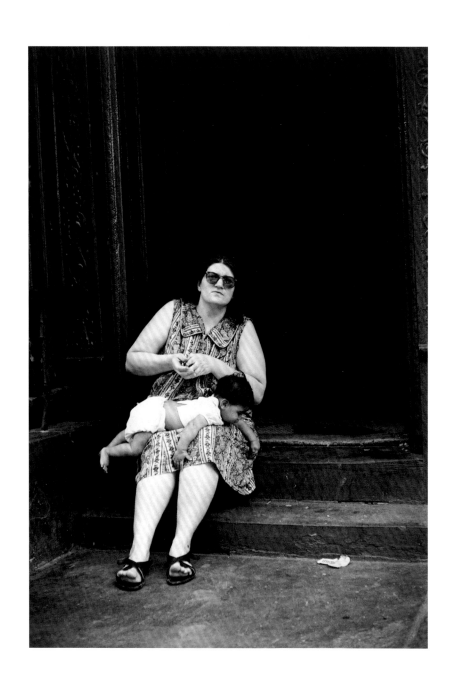

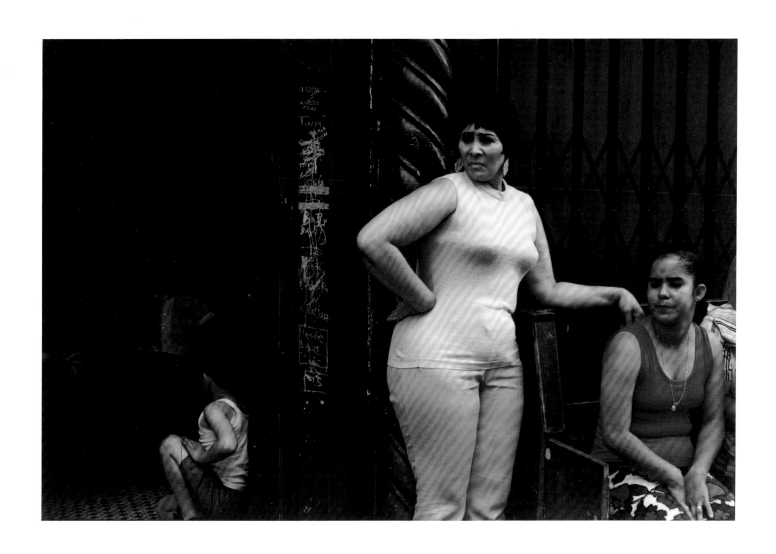

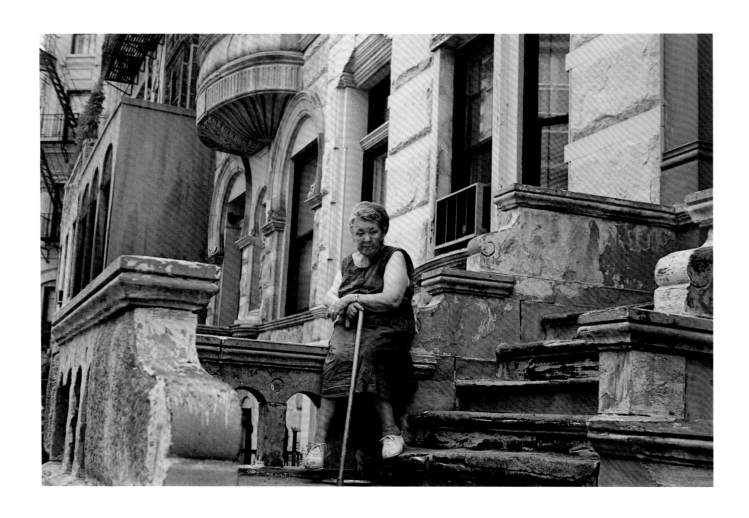

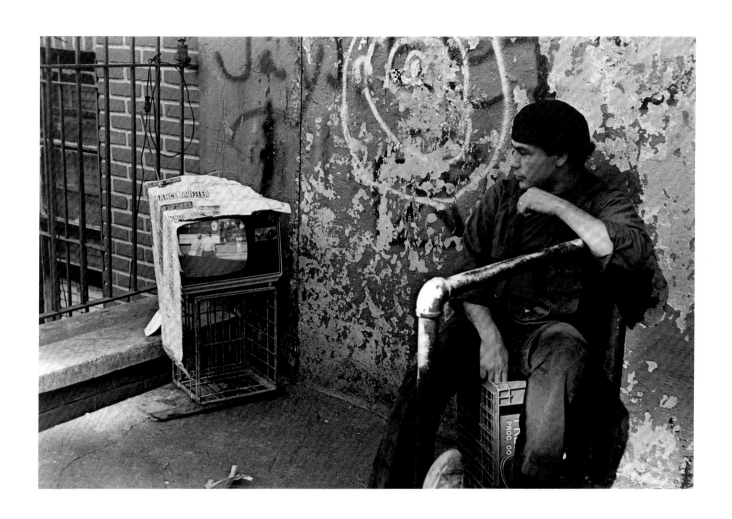

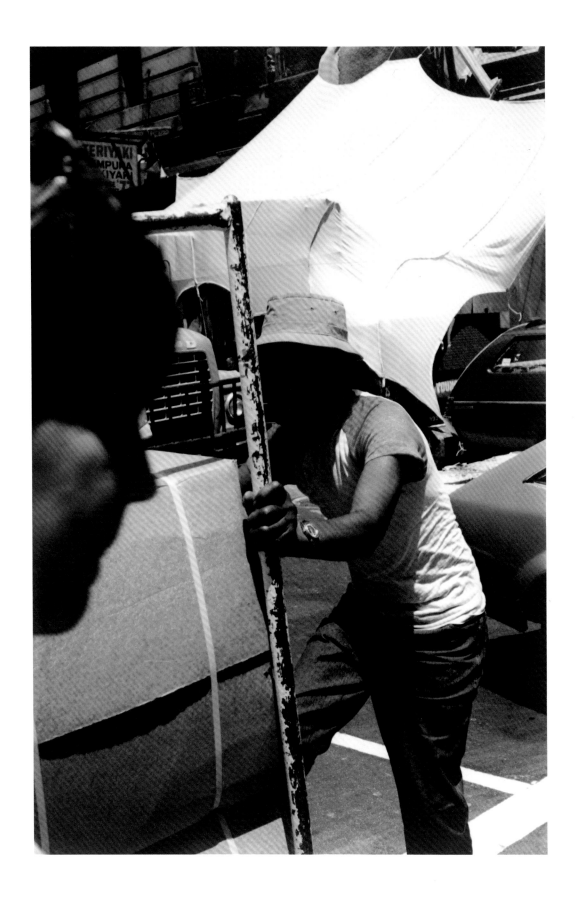

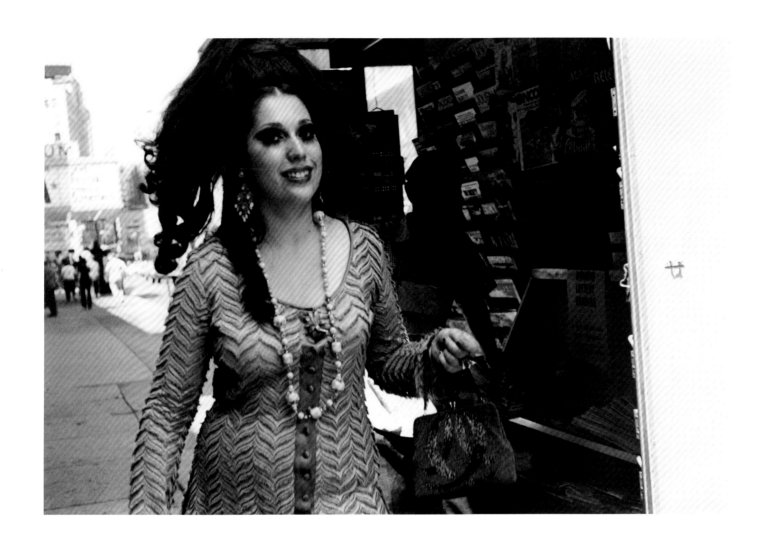

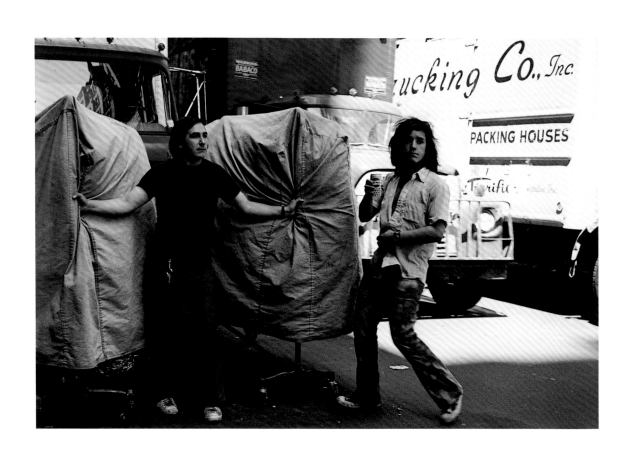

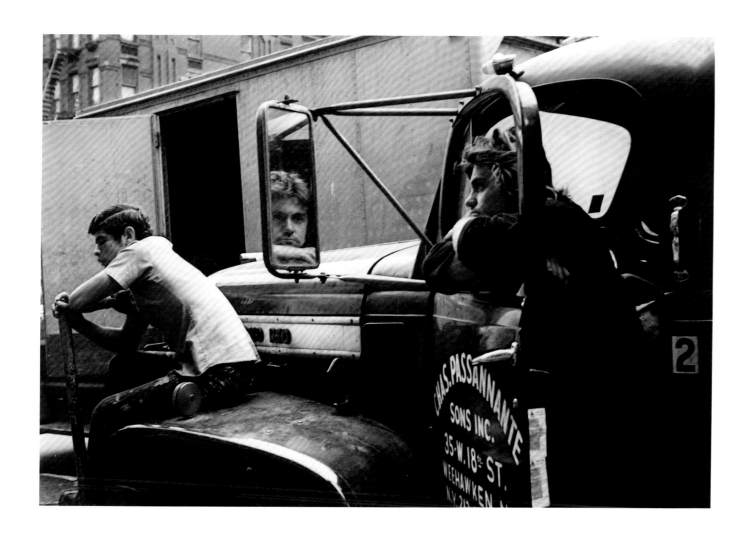

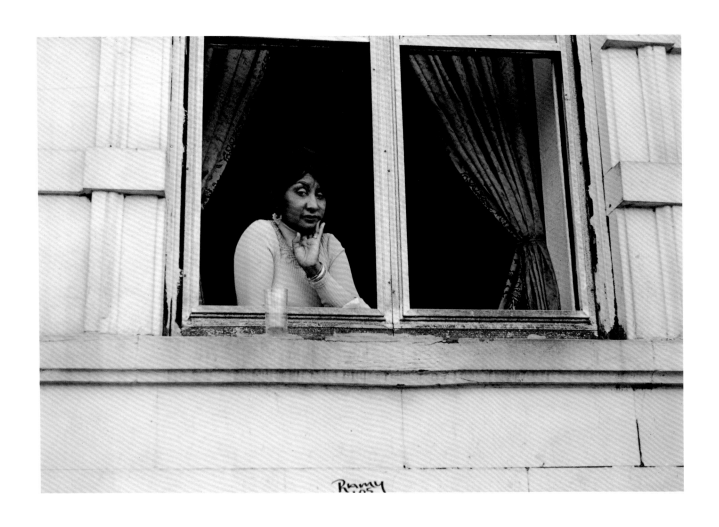

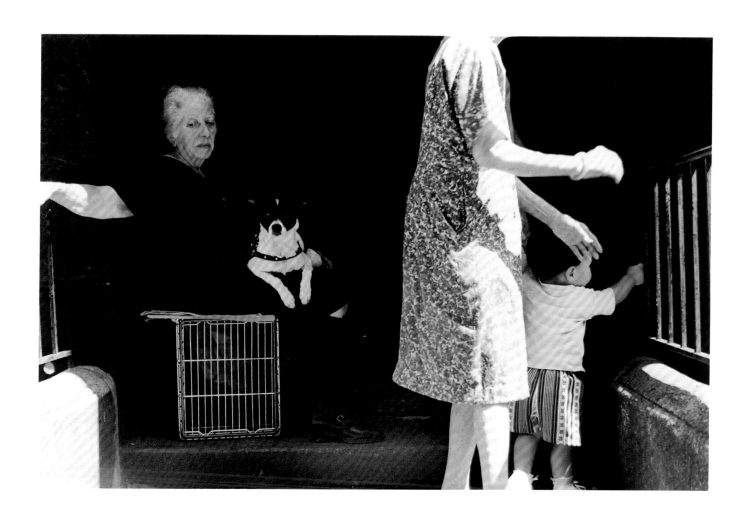

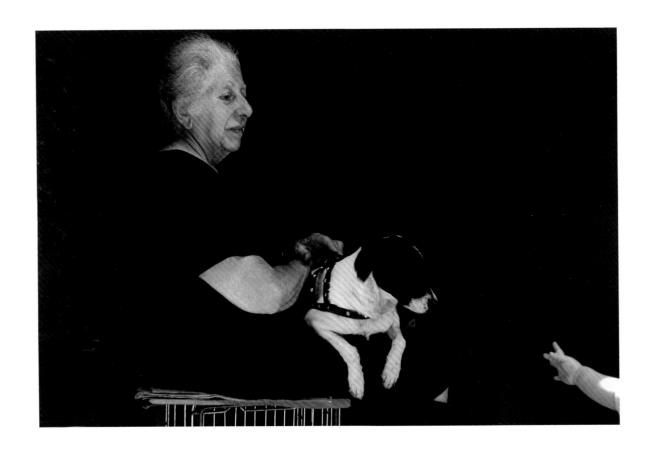

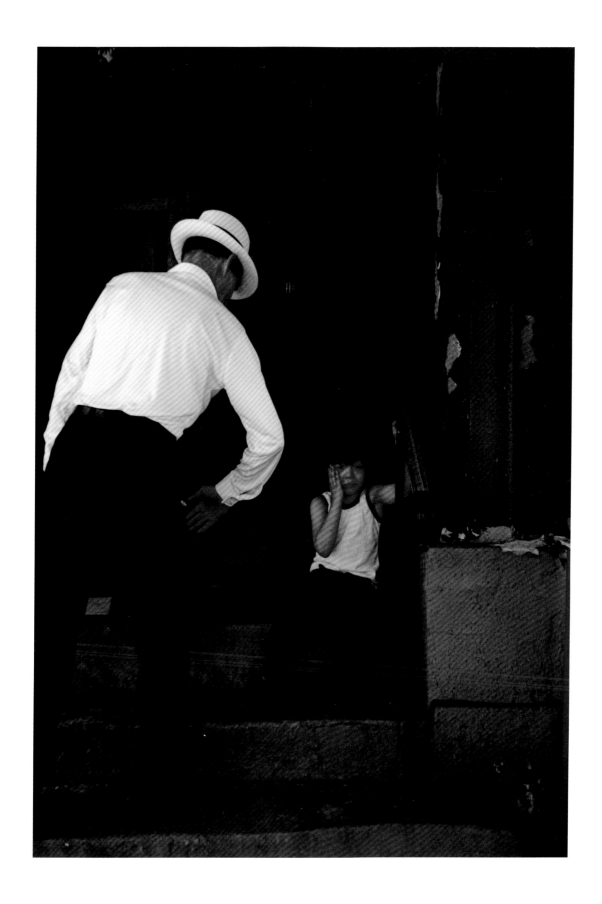

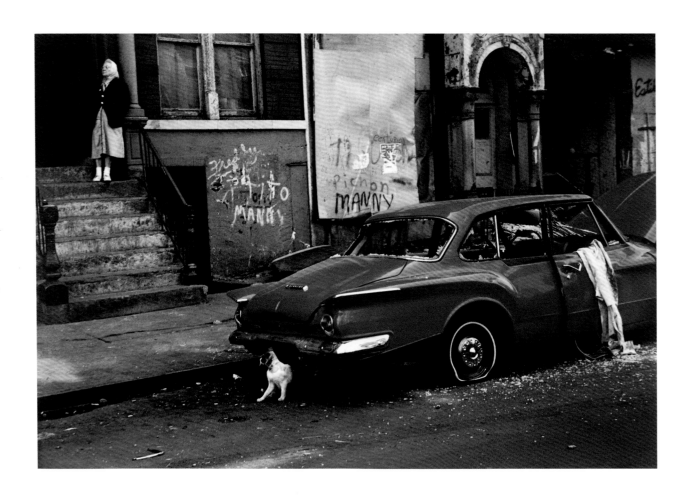

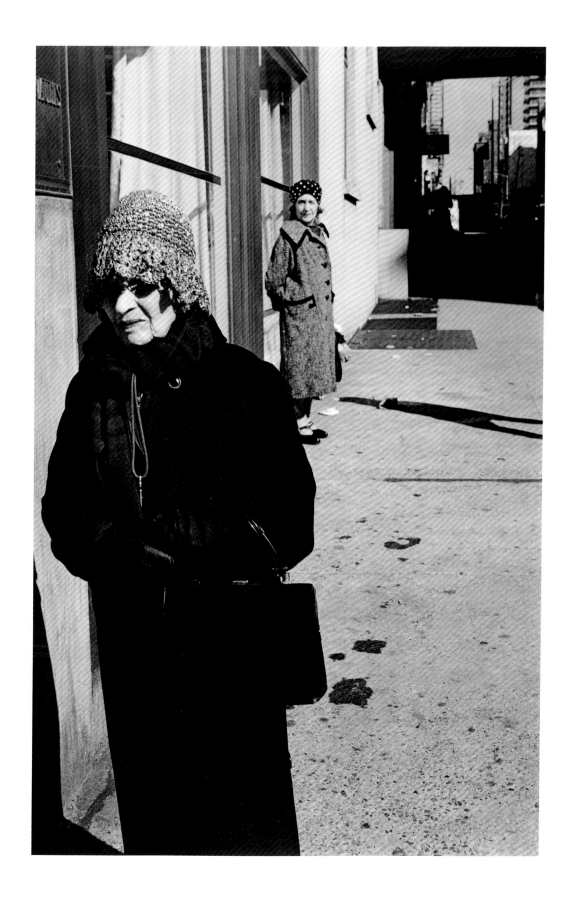

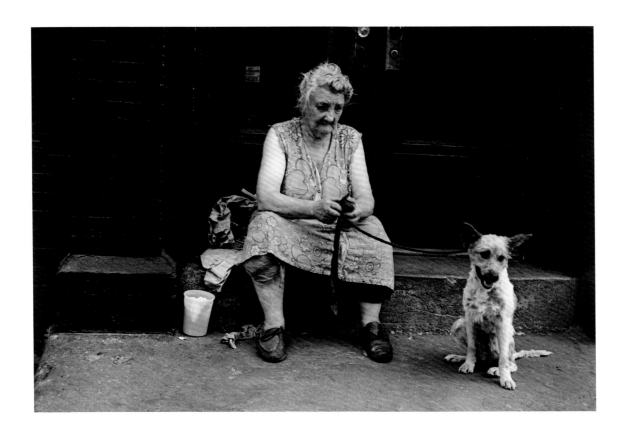

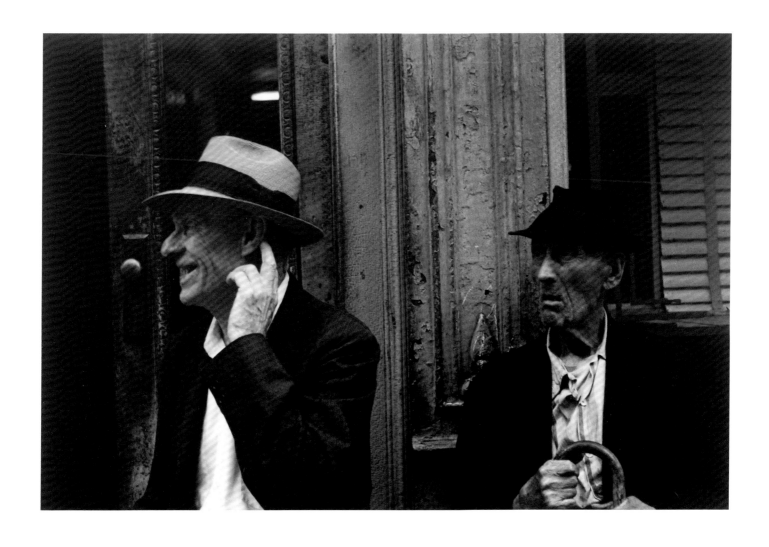

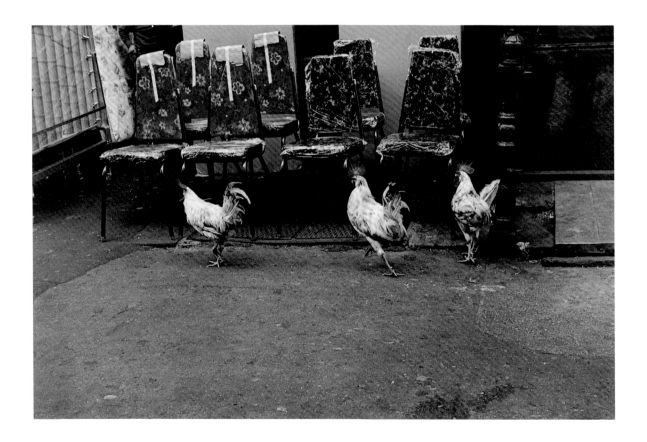

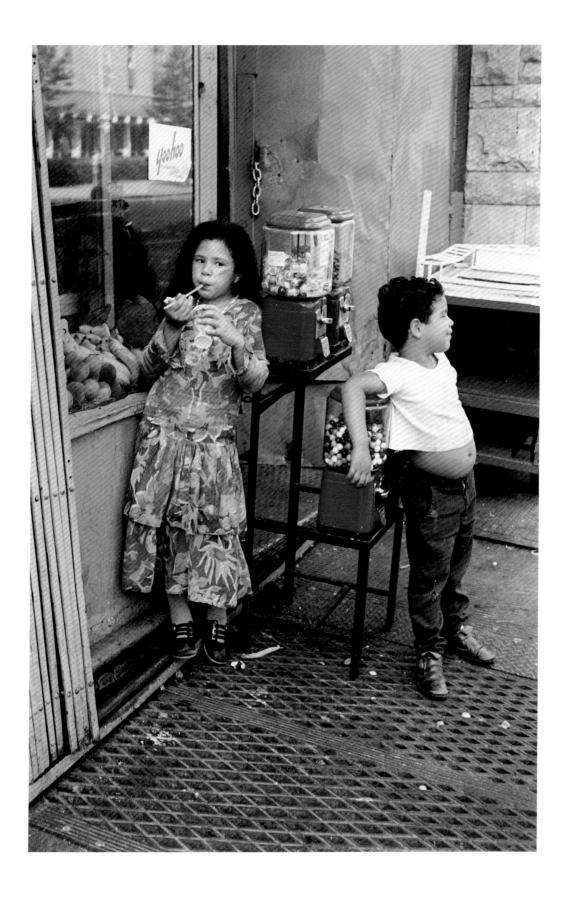

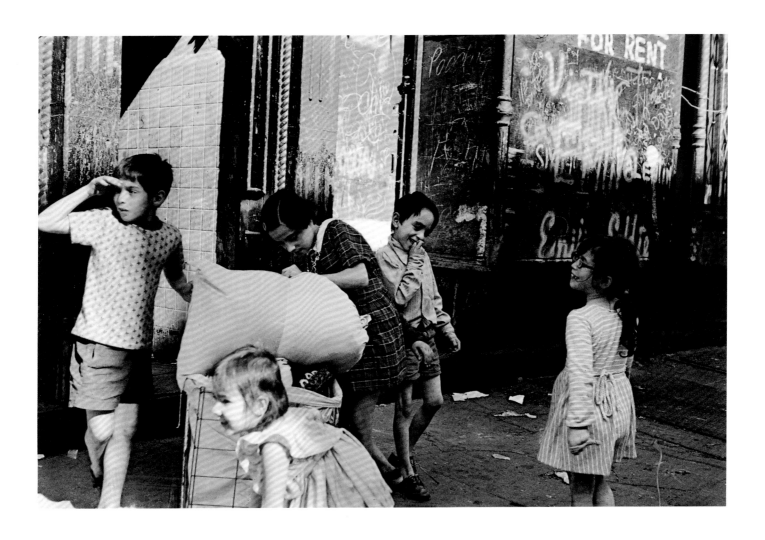